livable
MODERNISM

Kristina Wilson

livable MODERNISM

INTERIOR DECORATING AND DESIGN DURING THE GREAT DEPRESSION

Yale University Press, New Haven and London
in association with
Yale University Art Gallery

Published by Yale University Press in association with
the Yale University Art Gallery

Library of Congress Cataloging-in-Publication Data
Wilson, Kristina.
 Livable Modernism : interior decorating and design
 during the Great Depression / Kristina Wilson.
 p. cm.

 Includes bibliographical references and index.
 ISBN 0-300-10475-8 (hardcover : alk. paper)
 1. Design—United States—History—20th century. 2. Interior
decoration—United States—History—20th century. 3. Modernism
(Aesthetics)—United States. I. Yale University. Art Gallery. II. Title.

NK1404.W55 2004
747'.0973'09042—dc22 2004006767

A catalog record for this book is available from the British Library.

The paper in this book meets the guidelines for permanence and durability
of the Committee on Production Guidelines for Book Longevity of the
Council on Library Resources.

PUBLISHED WITH THE SUPPORT OF A GRANT FROM
THE GRAHAM FOUNDATION FOR ADVANCED STUDIES
IN THE FINE ARTS

for David

EXHIBITION SCHEDULE
October 5, 2004 – June 5, 2005
Yale University Art Gallery, New Haven

CATALOGUE
Editor
Lesley Baier
Design
Henk van Assen
Fonts
MT Grotesque, MT News Gothic, Electra
Printing
CS Graphics, Singapore

Jacket
FRONT
(top) Advertisement for Wear-Ever Aluminum, 1936
(detail; fig 2.24)
(bottom) American Modern armchair, 1936, Russel Wright, designer.
Yale University Art Gallery. Mabel Brady Garvan Collection,
by exchange (fig 1.14)
BACK
Advertisement for Chase Brass & Copper Company,
1934 (fig 2.28)

Contents

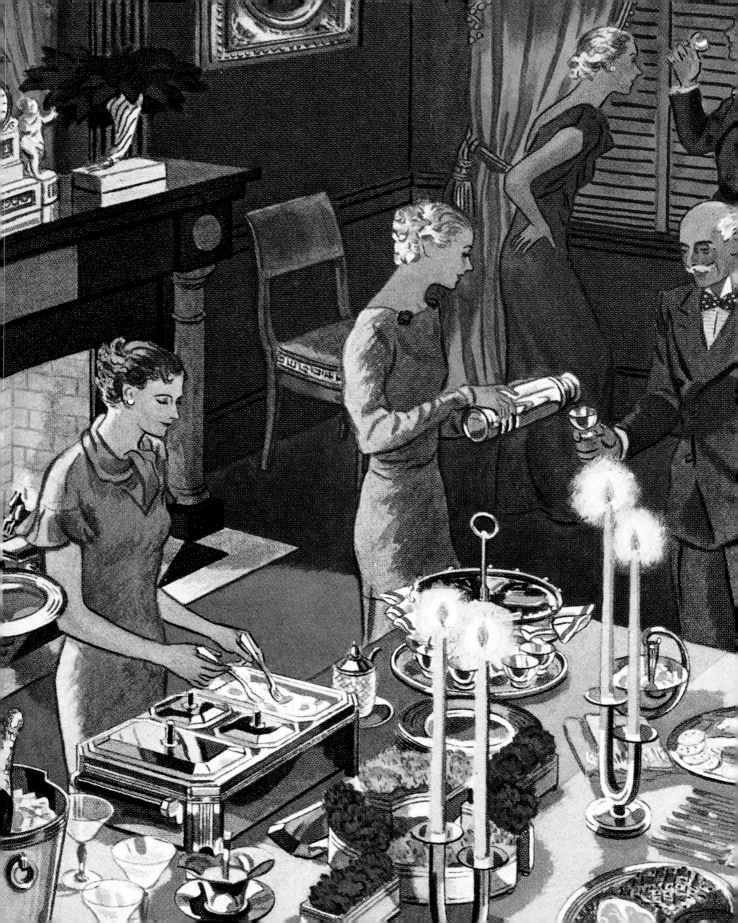

Director's Foreword

In 1983, the Yale University Art Gallery mounted the pioneering exhibition on 1920s American modern decorative arts, *At Home in Manhattan,* curated by Karen Davies, then a graduate student in the Department of the History of Art. *At Home in Manhattan* recovered a vibrant early world in American modernism and marked the beginning of the Art Gallery's commitment to collecting American decorative arts of the years between the two World Wars. After more than twenty years, the Art Gallery has returned to this rich period and now presents *Livable Modernism: Interior Decorating and Design During the Great Depression. Livable Modernism* provides a sequel of sorts to *At Home in Manhattan,* picking up the story of American modern design in the early years of the Depression. *Livable Modernism* also provides some insight into the history of the Yale collection of American Art. The collection of American Decorative Arts was established in the interwar years—at exactly the same time as the objects studied here were created—with gifts from Francis P. Garvan and Mabel Brady Garvan. The Garvan Collection focused on exemplary works from the seventeenth, eighteenth, and early nineteenth centuries, as followed the tastes of the day. As *Livable Modernism* explains, modernist design in the 1930s often actively engaged the public's enthusiasm for early American decorative arts, attempting to translate the popular veneration of the past into new forms. The objects studied here thus not only represent growth in the Art Gallery's collection, but also give us a new perspective on the existing collection: they remind us that the Garvans lived in a modern period and that their impulse to preserve objects from the American past was a modern one.

Kristina Wilson, Marcia Brady Tucker Curatorial Fellow in American Decorative Arts, began gathering ideas for this project several years ago as a graduate student in the History of Art department. When it became clear that the timing for her project would coincide with our major renovation of Louis Kahn's landmark building—another example of Yale's embrace of modernism—Ms. Wilson and Patricia E. Kane, Friends of American Arts Curator of American Decorative Arts, developed a proposal for a book-length study of Depression-era design. In the course of her research, Ms. Wilson has helped the Art Gallery expand our collection of twentieth-century decorative

arts and has also brought new light to bear on existing works in our collection. We are grateful to the Graham Foundation for their support of the resulting publication, *Livable Modernism.*

We are fortunate to have the American Arts galleries open during the course of the Kahn renovations, and to have the Matrix gallery available for temporary exhibitions. The exhibition that accompanies *Livable Modernism* is made possible through the generosity of the Friends of American Arts at Yale and a challenge grant from the National Endowment for the Arts. I would also like to thank John C. Waddell, Yale Class of '59, for his generous loans to the exhibition. In the acknowledgments, Ms. Wilson thanks the many members of the Yale University Art Gallery community who helped bring the exhibition and this book into being.

Finally, the Marcia Brady Tucker Fellowship in American Art was established to support the research pursuits of young scholars in the field, and is yet another example of the lasting legacy of the Garvan and Brady families. The Tucker Fellowship contributes to the educational mission of this institution by making possible such in-depth research projects as Ms. Wilson has conducted for *Livable Modernism.* It also allows us to reach out to the interdisciplinary arts community at Yale with a project that will stimulate conversation among architects, artists, and art historians. *Livable Modernism,* undertaken at a time when our facilities are under renovation wraps, is an example of the Art Gallery's enduring commitment to innovative scholarship.

JOCK REYNOLDS
THE HENRY J. HEINZ II DIRECTOR, YALE UNIVERSITY ART GALLERY

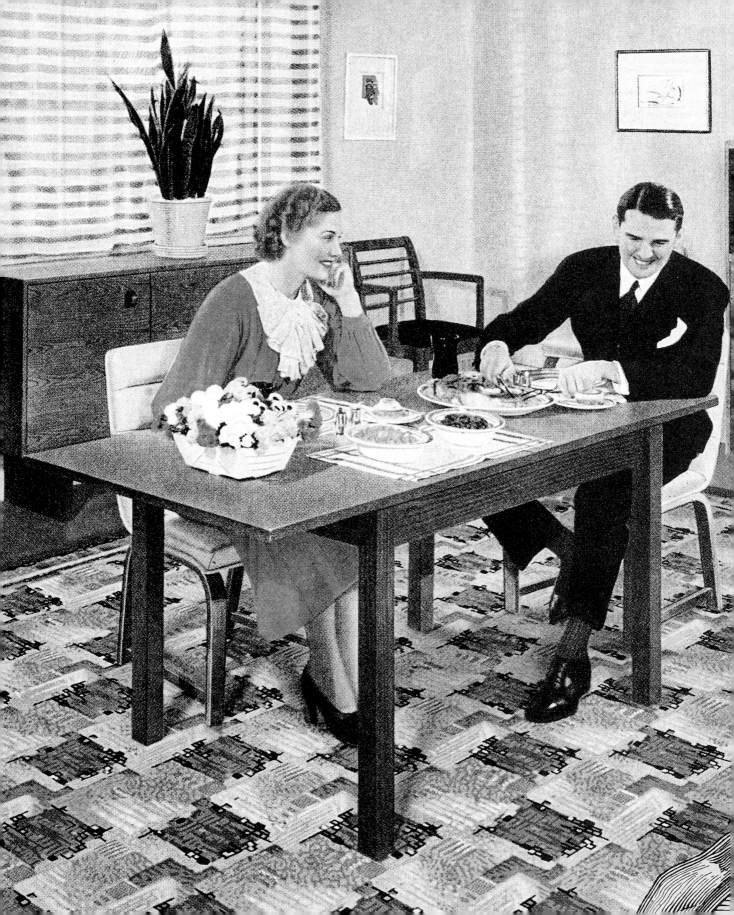

Acknowledgments

I have incurred debts to a great many colleagues and friends in researching and writing *Livable Modernism*. Foremost, I would like to thank Patricia E. Kane for her continual support and enthusiasm for this project. Pat and I first began to discuss a potential project on 1930s modernist design early in my graduate work at Yale, and her commitment to the realization of this book has been unstinting. Throughout the course of my two years as a Marcia Brady Tucker Curatorial Fellow, I have benefited from her advice, her wise comments on early drafts of the manuscript, and her insights on the state of the field of decorative arts history and its future.

I also want to thank Jock Reynolds, the Henry J. Heinz II Director of the Yale University Art Gallery, for his support of this project. Jock's zeal for twentieth-century art in all of its manifestations is infectious, and in conversations with him over the past two years I have continually been inspired to think both more critically and more broadly about American modernism. His commitment to the scholarly life of the Art Gallery community has made this a very congenial place to pursue my project.

I am grateful to several people for their close readings of earlier versions of the manuscript, in particular Karen Lucic, Sandy Isenstadt, Pat Kirkham, David Barquist, and Ned Cooke. Ned's interest in this project has been a continual source of support, for which I thank him. I have also benefited from conversations with several scholars in the field, who have generously shared their thoughts and time with me. I would especially like to thank Phyllis Ross, whose expertise on Gilbert Rohde's work is unrivaled; James Beebe, who has done extensive work on the Lloyd Manufacturing Company and patiently answered my questions about tubular steel manufacturing; and Donald Albrecht, who discussed with me his thoughts on Russel Wright and on larger questions of advice manuals in twentieth-century American culture.

This project would not have been possible without the help of several collectors who have graciously let me into their homes and shared their collections and their wisdom with me: John C. Waddell, Dick and Jody Goisman, Robert Schonfeld, and Dennis Mykytyn. I have benefited enormously from their insights, developed over years of close looking at objects from this period. I would also like to thank Richard Goodbody, Tom Cogill, and Jim Wildeman, whose elegant photographs appear

throughout the book. Finally, my thanks to Bill Straus and Nick Brown for sharing their knowledge about the careers and designs of Wright and Warren McArthur.

I spent the early part of this project immersed in several archival collections, and I would like to thank those institutions for making their papers available to me. Linda Baron and the late Bob Viol welcomed me at the Herman Miller Archives and made their extensive collections available to me. The staff at the Special Collections division of the Syracuse University Library helped me to navigate their massive industrial design collections. At the Cooper-Hewitt National Design Museum Library, I appreciated the help of Stephen Van Dyk and Elizabeth Broman. Helen Adair at the Henry Ransom Research Center, University of Texas, Austin, guided me through the Norman Bel Geddes Collection. Raechel Guest at the Mattatuck Museum, Waterbury, Conn., made the archives of the Chase Brass and Copper Company available to me. My thanks to Aimee Marshall at the Chicago Historical Society; Pat Bakunas at the Special Collections department of the Robert J. Daly Library, University of Illinois, Chicago; and Anthony Jahn, archivist at Marshall Field's, for their help sorting through extensive archives related to the Chicago World's Fair of 1933–34, *A Century of Progress International Exposition.*

This project could not have been accomplished without the help of everyone in the American Arts department at the Art Gallery. I am especially grateful to Nancy Yates, who approached the large task of acquiring illustrations for the book with amazing organization, tenacity, and humor. David Barquist and Robin Jaffee Frank shared their wisdom about transforming my rambling ideas into a project with a concrete narrative; Caroline Hannah and Katherine Chabla provided research assistance. Amy Kurtz Lansing and Dennis Carr offered friendship and support, as well as many opportunities to laugh at the folly of art history, throughout my time living among the carrels in the American Arts office.

At Yale University Press, I would like to thank Patricia Fidler, Michelle Komie, Mary Mayer, and John Long for their enthusiasm and professionalism. Lesley Baier gracefully fine-tuned the manuscript. I am especially grateful to Henk van Assen, who has created a book design that beautifully complements the dynamic world of 1930s modernism discussed here.

This book, and the exhibition that accompanies it, could not have been realized without the help of many colleagues at the Art Gallery. I would like to thank Anna Hammond, Liz Harnett, Lesley Tucker, Amy Porter, and Pam Franks for their creative approach to the public outreach for *Livable Modernism;* Marie Weltzien for her superlative skills as a publicist; and L. Lynne Addison, Associate Registrar, for coordinating loans. Burrus Harlow, Clarkson Crolius, and their excellent installation team have collaborated to create a compelling, dynamic exhibition design. Kathleen Derringer's fundraising helped to organize this project. Louisa Cunningham, Charlene Senical, and the staff in the Business Office have fastidiously attended to

the budgetary details. John ffrench, Janet Zullo, and Alex Contreras provided hand-
some photographs of the Art Gallery's own objects. Finally, Susan Matheson, as
Chief Curator, offered her advice and support in the earliest stages of this project.

A few important friends and colleagues who don't easily fall into the above
categories must also be thanked. Nonie Gadsden at the Milwaukee Art Museum
and Glenn Adamson of the Chipstone Foundation introduced me to the Goismans.
Glenn also read part of the manuscript at a crucial point in its development and
was always ready for wide-ranging conversations on twentieth-century design;
he and Alicia Volk make Milwaukee a fun place to visit. Thomas Denenberg of the
Wadsworth Atheneum shared his wisdom about the Colonial Revival. I have learned
a lot from Susan Greenberg, in the Modern and Contemporary Art Department at the
Art Gallery, whose ideas about design and how we live with it are always refreshing.
This project necessitated many trips to New York City, and I am grateful to Melissa
Jampol and Seth Moskowitz for their always generous hospitality and friendship.

My parents, Richard and Ellie Wilson, whose own parents' homes open this
book, not only provided an interesting house for me to grow up in, but also love and
support as I have worked on this project. Liz Geist, Mark and Daniel Geist, and Dick,
Susan, and Sarah Geist have given me new homes to be a part of. Abigail Wilson
always has a dose of humor on hand, as well as compelling insight on the furniture
we lived with as children. David Geist is not only willing to outfit our own home
in modern furniture, but has impressive reserves of patience and love, and for that,
this book is dedicated to him.

KRISTINA WILSON
MARCIA BRADY TUCKER CURATORIAL FELLOW

But not only Chippendale

All of them were modern . . Boule, Hepplewhite, Sheraton, Shearer, Louis XIV

They didn't make their furniture look like Queen Elizabeth's or Queen Anne's or King James' or anybody else's

They stole a lot of ideas from everybody else, just like Twentieth century designers. But they did not make REPRODUCTIONS.

In other words, they were all MODERN designers doing modern design . . . modern for THEIR day

18ᵗʰ Century Contemporary

20ᵗʰ CENTURY CONTEMPORARY . . .

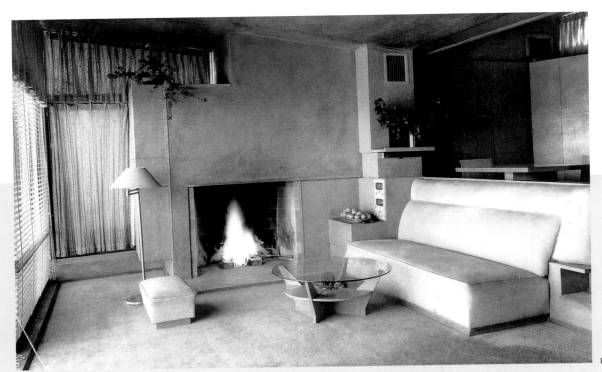

1.1

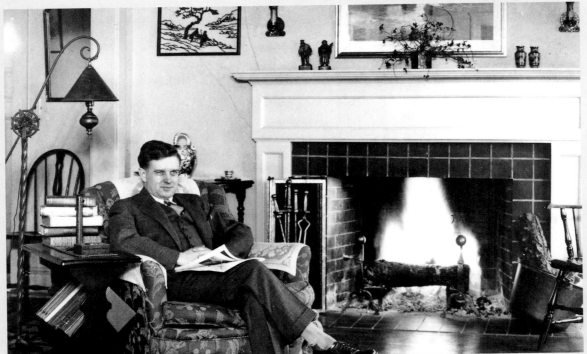

1.2

Introduction

This book examines modernist designs manufactured in America and market-
ed to middle-class homes during the decade of the 1930s. It studies both individ-
ual objects and the publicity that surrounded them, delving into the printed
world of advertisements, staged magazine photographs, and images of retail
showrooms. The audience for this campaign of modernist design can be defined
at its outermost extremes by the households of my two grandmothers. My
paternal grandmother trained as an interior decorator in Los Angeles in the
1930s and married a businessman who shared her taste for radically austere
modernist design. Their first home, commissioned from the southern California
émigré architect **R. M. Schindler**, featured vast expanses of window which
brought light and open views to the interior (fig. I.1). Schindler's furniture for
their living room and dining alcove, some of which was designed in collabora-
tion with my grandmother, had dramatically simple contours, was made of
industrial materials such as plywood, and was light and spare enough to create
a feeling of spaciousness in the limited interior. My maternal grandmother, a
librarian, lived her entire life in New England, and she and her scientist husband
set up their first home in a Rhode Island Colonial Revival house in the middle
years of the decade. Their living room had an armchair with squat cabriole legs,
several Windsor-styled side chairs, brass andirons in the fireplace, and a rustic
brass reading lamp (fig. I.2). Lace curtains provided translucent privacy for the
first-floor windows. Within this lace-shrouded room, layers of textiles and
turned spindles created an enveloping retreat.

The modernists who made the objects studied in this book sought to bridge
the aesthetic and lifestyle differences symbolized in my grandmothers' homes.
While they were committed to many of the ideals exemplified in Schindler's
interior—using industrial, affordable materials to make functional forms that
would liberate the family from the constraints of outmoded conventions—they
also appreciated the value of comfortable familiarity that my Rhode Island
grandmother found in furnishings that recalled traditions of handicraft produc-
tion. In their integration of modern design with consumer desire, the modern-
ists of the 1930s formulated a sympathetic model of domestic design which I

I.1
GUY AND ELISABETH WILSON RESIDENCE,
1935—38
R. M. Schindler, *architect*
Los Angeles, Calif.

I.2
ARTHUR AND HOPE VERNON RESIDENCE,
c. 1935
Kingston, R.I.

call "livable modernism." Livable modernism is defined not only by its adherence to the belief that a simplified aesthetic could facilitate an enlightened lifestyle, but also by its respect for the physical and psychological comfort of the user. It is defined, furthermore, by its willingness to make use of the language of the marketplace to reach potential users. In the terms of my grandmothers' homes, livable modernism was the trend in Depression-era design practice that attempted to make the ideals and forms of the Schindler interior appealing to consumers such as my Colonial Revival grandmother.

In recent years, design historians have dismantled the idea of modern design as a monolithic concept and replaced it with a wide range of contemporaneous, overlapping modernist designs. For many decades, the gold standard of modernist design was based on the abstract, industrial, functional forms epitomized in Ludwig Mies van der Rohe's MR armchair from 1927 (fig. I.3). This school of modernist design emerged primarily in Germany in the 1920s and, based on the attention the Museum of Modern Art in New York has given it, has been called International Style design.[1] Recent scholarship has demonstrated that although various design movements across the European continent, Britain, and the United States in the first decades of the twentieth century were committed to such basic International Style tenets as simplicity, use of industrial materials, and functionalism, they differed in prioritizing these qualities. Moreover, they incorporated other design practices, such as the selected use of craft skills and of whimsical, appealing ornamental motifs. These scholars have made us aware of the many *modernisms* in design.[2] The moniker "livable modernism" is intended to contribute to that intellectual project by

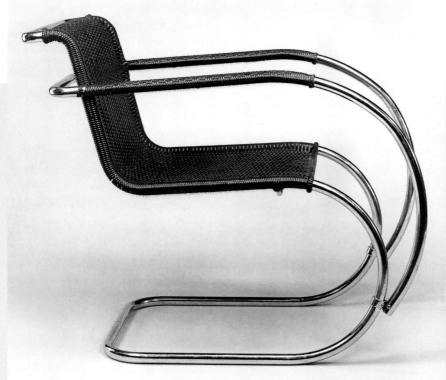

I.3

I.3
MR ARMCHAIR, 1927
Ludwig Mies van der Rohe, *designer*
Tubular steel and painted caning,
31 1/2 x 22 x 37 in. (80 x 55.9 x 94 cm).
Metropolitan Museum of Art, New York.
Purchase, Theodore R. Gamble Jr. Gift,
in honor of his mother, Mrs. Theodore
Robert Gamble (1980.351)

I.4
CABINET, 1926
Emile-Jacques Ruhlmann, *designer*
Macassar ebony, amaranth, and ivory,
50 1/4 x 33 1/4 x 14 in. (127.6 x 84.5 x 35.6 cm).
Metropolitan Museum of Art, New York.
Purchase, Edward C. Moore Jr. Gift, 1925
(25.231.1)

delineating—not only in its form, but also in its manner of appealing to the minds, bodies, and pocketbooks of consumers—a specific vein of modernist design practiced in the United States during the 1930s. Of necessity, the objects studied in this book are but a selected sample of the modernist design produced in the United States at this time; they have been gathered together because they share an interest in formal experimentation, a willingness to engage popular ideas about comfort and familiarity, and a commitment to affordability. Throughout the text I use the term "modern*ist* design" to highlight the plurality of practices that previously have been elided in the monolith of "modern design"; thus livable modernism is one strand of modernist design. The practitioners of the day, however, used the term "modern design" to describe their work, and in quoting them I have preserved their terminology.

Livable modernism arose out of the circumstances particular to the reception and dissemination of modernist design in the United States in the 1920s and 1930s. The idea of modernist design—broadly construed as domestic objects designed with a minimum of ornament and without reference to historical styles, constructed of newer, often industrial materials, and meant to express the specific experience of life in the modern twentieth century—first attracted public attention in the United States after the grand Paris exposition of 1925, the *Exposition Internationale des Arts Décoratifs et Industriels Modernes.* The organizers of the Paris exposition had demanded that participants contribute furnishings in a modern, nonhistorical style,

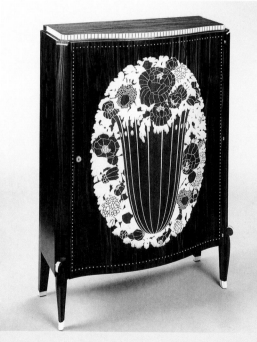

I.4

and although some of the most innovative furniture was being created in Germany at the time (in fact, Marcel Breuer designed his first tubular steel chair in 1925 at the Bauhaus), postwar politics prevented Germany's inclusion. Instead, the dominant interpretation of modernist design that emerged from the exposition was from the French school of simple forms, dramatic surface patterns, and luxuriant materials.[3] This school is epitomized in a cabinet designed by Emile-Jacques Ruhlmann and exhibited at the exposition, which includes such exotic materials as the orange-and-brown grain of macassar ebony and ivory, and which features a tour-de-force display of veneering and marquetry skill (fig. I.4).

In the United States, despite the presence of a small, dedicated group of modernist designers,[4] Secretary of Commerce Herbert Hoover decided that the country had little to contribute to the international event, and declined to participate. However, he did send a delegation of designers, educators, and critics to study the exposition, and their reports ensured that a broad segment of the American public soon learned about the movement.[5] In addition to writing numerous articles for popular and professional publications, members of Hoover's delegation supported

an exhibition of French objects from the exposition that traveled to museums throughout the country in 1926 and which resulted in the Metropolitan Museum of Art's acquisition of the Ruhlmann cabinet. The delegation also encouraged urban department stores, which could reach larger audiences than museums, to sponsor their own exhibitions of modernist design.

The articles and exhibitions that featured modernist design throughout the late 1920s tended to emphasize two principal qualities about the movement. First, critics and curators celebrated modernist furnishings and decorations as works of art that would enhance the quality of daily life for those who lived among them. The critic for the *New York Times* explained that a 1927 exhibition at R. H. Macy and Company department store offered "the opportunity to see what the addition of an artist's intelligence, skill, and feeling does for the objects brought constantly before our eyes in daily life." Household objects that had been designed by artists were not only aesthetically improved, but also, in capturing the "most significant, and naturally the most sympathetic, expression of life as we daily see it,"[6] would fundamentally enhance the lives of those who lived with them.

Second, critics and curators highlighted the potential for modernist design to be truly affordable: the possibility that the intelligent collaboration of designers with large, industrial manufacturers could bring the "priceless element of art" into the homes of many "for only a little price."[7] Robert W. de Forest, the President of the Metropolitan Museum of Art and a supporter of modernist design, lauded the efforts of manufacturers in a speech at the 1927 Macy's exhibition:

[Department stores] not only show, but they circulate—they give the opportunity not only of seeing but of buying, taking away, and bringing into the home. They can do so because art of this character is no longer expensive and out of the reach of people of modest incomes. In years past such objects were produced only by the hands of the craftsman...but handwork, being costly, is only for the rich. While mass production of the machine cannot produce so great a degree of beauty as the hand of the craftsman, it can produce a high degree of beauty and the department store can distribute it.[8]

However, despite repeated claims that modernist design would be affordable to many, the actual objects featured in American department store and museum exhibitions throughout the late 1920s were more often one-of-a-kind experiments inspired by the aesthetic of simplified contours and stylized ornament found in the Ruhlmann cabinet; these objects were intended to look as though they could be inexpensively replicated rather than, in fact, embodying that quality. The critic Douglas Haskell condemned the Metropolitan Museum's 1929 exhibition of modernist design, *The Architect and the Industrial Arts,* for precisely this reason. By way of contrast, he invoked the *Weissenhofsiedlung,* a large exhibition of working-class housing and furnishings held in Stuttgart in 1927 and sponsored by the Deutscher Werkbund, a professional association of designers and architects committed to developing relationships between designers and industries to produce low-cost, intelligent designs:

One expected to find that these architects [in the Metropolitan's exhibition], who among them have built some of our finest skyscrapers, had designed or chosen tables, chairs, desks, bath tubs, closets, walls, floors, windows and what not, of a kind that could be industrially fabricated...That would have been a splendid idea, and not an entirely unfamiliar one, since something very similar was done in Germany with complete houses in the famous Stuttgart Exposition of 1927. But the architects here have failed...Is it because the architects are so much professional men, and their clients all from Park Avenue? Very well...pray that the good strokes in design may eventually filter through to the rest.[9]

A cocktail shaker and set of glasses designed by the architect Ralph T. Walker for the Metropolitan's exhibition exemplifies Haskell's complaint (fig. I.5). The cocktail party itself had become a popular social institution during the decade, and Walker's set, with twelve matching glasses standing ready for a large gathering, symbolized an aspect of modern life that was both informal and gregarious. Moreover, the shaker featured a clever, functional design for pouring its contents: the top of each handle doubled as a spout, so that the liquid would appear, as if miraculously, from either side when the vessel was tipped. Yet this set, which embodied the era's rebellion against Prohibition (instituted in 1920 and repealed in 1933), was made of silver, an expensive material like Ruhlmann's ebony and ivory, not affordable to

I.5
COCKTAIL SET, 1929
Ralph T. Walker, *designer*
Silver, 14 x 14 x 23 in. (35.6 x 35.6 x 58.4 cm). Yale University Art Gallery. M. Josephine Dial in memory of Gregory T. Dial, B.S. 1930, Fund (1985.23.1.1-.14)

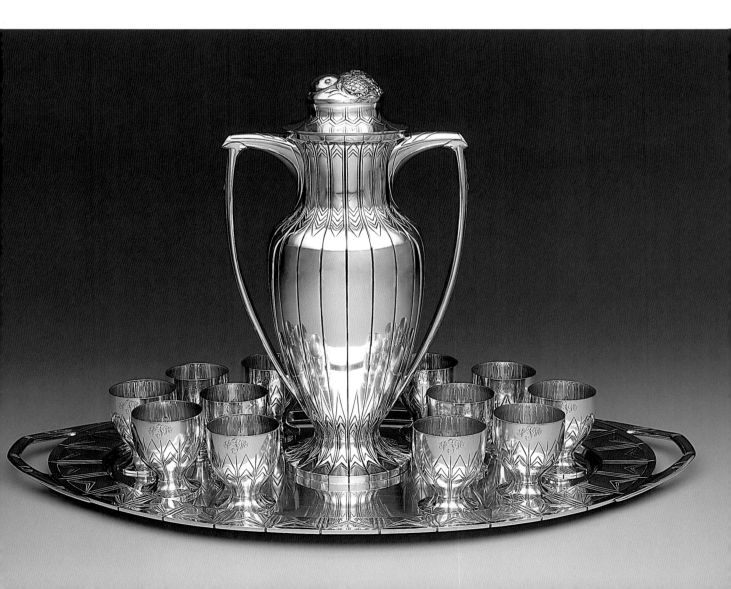

many consumers. The forms of the shaker and glasses mirror this contradiction: despite their streamlined contours, these objects display handwrought decoration in their geometric surface patterns and the chased assortment of fruit and flowers in the shaker's cap, indicating, again like Ruhlmann's marquetry, their origins in handicraft production rather than industrial replication.

After the onset of the Great Depression, critics, curators, and designers themselves turned an increasingly critical eye to designs from the late 1920s that had not embraced the efficiency of industrial manufacture. A critic writing for *Fortune* in 1935 summarized the post-crash attitude toward this earlier design when he wrote dismissively, "America first got wind of [modern design] through the splurgy Paris Exposition of 1925… [In the following years,] bad as well as good, all modern furniture was obscenely expensive."[10] When the Metropolitan Museum sponsored a major exhibition of modernist American design in 1934, the Depression-induced sobriety of many of the objects prompted comparisons with the 1929 show that echoed these themes. As the *New York Times* reviewer commented, "In 1929 the [display] rooms and their furnishings reflected the opulence of the times then reaching a climax and a mood for luxurious accents rather than for usability." He continued approvingly, "In the present exhibition it is evident that the soberer spirit of the present has tempered the more fanciful flights of designers."[11] According to one of the exhibition architects, Ely Jacques Kahn, the explicit goal of the 1934 exhibition was to promote affordable modernist design: "Those of us who assisted in arranging exhibits [for the 1934 exhibition] have realized that the demand for the precious, elaborate, and individual article is restricted, and have searched for material adapted to production in quantity and at a price that would make any of the objects shown available to a large group of people."[12]

Yet even as critics and designers, working under the weight of the Depression, agreed that modernist design should be "suitable for mass production by machinery, at such a low cost as to be available to all,"[13] they remained skeptical that objects such as Mies van der Rohe's tubular steel cantilevered chair—touted for its potential for industrial reproduction at the Stuttgart exhibition—would attract large consumer audiences.[14] Indeed, the mechanistic, austere forms emerging from places such as the Bauhaus, the Werkbund, and Le Corbusier's studio were quickly assailed as cold and alien: some German critics complained in 1927 of the "brutal *Sachklichkeit*" of the metal furniture shown in Stuttgart, and even Henry-Russell Hitchcock and Philip Johnson warned that the excessive rationality behind some modernist architecture could be too cold, writing in their 1932 book *The International Style: Architecture Since 1922* (which accompanied MoMA's *Modern Architecture: International Exhibition* and ultimately gave the school its name), "There should be a balance between evolving ideal houses for scientific living and providing comfortable houses for ordinary living."[15] Designers and critics in the United States

I.6
MODEL ROOM
In *Wallace Nutting Final Edition Furniture Catalogue* (1937), 23

in the 1930s, such as decorator Joseph Aronson, likewise dismissed the "chill harshness" of the "purely mechanical line"; he instead advocated "simplicity" with a "greater congeniality of effect," which could be achieved "through the softening of the line, the more judicious use of contrasting textures, or a wider vocabulary of forms."[16]

The debates within the modernist design movement in the United States during the 1930s thus centered on achieving affordability and alleviating the apparent coldness of industrial materials and manufacturing processes. At the same time that these debates raged, however, the favored decorating style for most Americans was the Colonial Revival, not modernism, and it is against this backdrop of nostalgia for the nation's past that livable modernism acquires its particular identity.[17] The Colonial Revival had first emerged as a decorating style in the aftermath of the Philadelphia Centennial Exposition of 1876, where a mock colonial "kitchen" drew thousands of visitors.[18] In the ensuing fifty years, the American Wing period rooms at New York's Metropolitan Museum of Art (opened in 1924) and Wallace Nutting's revival furniture (fig. I.6) further popularized colonial styles and imbued these objects with quaint, pietistic histories: as Nutting wrote in his study of early American furniture, "There is enshrined in the forms of furniture used by our ancestors a spirit absent from the exotic shapes that come from Italy and France. We love the earliest American forms because they embody the strength and beauty in the character of the leaders of American settlement."[19]

As the grim realities of economic depression emerged in the early 1930s, Americans turned with increasing frequency to the myths and heroes of their national past, searching for inspiration and assurance that their society and its culture would survive. Colonial Revival furnishings became one way for modern

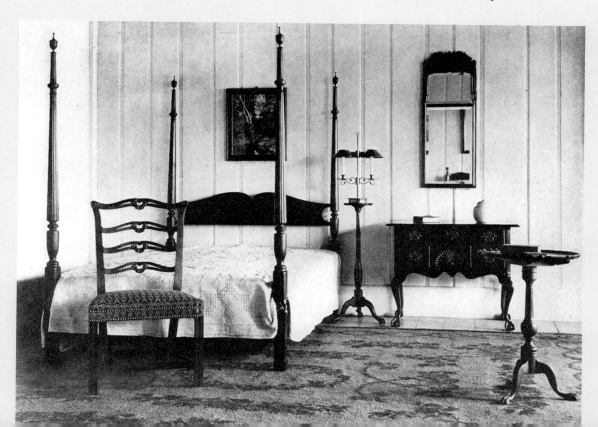

Americans to immerse themselves in this celebrated past, bringing "A little bit of Colonial America," as one advertisement claimed, "[into] your own home!"[20] One 1934 retailing guide offered an interpretation of the Colonial Revival typical of the period: the author proclaimed that the "story of America is the story of colonial furniture," and urged salesmen to explain to their customers that such styles, which were the "height of fashion when John Hancock and his cabinet signed the Declaration of Independence...[have] been in vogue ever since."[21] Colonial Revival furnishings thus not only connoted inspirational stories to down-on-their-luck modern citizens, but also, through their very similarity to authentic colonial objects, made their owners into the rightful heirs of patriotism. The popularity of the Colonial Revival in homes of the 1930s must be seen in concert with such phenomena as the restoration of Colonial Williamsburg (opened to the public in 1935) and the publication of such large-scale historical studies as Van Wyck Brooks's *The Flowering of New England* (1936).[22] Together, these various elements convey a collective Depression-era veneration of the nation's history, albeit one disproportionately focused on its Anglo-American, East Coast origins.

The consumer audience for home furnishings—both livable modernism and Colonial Revival—was predominantly female. In a continuation of the gendered roles of late-nineteenth- and early-twentieth-century families, housewives of the 1930s were usually expected to make the decorating decisions for their homes.[23] Decorating magazines from the period such as *House and Garden, Good Housekeeping,* and *American Home* were filled with advertisements directed to mothers and wives, and trade journals regularly published articles on the best ways to reach female consumers. A 1933 article from the *Furniture Record* detailed the "facts and romance" which were used by a successful salesman when talking to "groups of women" consumers, while the *Crockery and Glass Journal* reminded its readers in the tablewares industry to attend to the opinions of "Mrs. Customer...whose reaction to your department is naturally of the greatest importance to you."[24]

The design movement that I call livable modernism includes designers such as Gilbert Rohde, Russel Wright, George Sakier, and Lurelle Guild, who collaborated with established manufacturers—including the Herman Miller and Conant Ball furniture companies, Fostoria Glass Company, and the Aluminum Company of America—to produce modernist objects for every room in the house. Livable modernism gained from the larger modernist design community a belief in the fundamental benefits of living with modernist objects, a commitment to affordability, and an ideal of simplicity without alienating austerity. From the popularity of the Colonial Revival it gained an appreciation of consumers' psychological desire for familiarity and their physical desire for comfort, manifested in products such as wing chairs and quilts. Finally, as a consequence of competing in the same market as the emotionally resonant Colonial Revival, at a time when the advertising

industry had reached unprecedented levels of psychological suasion, livable modernism can be characterized by its sophisticated marketing strategies.[25]

Thus, most of the designers discussed in this book adhered to the ideology that simple and affordable modernist design would improve consumers' lives. "A modern girl sprawling in a Louis XVI chair is pretty absurd, you will admit," wrote Russel Wright in 1934, for the popular women's magazine *American Home.* "These chairs were designed for elegant ladies of the court who sat primly and daintily upon them." He continued by arguing that modernist design would improve, and its simple aesthetics enlighten, life in the house of 1934:

[Modern design] is a design solution to living, a solution that is absolutely necessary if you are going to live gracefully, comfortably, and naturally in the world at the time at which you happen to be born into it. Thus if our homes are planned for modern comfort by means of modern materials, it is possible to achieve a new kind of beauty—not the pictorial beauty of the past, but the honest practical beauty of the present, which is the only true refuge in these harsh and strident times.[26]

Gilbert Rohde similarly defended the power of modernist design, made affordable and aesthetically simple through the use of industrial manufacture, to improve twentieth-century life. He dismissed "Tall buildings [which] were built with frames of steel…[on which] was hung a camouflage of stone simulating a façade of the Renaissance," and instead celebrated "the forces of reason" that "are now… prevailing against these perversions."

[Modern design] is of our day and our spirit. It arises because there is a need for it. It does not imitate. Modern furniture seeks to make use of our beautiful and useful new materials honestly and directly as craftsmen have always used their materials…Modern design seeks to combine in the traditional manner all of the devices of comfort and utility to provide us with furniture that is suited to our living needs and as always, satisfying our sense of the beautiful.[27]

However, even as designers such as Wright and Rohde praised the simplicity of modernist design and its suitability to the demands of modern life, their work reveals other influences. Most of the designs featured in this book offer consumers a way to forge a meaningful connection with the past, either through the use of materials and selected details or in the images and language through which they are marketed to the public. They often, for example, lend themselves to being used in daily rituals that mimic the social traditions of the past rather than respond to the needs of present-day living. Furthermore, these objects are frequently playful in spirit, aggressively attempting to catch the consumer's eye and draw her in. These designs do not always feature the platonic abstraction of International Style modernist design. Instead, their attention-getting geometric forms are a part of their existence as consumer items operating in a competitive marketplace. Thus, I call this movement livable modernism because it is designed with the consumer's experience in mind: her possible insecurities and emotional desires, her physical

comfort, her delight, and what it would take to make her commit her own (or her husband's) money.[28] This is modernism not driven solely by ideological or aesthetic concerns. Rather, it is modernism that is meant to be lived with.

Needless to say, a designer's willingness to engage the potential desires of consumers has frequently been discredited as a lapse in fidelity to the ideals of function, technological innovation, and efficiency that defined the benchmark modernism of the International Style. Not only did some modernists of the day decry such a design approach—one thinks of Le Corbusier's blanket assertion that a house is a "machine for living"[29]—but design historians have often recapitulated these same prejudices, dismissing objects like those featured in this study as too derivative or hybrid when compared with the ideal modernism of the International Style.[30] This project refuses to see a designer's involvement with the non-ideal desires of consumers as a fault, and strives to establish a different set of parameters by which to evaluate modernist design. These parameters frame modernist design not as an idealized creation borne of a single person's creative genius, but rather as a solution that is forged in response to a set of diverse demands, both ideological and market-based. There is never any single best solution to the constellations of problems faced by a designer. There are instead degrees of inventiveness with which objects juggle and satisfy such competing concerns. That struggle defines livable modernism, and is the true subject of this book.

This study focuses on designs for Depression-era living, dining, and bed rooms, rather than on the kitchens and bathrooms, precisely because modernism vied with many other styles—such as the Colonial Revival—as acceptable options for outfitting these rooms. In the kitchens and bathrooms of the period, in contrast, modernism predominated as the style most expressive of innovative technologies, even in houses otherwise outfitted in period styles. Norman Bel Geddes revolutionized the aesthetics of the kitchen when he designed an unornamented cube of sheet metal to encase Standard Gas's new electric stove in 1933 (fig. I.7). Implicit in his design was the assertion that a modern, efficient energy source (electricity) required a modernist, efficient form. Similarly, George Sakier designed a radically modernist bathroom sink for American Radiator and Standard Sanitary Corporation in 1933 that featured spherical handles and a pipe-like spout, both of which were an aesthetic interpretation of the technology of indoor plumbing (fig. I.8).[31]

Designers and manufacturers, however, found it more difficult to argue that a modernist sofa, dining chair, or vanity table embodied any sort of technological improvement over their

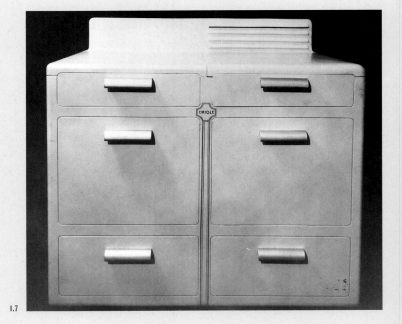

I.7

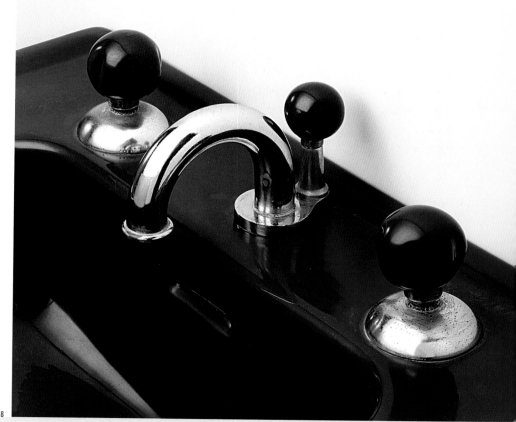

I.8

I.7
ORIOLE STOVE, c. 1933
Norman Bel Geddes, *designer*
Standard Gas Equipment Company,
Baltimore, Md., manufacturer.
Enameled sheet-metal.
University of Texas at Austin,
Harry Ransom Research Center,
Courtesy Estate of Edith Lutyens
Bel Geddes

I.8
SINK, 1933
George Sakier, *designer*
American Radiator and Standard
Sanitary Corporation, N.Y., manufacturer.
Porcelain and chrome-plated metal,
34 x 29 x 19 1/2 in. (86.4 x 73.7 x 49.5 cm).
Metropolitan Museum of Art, New York.
John C. Waddell Collection, Gift of John
C. Waddell, 1998 (1998.537.29)

period-styled counterparts. To sell modernism in these other rooms of the middle-class house, they balanced their claims for artful simplicity and space-saving efficiency with an awareness of the popular ideals with which consumers might be enmeshed. Magazines, decorating manuals, popular literature, and films, for example, all encouraged an atmosphere of enveloping coziness in the living room. For the dining room these popular sources prescribed a stage for gracious hospitality. Bedrooms, finally, were meant to be the site of the normative nuclear family, comprised of the protective husband, the beautiful wife, and the well-behaved child. While these sources do not reveal how consumers actually outfitted homes, their collective portrait of a domestic environment with sentimental and conservative overtones created a pervasive, compelling social ideal that was effectively captured in the Colonial Revival fad. It is into this popular matrix that livable modernist designs attempted to insert themselves. Thus, as Chapter 1 demonstrates, while modernists promoted their designs for the living room as a space-efficient means to furnish the smaller rooms of many 1930s homes, their work also reveals an abiding concern with providing indulgent physical and psychological comfort. Similarly, Chapter 2 suggests that although livable modernist dining suites and tablewares

presented themselves as tools for debunking the traditional hierarchies of formal dining—which few consumers could afford to maintain in these years—many of these designs could also, in fact, be used to uphold establishment etiquette and thus to support the social expectations of the past. And Chapter 3 argues that although livable modernist bedroom furniture encouraged the cultivation of expressive individuality, liberated from social conformity, it also participated in the retrenchment of conventional gender roles. The elements of these designs that so readily incorporated the comfort and the status- and gender-confirming techniques of the Colonial Revival—such as deep sofa cushions, differentiated stemware for various alcohols, and attention-getting vanity tables—helped to cultivate a larger audience for modernism in this period. These elements reveal the extent to which American designers were inspired to integrate their philosophies with the fantasies and demands of their middle-class consumer audience. Indeed, such features define livable modernism.

The Middle Class and Livable Modernism

The sprawling "middle-class" consumer audience of the Depression years is, at best, an elusive topic for a historian. Not only is the middle class a segment of society that is notoriously difficult to define, but its experiences during the Depression are less familiar than those of the extremely poor. Our twenty-first-century popular conception of the Great Depression is largely defined by the powerful documentary photographs of the migrant, rural poor taken by artists such as Dorothea Lange, Walker Evans, and Margaret Bourke-White. Yet, as historian Warren Susman pointed out, middle-class culture both inspired the documentary mindset, defined by an investigative edge and social conscience, and constituted the photographers' primary audience in such magazines as *Life* (founded as a magazine of photojournalism in 1936).[32]

The white-collar workers and their families who comprised the readership of popular magazines, which in these years included both clerical workers and managers, skilled craftsmen as well as professionals, did suffer significantly during the years of the Depression. However, their restrictions in lifestyle varied widely and were less visibly recorded than those of the very impoverished. Although unemployment jumped dramatically from 3 million in 1929 to 12.5 million in 1932, and although the average household income in 1931 was only seven-tenths of that in 1929, several circumstances prevented the complete disruption of a middle-class style of life.[33] Perhaps most significantly, while incomes declined during the first years of the 1930s, so too, although at a lower rate, did the average price of food, clothing, furnishings, and household equipment; the result was a slight increase in the value of earned incomes.[34] Moreover, middle-class families were frequently inspired by an individualistic, progressive ethos to muster the appearance of "making do," and adopted a range of strategies to maintain their 1920s standards of living, which had

been based around access to consumer goods.[35] These included producing items at home that could have been purchased, creatively reusing commodities, moving into smaller homes or apartments, and finding income-earning work for more than just the head of the family (such as a wife or son).[36] Women's magazines encouraged housewives to establish penny-conscious budgets in an effort to eliminate wasteful purchases;[37] these popular budgets even became fuel for advertising campaigns, such as that for Royal Baking Powder, which featured housewives testifying, "Some Women may be able to waste 35¢ worth of Cake Ingredients—*but not I!*"[38] Many families also continued to buy durable goods such as automobiles, appliances, and furniture on credit payment plans; one study suggested that in the period 1929–38, about 45 percent of all durable goods were purchased through credit plans, with approximately two-fifths of all furniture store sales made on credit.[39] Historian Susan Ware summarizes the lives of many middle-class housewives and their families during this time:

The vast majority of American women were neither very rich nor very poor. Somewhere in the middle, they were struggling to get by with less... The typical woman in the 1930s had a husband who was still employed, although he probably had taken a pay cut to keep his job; if the man lost his job the family often had enough resources to survive without going on relief or losing its possessions. Life was not easy for women in these situations, but the picture was not uniformly bleak.[40]

Thus, while the white-collar, educated, almost entirely Caucasian middle-class households of the Depression were faced with limited funds, they did not entirely eschew the home furnishings marketplace. Instead, because of the self-respect involved in maintaining "normal living conditions,"[41] these housewives attempted to keep their homes looking attractive through occasional purchases and the resourceful reorganization of spaces. They also supported the home furnishings industry indirectly when they opted to read the abundant selection of women's and decorating magazines; the imaginary (or merely exclusive) worlds depicted in these venues indulged the consumer's fantasy life and became a kind of surrogate for lived experience. *House Beautiful* and *House and Garden,* for example, which each sold for 35¢ an issue in the 1930s, regularly featured private homes of the wealthy in a variety of period and modernist styles. When these magazines showcased the affordable designs of livable modernism, they usually presented them as a selected, inexpensive commodity amidst more costly alternatives.[42] Alternatively, the editors at magazines such as *Good Housekeeping, Ladies' Home Journal,* and *American Home,* which all retailed for 10¢ during the 1930s, tended to fill their publications with practical household and decorating advice. They offered examples of livable modernism as the tools for an affordable make-over of the reader's entire home,[43] or occasionally as the inspiration for a home-craft project.[44]

While these two groups of magazines have clearly different profiles—the former catering to a vision of elite living and the latter to housekeeping advice—it

would be a mistake to presume that their audiences were therefore similarly distinct. As evidenced by the fact that *American Home* advertised itself on the pages of *House and Garden,* the readership of these various journals quite likely often overlapped. *House and Garden* may have catered to a reader's full-fledged fantasies of fine living, while *Good Housekeeping* provided tangible advice on how to maintain as high a standard of living as possible. In both cases, the magazines provided tools (psychological and practical) to alleviate the limitations wrought by the Depression. While neither group of publications offers us, the historians, a picture of lived experience, together they provide a portrait of the ideals and aspirations that accompanied middle-class existence in the bleak years of the 1930s.

If the 1930s were difficult for all but the very wealthy, the presence of modernist design in various types of middle-class publications raises a simple question: why is the decade of the Great Depression also the decade that designers and manufacturers first attempted to find a broad audience for modernist wares? Although it may at first seem surprising that modernism would be pitched to a mainstream consumer base just as that group suffered major economic setbacks, there are numerous reasons ranging from the pragmatic to the psychological that help to explain this coincidence. First, as we have seen, the Great Depression coincided with the growing interest in modernist design in the United States, and in particular in its potential as a broadly affordable style of home furnishings. Second, by the early 1930s, manufacturers were desperate to stimulate consumer interest and viewed modernism as a novelty that might help to achieve this end. A few businessmen were interested in the larger social ideals of modernist design, such as D. J. De Pree, the president of Herman Miller Furniture Company; as he later recalled, working with Rohde in the early 1930s taught him that "the manufacturer was not to produce copies of antiques but rather devote his energies to producing furniture of the day, embodying the best available contemporary materials to solve problems of living and working in the home."[45] Many more manufacturers, however, considered modernism merely a stylistic alternative in their line of products—a new option to offer to the consumer in an effort to convince her to part with her savings. As one retailing analyst bluntly wrote in an industry journal in 1933, "There is every indication that the trend in architecture and interior decoration is forward looking toward a new decorative period [i.e., modernism] and that the rate at which business stimulation will take place, will be in proportion to the speed of our creative endeavors to develop corresponding new furniture types."[46] Manufacturers tried to encourage consumer spending not only to save their businesses, but also as part of a larger campaign, waged by both industry and the government, to stimulate consumption in an effort to resuscitate the national economy. "Buying power has been underestimated," proclaimed a typical advertisement in the *Saturday Evening Post* from 1932. "There are millions in deposit boxes, billions in savings accounts. When these reluctant dollars circulate, there will be jobs

for all. It is up to manufacturer, to distributor, to merchant, to advertising agent—
to create confidence."[47] Livable modernism, which was both new and calibrated to
appeal to consumers using the images and language of the marketplace, was a prod-
uct of these times, a potential vehicle to pull the country out of the Depression.

Third, modernist design succeeded in making itself known to a broader public
during the years of the Depression because it was well-suited to the dominant
style of commercial display, the ensemble setting. Over the course of the preceding
decade, ensemble displays had become the undisputed, favored marketing tool for
the home furnishings industries. American department stores throughout the later
1920s increasingly arranged their furniture in domestic vignettes on the sales floor,
taking inspiration from the popular period room displays in public museums (in addi-
tion to the American Wing, the Museum of Fine Arts, Boston, opened its own period
rooms in 1929) and from the ensemble groupings at the 1925 Paris Exposition.[48]
Furniture retailers and manufacturers believed that these displays—which ranged
from a few items gathered together to fully outfitted model rooms and even multi-
room model apartments—were potent sales vehicles. Not only did a model room
demonstrate how various products could be used in an interior, but it also provided
a coherent picture of a fantasy home that the consumer could acquire in pieces (or
in its entirety). "The store floor cannot longer resemble a whole-sale storage room,"
instructed one display stylist in a 1933 article from the *Furniture Record,* "It must be a
house of decoration, demonstrating home furnishings in their appropriate settings."
Drawing attention to the psychological sales appeal of this strategy, he continued
with a patronizing discussion of the competitive reasons housewives buy furniture,
and how the ensemble technique could capitalize on these:

Women, fundamentally, are stylists—but not (and we can thank our lucky stars) expert stylists. They
have to be shown. They have, however, in trying to outdo each other, accomplished an expert mode of
competition. Consequently our [displays] must not present a chair as a chair, but as a means for making
a room more stylish—not only more stylish than it was before, but more stylish than a neighbor's room.[49]

Modernist designs in particular benefited from the ensemble strategy. A mod-
ernist armchair or vanity table could be displayed in a model room of complementary
aesthetic, enabling customers to "understand the simplicity of modern furniture"
more effectively than if it were placed in a period-styled room. Even if a consumer
might not want to purchase an entire modernist living room, the sympathetic setting
helped to make the unfamiliar familiar, and encouraged her to see individual objects
as potential acquisitions: "To pick a chair or a table or a bureau out of a room
(instead of from among a thousand chairs and bureaus)," noted a 1935 article on
model rooms, "is like picking fruit off the tree—it has more taste."[50] The modernist
model room, in effect, created a self-referential world—a fictional room or apartment
in which the armchairs, side tables, and mantel accessories all shared simplified

contours, a lack of ornament, and a smattering of geometric patterns and industrial materials. When viewed next to other model rooms in various styles, modernism became less strange and was transformed into just another schema available to outfit one's domestic habitat.

Finally, modernist design gained the public's interest because it successfully spoke to the frustrating limitations of the Depression. Modernists frequently claimed to provide functional efficiency in their designs, whether in the form of a modular bookshelf for the living room that could be expanded as needed (discussed in Chapter 1), a canapé plate that allowed one to hold an hors d'oeuvre and a drink (discussed in Chapter 2), or a metal-framed bedroom suite that was easy to clean and germ-resistant (discussed in Chapter 3). This emphasis on efficiency was, of course, an ideological emphasis among such European modernists as Le Corbusier and the leaders at the Bauhaus. However, in the context of the Depression it also resonated with the general social temperament, echoing the deeper preoccupation with frugality and the elimination of waste that permeated middle-class culture. For families who began saving scraps and worn items to recycle in various ways, or for housewives who counted every penny of their weekly food budget, modernism appealed for its obsessive attention to minimizing extraneous details and maximizing use.

Designers and manufacturers also encouraged the public to interpret modernism as a symbol of an optimistic future. An article in the *Furniture Record* illustrates how readily the furniture industry promoted the new aesthetic as a style of optimism: predicting the next consumer trend, a reporter in January 1933 confidently wrote that "people will be wanting something different, something that will add a new note to their homes, that will signify a change from a period of distress and trou-

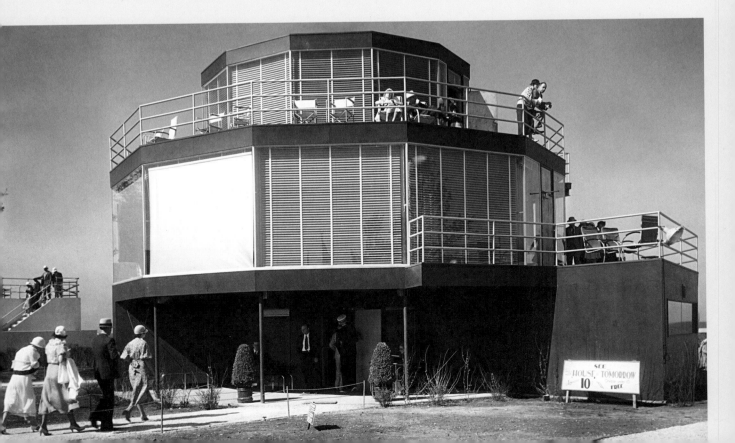

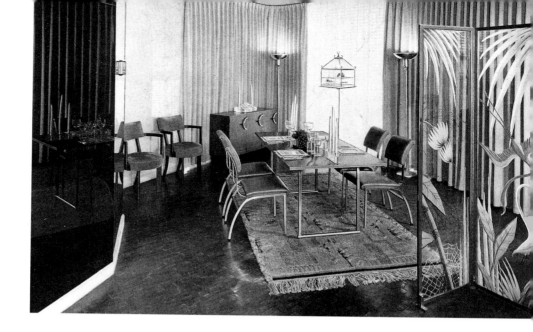

ble to a new era of cheer and hope and courage. Bright colors, modernistic design...
will be my guess on the subject."[51] One of the best-known futurist icons of the early
years of the Depression was George Fred Keck's model home, the House of Tomor-
row, at the 1933–34 Chicago World's Fair, *A Century of Progress International Exposi-
tion*. The three-story, twelve-sided structure featured all of the newest available
building technologies, including a steel frame, large panes of glass in place of
load-bearing exterior walls, central air conditioning, and an all-electric kitchen.
Its unusual form was complemented by livable modernist furnishings (figs. I.9, I.10)
(like all of the model homes at the World's Fair, the modernist furnishings in the
House of Tomorrow from the 1933 season were replaced with new designs for the
1934 season). While Keck emphasized that all of the building materials were "now
on the market," and thus available to consumers, he also garnished the house with
a few extravagant amenities, such as an airplane hangar in the basement, outfitted
with a Curtis-Wright "Sport Biplane" (fig. I.11).[52] With elements such as this, the
building's modernism was explicitly transformed into a style of the prosperous near
future; its modernist architecture and furnishings became, in the eyes of the millions
of tourists who visited it, the accessories for the economic recovery that President
Franklin Delano Roosevelt's New Deal would bring.

Methodology

The concept of livable modernism is intended to describe how an object circulates
in society: balancing reform and desire, making use of the language of the market-
place to bring designers and consumers together. It denotes a broad stylistic
category—a simplicity that tries to avoid austerity, and occasionally references

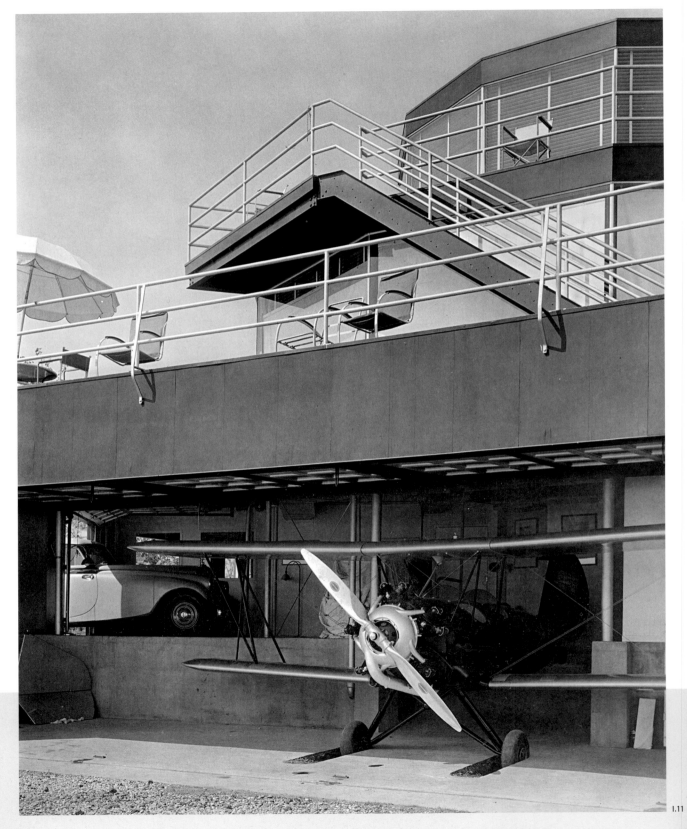

1.11

past styles—but ultimately livable modernism goes beyond style. Some of the objects discussed in this book have more abstract, geometric forms than others, and some have design elements that could be interpreted as extraneous ornament. Historians have tended to classify modern design according to stylistic guidelines, using terms such as "zig-zag modern" or "streamlined" to refer to differing schools.[53] The narrative that follows does not dwell on the stylistic similarities and differences of the objects, but it does discuss in depth their visual appearance. Indeed, I consider the formal properties of an object as one tool that the designer uses to express his or her resolution of competing requirements. Although articles, manufacturers' pamphlets, and advertisements are other tools through which these designers explained their priorities and design processes, the formal analysis of an object can reveal both the stated goals of the designer and his or her unstated commitments. Furthermore, the study of the appearance of an object provides us with the means to speculate on how consumers may have interpreted it in the marketplace and interacted with it. Thus, the visual form of objects plays a central role in this study, not as an end-game classification of style but instead as an instrument of historical inquiry.

Although this is a study of modernist design for the middle-class domestic consumer, it is difficult to make firm conclusions about actual daily life with these objects. But while we can never know *how* countless individuals consumed such products, we can know how they *were told* to consume them. Thus, of necessity, this study examines what historians have called "the ideal life" of livable modernism—that is, the lifestyle it was meant to foster as described through manufacturers' pamphlets, advice manuals, and advertising.[54] This study also considers the ways livable modernist designs, through their functional and formal qualities, created ideal users—how the objects themselves compelled an ideal lifestyle. While it is important to keep in mind that advertisements and objects project only idealized forms, these forms can reveal much about the society that made them. As Susman has argued, the forms that a society generates—the images and stories that appear in magazines, advertisements, novels, and films—can be understood as ideals that individuals grasp onto and by which they measure themselves.[55] In the years of the Great Depression, these ideal forms, developed in the popular

I.11
HOUSE OF TOMORROW, *CENTURY OF PROGRESS*, 1933–34
George Fred Keck, *architect*
Hedrich Blessing, photographer.
Chicago Historical Society
(neg. HB-09789-E)

I.12
LIVING ROOM, HOUSE OF TOMORROW, *CENTURY OF PROGRESS*, 1934
Gilbert Rohde, *designer*
Herman Miller Furniture Company, manufacturer. Kaufmann-Fabry, photographer

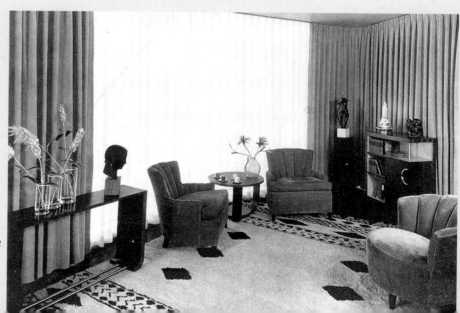

I.12

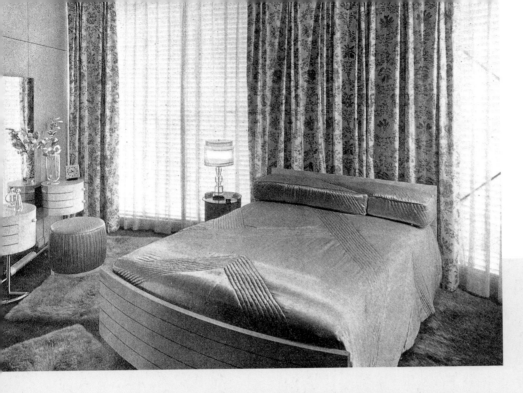

realm and recapitulated by livable modernist objects, repeatedly reveal the society's desire to see itself as a unified, healthy community.

Livable modernism may have emphasized its newness or its efficiency in an effort to distract consumers with visions of a rosy future. Certainly the technology featured in the House of Tomorrow was overtly optimistic, the tall windows letting in the rejuvenating light of the sun and the central air conditioning keeping out the overwhelming heat of the Chicago summer to create a dust-free, temperate interior. Yet the unstated commitment to physical and psychological comfort in these designs eloquently reveals the fears behind such optimism. The interior of the House of Tomorrow was not only a temperate, technological marvel; it was also a cocoon that safely ensconced the family. In the living room from 1934, outfitted with Rohde designs for Herman Miller, the thick pile rug and deep armchairs, arranged in a conversational grouping to either side of an end table, cultivated a cozy, den-like atmosphere (fig. I.12). The dining room from 1934 featured an elegantly set table where each diner was offered a full armature of cutlery and stemware, and food seemed to be an idle afterthought (see fig. I.10). Finally, in the 1934 bedroom, the reflective sheen of the bedspread and the whimsical vanity table gave the impression of a room for an indisputably feminine, if confidently independent, housewife (fig. I.13). These scenes of retrenched comfort and well-being for an imaginary, normative family reveal, through their very denial of strife, the fears of economic failure and social decay that were a part of the daily lives of audience members walking through the door to the House of Tomorrow.

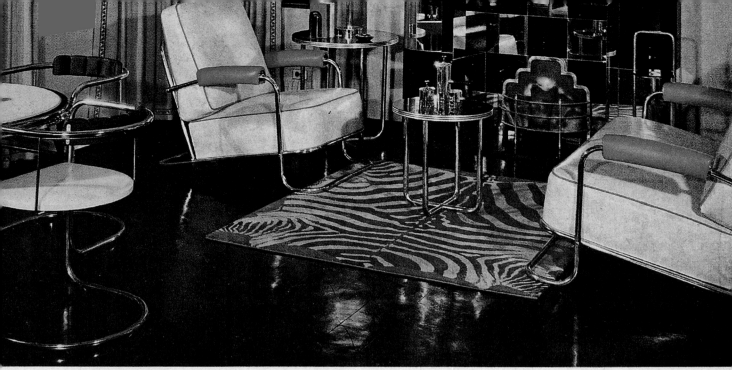

● The card table grouping at the left shows the modern round card table (No. 50) with smart new chromsteel rim and washable fabric top; the chairs (No. 438) have cushioned backs, with seats covered in washable fabric. The reclining lounge chair (No. 434-1) and the two passenger settee at the right (No. 434-2) have upholstered spring seats, inner spring cushioned backs and are covered in washable fabric. The table just beyond the lounge chair (No. 452) and the table in the center of the room (No. 455) are of Chromsteel and have Formica tops.

...ELL ... *Forerunners in the Modern Trend*

No hasty improvisers, Howell designers are ...aster artisans who have captured in gleam- ...g lines and color overtones the vital patterns ...today. Specified by America's leading dec- ...ators as *first choice* at A Century of Progress ...position, its subsequent popu- ...ity has proved conclusively ...at HOWELL CHROMSTEEL ...RNITURE is not a whim of the ...ment but the distinctive in- ...ument of today's living. Mod- ...n-minded men and women ...erywhere have turned to it

instinctively, and are revitalizing their homes, often a room at a time, with HOWELL CHROMSTEEL FURNITURE. They readily sense its unrivaled practicality, its lithe comfort, its amazingly simple beauty, and its substantial economy. No other type of furniture expresses so well the deeply moving rhythm of today. And no other type of furniture on the retail floor shares the eye-compelling force, the suggestive selling power of HOWELL CHROMSTEEL FURNITURE.

● Indispensable to every dealer and decorator awake to contemporary trends is the new catalog, with many pages in full color depicting Howell Chromsteel Furniture in skillfully arranged room ensembles. A copy will be sent you upon request.

...HE HOWELL CO.

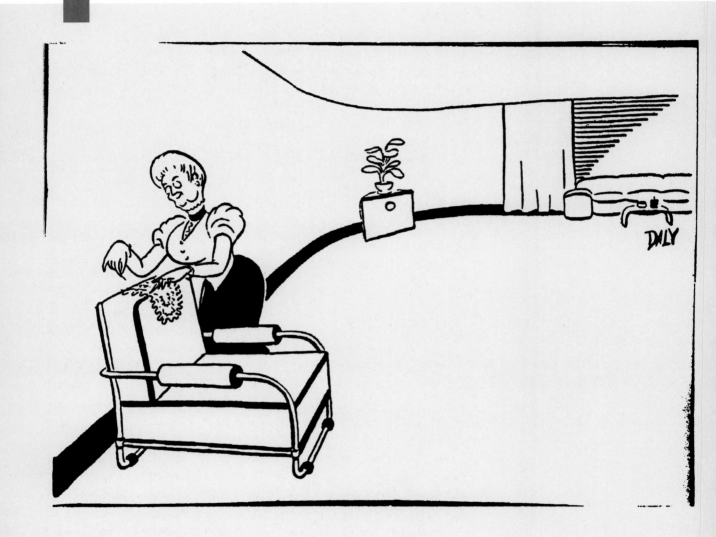

Cozy Modernism for the Living Room

A cartoon from the mid-1930s reveals ambivalence about modernist furniture in the living room (fig. 1.1).[1] A woman dressed in Edwardian fashion—complete with upswept hair, starched lace collar, and pronounced bosom and bustle—drapes a lace antimacassar over the back of a low-slung geometric armchair framed in tubular metal. Behind her sweeps an emphatically spare modernist living room: a small cabinet fits against the curved contour of the wall, and a low sofa is paired with a small, streamlined coffee table. The cartoon's attitude toward the old-fashioned matron—who represents the turn-of-the-century homes that were filled with a cacophony of historical styles and bric-a-brac—is both snobbish and sympathetic. On the one hand, her lace contaminates the geometric simplicity of the modernist living room. On the other, the living room has the extreme austerity of a stereotypical modernist interior: even the plant sitting atop the sideboard sports an architectonic array of leaves, and the window, an outlook to the natural world, has been covered with horizontal blinds. In such an environment, the cartoon proposes, who wouldn't desire some familiar, comforting reference to the history of human society and craft? The lace stands as such a symbol.

The wry collision of aesthetics that occurs in this cartoon between the overdressed woman and her under-dressed interior expresses the contradictory impulses that motivated livable modernism in Depression-era living rooms. Designers claimed that the simplicity and smaller scale of their objects would benefit the often diminished spaces of the 1930s living room by serving the same functions as larger, old-fashioned pieces but requiring less room; the result would be an open, spacious feeling in the most confining of circumstances. The

1.1
CARTOON
Daly, *cartoonist*
In *The Saturday Evening Post,* c. 1936

25

overly dramatic spatial recession in the cartoon creates this effect. The room appears to be enormous, yet perhaps is only large enough for the armchair and the sofa group. However, even as modernist designs open up small spaces, the cartoon's matron seems to find them alienating. Her antimacassar becomes a signifier of both psychological and physical comfort, meant to balance the efficiency of her interior. The lace offers psychological comfort through its familiarity, connoting styles and manners of the historical past as well as the traditions of handicraft production. And, as it lies over the back of the chair, the antimacassar seems poised to cradle the head of the person who will next sit down, protecting the sitter from the chair's angles rather than (in its conventional role) protecting the chair from the sitter. Finally, the buxom matron and her lace raise questions about the gendering of both modernist design and the living room. Her excessive femininity is out of place in the cartoon's interior and implies that modernism is a masculine style, perhaps not equally hospitable to all who live with it. Likewise, the presence of the frilly, overtly feminine lace poses questions about the gendering of Depression-era living rooms. Should this room where the family gathers be explicitly masculine? feminine? Is it possible to balance the decoration of the room so that it welcomes all members of a family equally, just as the new "companionate" model of marriage claimed to respect both partners equally?

This chapter examines livable modernist furniture and accessories produced for the living rooms of the Depression. It first discusses the architectural space of the living room, which many during these years believed had become smaller and more burdened with family activities. It then analyzes the self-conscious modernist rhetoric of efficiency that many designers and manufacturers used to promote their work in response to these alleged spatial restrictions. The chapter continues by discussing a different set of expectations promoted in popular images of living rooms, symbolized in the cartoon by the matron's concern with gendered balance as well as psychological and physical comfort. It argues that the designers of livable modernist furnishings, despite their apparently single-minded commitment to efficiency, actually used a wide variety of intellectual and formal tactics to cater to those concerns. The living rooms created by these objects fostered informal, intimate gatherings and created a cozy—not alienating—atmosphere. They were living rooms that attempted to embody the community and comfort so central to the solace of Depression-era society.

The Space of the Living Room

Modernist architects and designers throughout the 1930s published prospective designs for the middle-income, single-family home. Although the depressed economy of the decade prevented much actual residential development, these speculative

plans yield insight into the values and ideals of middle-class life. Their varied designs all featured greatly simplified floor plans which, on the ground floor, were dominated by an open, multi-use living room. As architectural historian Gwendolyn Wright has documented, since the turn of the twentieth century, middle-class domestic architecture had followed a trend toward increasing simplification. This developed, in part, as a consequence of improved household systems such as furnace heating and running water; these raised construction costs and forced architects to sacrifice elaborate, sprawling floor plans that often included a library, parlor, and morning room for smaller, simpler schemes that frequently comprised just a living room.[2] The designers of fictional homes in the 1930s, although operating within a design schema already several decades old, situated their work in a constellation of practical and conceptual concerns appropriate to the day. Many designers, for example, agreed that an open living room was a safe, practical option for speculative plans: without a specific client, an open-plan living room could appeal to a wide variety of family demands.[3] Lurelle Guild, an industrial designer who began his career illustrating model interiors for magazines, evocatively captured the multiple uses a modern living room might serve in a 1936 decorating manual:

We think of a living room as the heart of the house, since here family life is carried on, entertaining done, and, in general the spirit of hospitality and the real atmosphere of the house best revealed. It should be a charming room, with signs of use and a certain informality, and yet of genuine beauty, too…[L]et us turn our thoughts to arranging the furniture so that the room will have centers of interest for everyone in the family; for the reader, the musician, the writer, and above all, for those who would sit and quietly talk as they enjoy the after dinner coffee or gaze at dancing flames.[4]

Architects and designers also invested their open living rooms with symbolism as both the organizational center of the home—a place of "logic" and "efficiency"[5] during a period when household budgets had little room for excess—and as the emotional center of the home: a place of retreat at a time when families were experiencing unprecedented stress from the world outside. For example, the flamboyant industrial designer Norman Bel Geddes designed one of the earliest and best-known speculative modern homes, entitled the "House of Tomorrow" and published in the

1.2
FIRST-FLOOR PLAN,
HOUSE OF TOMORROW, 1931
Norman Bel Geddes, *architect*
University of Texas at Austin,
Harry Ransom Research Center,
Courtesy Estate of Edith Lutyens
Bel Geddes

1.3
SECOND-FLOOR PLAN,
HOUSE OF TOMORROW, 1931
Norman Bel Geddes, *architect*
University of Texas at Austin,
Harry Ransom Research Center,
Courtesy Estate of Edith Lutyens
Bel Geddes

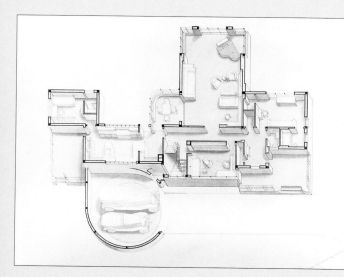

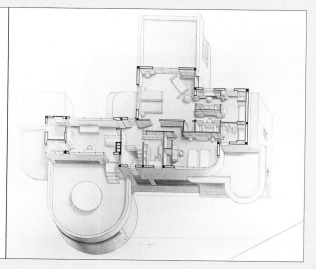

1.2

1.3

April 1931 issue of *Ladies' Home Journal* (figs. 1.2, 1.3).[6] His house featured a "greatly extended living room," with a small dining alcove, positioned at the back of the house. As he explained, his design arose from a willingness, at a time when society was constrained by the economy, to flout tradition and "forms and conventions": "We are more forthright people than were our forefathers...and so it is surely fitting that we carry our ideas into our homes." His design was also a consequence of his commitment to the privacy and comfort of the family, and to the added health benefits of proximity to the fresh air of the back garden:

It has always been the custom to place the living rooms facing the street, in the most overlooked and least private position...Since we are thinking of our own convenience and not of tradition, in the twentieth-century house we reverse the order and have our living rooms secluded from the street and facing such little garden as we may have.

In the spring of 1933, *House Beautiful* published a detailed article on another model modern house for the "large, middle-income class," which featured an open-plan living room: John C. B. Moore's Design for Living House, constructed at Chicago's *Century of Progress International Exposition,* where millions of visitors walked through it (fig. 1.4).[7] The article's author emphasized the functional practicality of the large living room, reminding readers that although the ground floor appeared to have only a kitchen and a living room, "this living-room is in reality three rooms in one." The author also noted that the living room was located at the back of the house, "overlooking the garden," ensuring that "more privacy is thus secured" for the family. For the living room's interior, Gilbert Rohde designed furnishings and selected materials that underscored its multiple functions and its role in bringing the family together (fig. 1.5). The furniture, manufactured by the Heywood-Wakefield Company, consisted of a dining group in the alcove next to the kitchen, a desk and bookshelf in the library area, and several armchairs and a sofa gathered in front of the fireplace. As long as the rug and sofa were anchored before the hearth, the space was conceptually divided by function. However, when the rug was rolled back and the furniture pushed to the walls, a continuous floor of eggplant-colored linoleum and the seamless metallic frame of the fireplace created a large open space, so that "the entire room is available for dancing."

In their descriptions of the space and the activities carried on there, architects and designers thus presented the open-plan living room as a product of the unique concerns of 1930s society. In its simplicity it was economically efficient, and in its location at the back of the house it encouraged a more private, relaxed atmosphere. It not only fostered the health of the members of the household (through access to the garden and space for dancing), but it also allowed them to gather both as individuals and as members of a cohesive family unit.

1.4

Modernist Design for the Living Room: the Rhetoric of Efficiency

Designers in the livable modernist mode, such as Gilbert Rohde, Russel Wright, and Warren McArthur, investigated new forms for the 1930s living room with an enthusiasm that bordered on the messianic. In articles and marketing materials, they proclaimed that overtaxed, limited living spaces were a specific problem that needed an efficient, concrete solution. Their concern may have sprung from the smaller spaces or more crowded homes (with family and tenants) to which some middle-class families resorted in these years. However, as the open-plan living room of the 1930s did not in itself represent a significant architectural shift from earlier domestic structures, it is more accurate, perhaps, to view the designers' zealousness as a response to the psychology of limited budgets and frustrated aspirations bred by the Depression.

In proposing that the smaller size of the Depression-era home was a problem in need of resolution, modernist designers gained two rhetorical advantages. Their tangible example of cramped living spaces became a symbol of the larger foiled dreams of the period, and their modern furniture, by extension, acquired the aura of a society-stabilizing force. As an article in *House Beautiful* noted in 1933:

> Our standards of living have changed so fundamentally during the last few years that it is more than ever important that the things with which we surround ourselves measure up to the new regime. The increased pace of our lives and the decreased space forced upon us by the dwelling system of today make it impossible to devote as much room as in the past to things that are merely ornamental. The first purpose of our furnishings must be utilitarian.[8]

The problem/solution rhetoric also gave livable modernists a technological imperative for their work. Unlike designers who reshaped refrigerators and electric mixers, and who could argue that the modern style of the product was merely an inevitable consequence of its modern technology, these modernists found it difficult to claim that a modern-styled sofa or coffee table demonstrated any improved functioning over the same objects in period styles; while a new material or unornamented form

1.4
FLOOR PLAN, DESIGN FOR LIVING HOUSE,
CENTURY OF PROGRESS, 1933–34
John C. B. Moore, *architect*
University of Illinois at Chicago Library,
Special Collections Department

1.5
LIVING-DINING ROOM,
DESIGN FOR LIVING HOUSE,
CENTURY OF PROGRESS, 1933
Gilbert Rohde, *designer*
Heywood-Wakefield Company,
Gardner, Mass., manufacturer.
Chicago Historical Society
(neg. ICHi-36087)

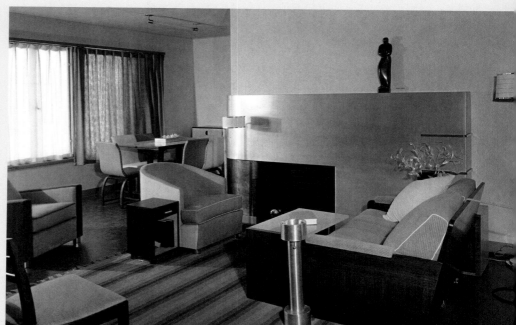

1.5

might make modernist versions of these objects easier to clean, for example, such features did not necessarily affect their ability to provide comfortable seating or a surface on which to place a coffee service.[9] Instead, these designers created the requirement that furnishings not crowd the small, multi-functional space of the Depression-era living room, and declared their work the best suited to this "need." A 1934 bulletin to Herman Miller salesmen, probably written by Rohde, exemplifies this rhetoric: "Herman Miller 20th Century Modern...*fulfills an actual need*—by creating an effect of greater space in small interiors and making for more harmonious unity in furnishing. It is the ideal solution."[10]

In keeping with their allegedly rational design process, designers and manufacturers focused on three design properties that they believed would most efficiently serve the limited spaces and multiple uses of modern living rooms: modularity, lightness in appearance and physical weight, and mobility. Modular furniture—in which individual objects can be arranged together in a variety of combinations to create larger pieces—offered several apparent benefits to the Depression-era homemaker. First, because each unit could stand alone or be grouped with others, consumers could tailor their selections to precisely fill the space of their living room and meet its intended functions. The customized aspect of modular furniture imbued it with a self-evident air of rationality: one bought only what one needed, and did not need to tolerate wasted space or oversized objects. Russel Wright touted the "flexibility" of modular units in his popular American Modern furniture line, which was manufactured by the Conant Ball Furniture Company and retailed at Macy's department store beginning in 1935.[11] Wright had begun his design career in the 1920s as a theater set apprentice to Geddes, where, he later claimed, he gained an appreciation for the importance of a coherent aesthetic experience within an interior. After a limited collaboration with the Heywood-Wakefield Company in 1933–34 that was plagued with production problems, he established a partnership with Conant Ball to produce a complete line of furniture for the living room, dining room, and bedroom.[12]

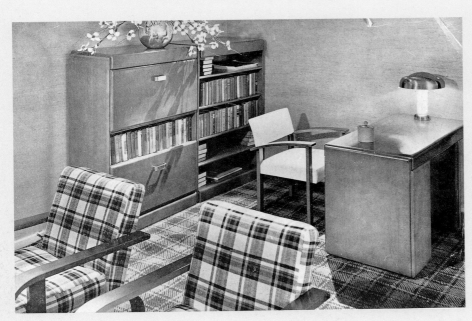

1.6
AMERICAN MODERN LIVING ROOM FURNITURE, c. 1935
Russel Wright, *designer*
Conant Ball Furniture Company, Gardner, Mass., manufacturer.
Syracuse University Library, Department of Special Collections

Among Wright's modular groups for Conant Ball that would "lend [themselves] to a great variety of arrangements, combinations and uses" in the living room was a set of three tall case pieces: a secretary bookcase, a living room chest, and a bookcase.[13] Each of these objects shared identical external dimensions and could be used standing alone or in combination with another to form a single wall unit (fig. 1.6). The secretary had a drop-front desk, a central bookshelf, and a lower storage compartment, while the chest contained large storage spaces above and below a central shelf; when closed the two objects looked identical, the single shelf suspended between two large planes of wood punctuated only by a broad, rounded wooden handle. While the rounded or "cushioned" edges (as Wright called them) on all three objects, as well as the bulging plane of wood wrapping over the top of each, prevented them from fitting tightly together as a seamless unit, these motifs created a distinctive, undulating line that cohered across the entire group. Wright also designed a smaller modular unit which he named the "Trestle" shelf (fig. 1.7). He promoted this open-backed, three-level bookshelf, constructed of interlocking planks of wood, as "one of the most versatile [designs] in the entire line," claiming, "there is no name in our furniture vocabulary by which we can classify this piece." The trestle shelf could be used singly, with recommended functions as a console table or a plant stand. Alternatively, it could be joined with other identical units through a system of notches to wrap around the corner of a room—"eliminat[ing] open wall space in the corner"—or stack to the ceiling. With its endless permutations, Wright envisioned that the trestle shelf would accommodate a wide variety of needs and maximize space in a living room of any size.

Modular designs, secondly, provided consumers with a decorative scheme to which they could add as their horizons (and homes) expanded; rather than discarding items from an outgrown living room set, they could acquire additional items in the line to fulfill new needs while maintaining a coherent decorative statement. Gilbert Rohde's modular designs for the Herman Miller Furniture Company, displayed in the company's Grand Rapids showroom and in its sales catalogues, eloquently captured this spirit of economical expansion. Rohde began his career as an illustrator for furniture advertisements in New York City in the early 1920s. After an influential trip to Europe in 1927—during which he traveled to Germany and possibly attended the *Weissenhofsiedlung* in Stuttgart—he established his own furniture design office. Rohde actively pursued contracts with established furniture manufacturers such as Heywood-Wakefield and the Kroehler Manufacturing Company, but it was in his 1930s work with Herman Miller, a smaller company known at the beginning of the decade only for its period reproductions, that he found the most conducive partner for his vision of modernist

1.7
RENDERING OF AMERICAN MODERN
TRESTLE SHELVES, c. 1935
Russel Wright, *designer*
Conant Ball Furniture Company,
manufacturer. Watercolor and graphite
on board. Syracuse University Library,
Department of Special Collections

design.[14] Among Rohde's earliest living room designs for Herman Miller was a modular sofa, offered in armless sections (of one, two, or three seats) and corner chairs. These could be variously configured, as publicity photographs illustrated, to fit any size or shape room. In a smaller living room, two armless sections could be paired to create a loveseat (fig. 1.8). If the owner "hope[d] to have a larger apartment next year and, the year after, a small house perhaps,"[15] Rohde demonstrated that his sofa sections could multiply—perhaps like children in a healthy family—growing into an ample, L-shaped sofa ideal to frame a fireplace (fig. 1.9).

In another modular design for the living room, Rohde developed a series of wall cabinets that included an assortment of wide and narrow bookcases, a drop-front desk, and a chest of drawers (figs. 1.10, 1.11, 1.12). Each of these units was a standardized height of either forty-one or thirty inches and featured identical chromed circular drawer pulls, East India laurel veneering, and razor-sharp corners. Standing alone, perhaps in "one of those compact room-and-a-half modern apartments,"[16] each offered storage space and stood as a compelling modernist object with an unusual asymmetrical design. When an owner moved into a larger living room and had more possessions to stow, the cabinets could be combined. And, as the Herman Miller catalogue demonstrated, any variation of units could become a weighty, single piece: presented on the page divorced from their domestic habitat, the East India Laurel Chest Groupings became an endless parade of dark, massive rectangles with crisply articulated edges, across their facades a shifting array of chromed pulls, drawers, and open shelves (fig. 1.13).

Modular furniture had embedded within it an optimistic view of the future—a future in which one's home could grow infinitely and along with it, one's furniture—which may, in part, account for the popularity of these designs. Wright's furniture, intended to be competitive as a "middle-priced line," sold so well at Macy's that the store ordered an additional 50 percent of stock after only six weeks in the summer of 1935.[17] And, by February 1936, the store's furniture floor boasted both the "Modern Maple House," a suite of display rooms with the American Modern line in its original, dark finish, and the "Forward House 1936," which featured Wright's furniture in a

1.8
HERMAN MILLER FURNITURE COMPANY
SHOWROOM, GRAND RAPIDS, MICH., 1934
Gilbert Rohde, *designer*

1.9
HERMAN MILLER FURNITURE COMPANY
SHOWROOM, GRAND RAPIDS, MICH., 1934
Gilbert Rohde, *designer*

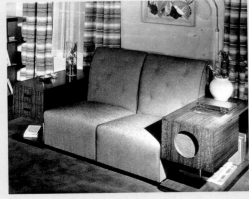

1.8

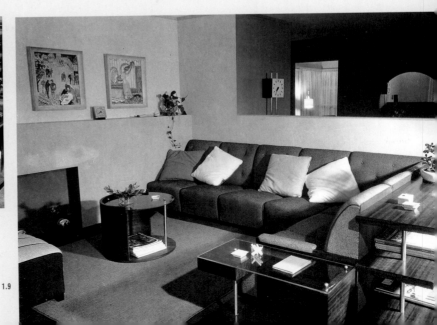

1.9

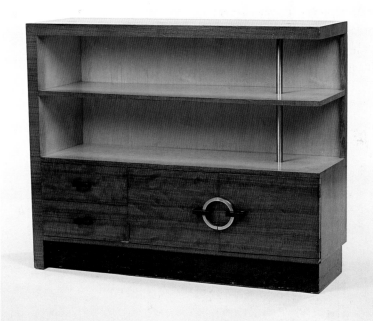

1.10
BOOKCASE (NO. 3448), 1934
Gilbert Rohde, *designer*
Herman Miller Furniture Company,
manufacturer. East India laurel,
41 x 48 x 15 in. (104.1 x 121.9 x 38.1 cm).
Photograph courtesy of Wright Auction,
Chicago, Ill.

1.11
DESK (NO. 3425), 1934
Gilbert Rohde, *designer*
Herman Miller Furniture Company,
manufacturer. East India laurel,
41 x 32 x 15 in. (104.1 x 81.3 x 38.1 cm).
Photograph courtesy of Wright Auction,
Chicago, Ill.

1.12
BOOKCASE (NO. 3432), 1934
Gilbert Rohde, *designer*
Herman Miller Furniture Company,
manufacturer. East India laurel,
41 x 32 x 15 in. (104.1 x 81.3 x 38.1 cm).
From the Collections of The Henry Ford,
Greenfield, Mich.

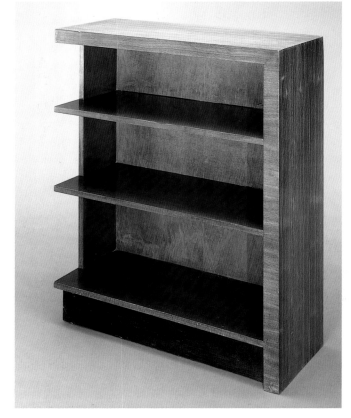

new, lighter finish called "blonde Modern."[18] Rohde's unit designs for Herman Miller were distributed throughout the country in department and furniture stores, but usually retailed for 30 to 50 percent more than American Modern.[19] Even in this higher-level market, where consumers may have already owned the "small house" that symbolized financial solvency, there is ample evidence of the success of modular items. Not only did Herman Miller continue to manufacture and promote the sectional sofa

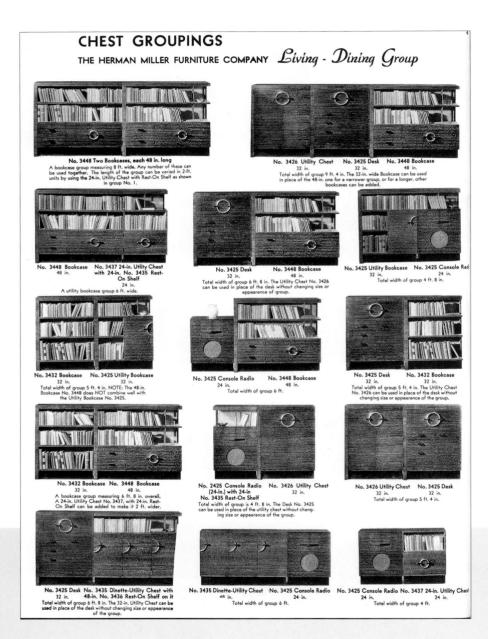

1.13
SAMPLE WALL GROUPINGS FROM THE EAST INDIA LAUREL SERIES
In *1939 Catalog and Sales Guide*, Herman Miller Furniture Company, 4

and East India laurel cabinets from their introduction in 1934 through the early 1940s, but Rohde eventually designed another sectional sofa and two more modular cabinet groups for the company.[20]

Another supposedly beneficial quality in furniture for the 1930s living room was the appearance of lightness. Objects that occupied less visual mass would, designers argued, make a smaller room seem more spacious. Wright's trestle shelves, which were mere skeletons, embodied this principle: their thin wooden frames were nearly invisible when books and various domestic accoutrements filled them, and they thus became less monolithic as they multiplied. In addition to the trestle shelves, which were ample but did not dominate a room, Wright designed a selection of wooden-framed armchairs for the American Modern line that provided comfortable reclining without seeming massive. According to Wright's logic, the apparent light weight of his chairs accomplished the task of saving space in a smaller living room: the chairs were "higher, less bulky, avoiding the popular 'nailed to the floor' appearance," and would "provide maximum comfort with minimum bulk—thus saving space."[21] In one of Wright's original designs, the chair's arms, which curve down at the front, appear to be supported only by the two fore legs and to float miraculously at the back of the chair above the curved rear legs (fig. 1.14). (In reality, the arms are attached to a wooden frame within the upholstered back.) The cantilevered effect of the arms and their thin, bent-wood elements give the entire chair an air of economy, while the opposing curves in the arms and legs create a syncopated rhythm. The chair is light-weight and animated, as if it might walk across the room on its bent legs. At the same time, it invites the sitter to relax into its deep seat and full cushions.

Designers also pursued their commitment to lightweight, open-framed furniture through experiments with tubular metal, both chromed steel and aluminum. Because tubular metal was a new material for domestic furniture, it readily lent itself to arguments based on a rhetoric of innovation, practicality, and functionality. The Howell Company, a prominent manufacturer of chrome-plated tubular steel furniture, announced in its 1933 catalogue that the technological sophistication of modern life made metal the only appropriate material for modern furniture: "[Today's] furniture should be of steel, for this is an age of steel, and steel sounds the keynote of practicability, energy and strength which dominates our modern life."[22] Warren McArthur pursued a similar line of reasoning in his 1936 catalogue of aluminum furniture, making concrete the connection between his designs and modern technological marvels: "Warren McArthur furniture is built from a specifically heat-treated aluminum alloy possessing the same qualities of super strength as those special alloys, developed for airplanes and dirigibles...The inherent propriety of this furniture [is] due to its basic attributes of beauty, economy and light mobility."[23] Indeed, as McArthur's rhetoric demonstrates, the lightness of tubular metal furniture was often presented as merely an inevitable by-product of the efficient material.

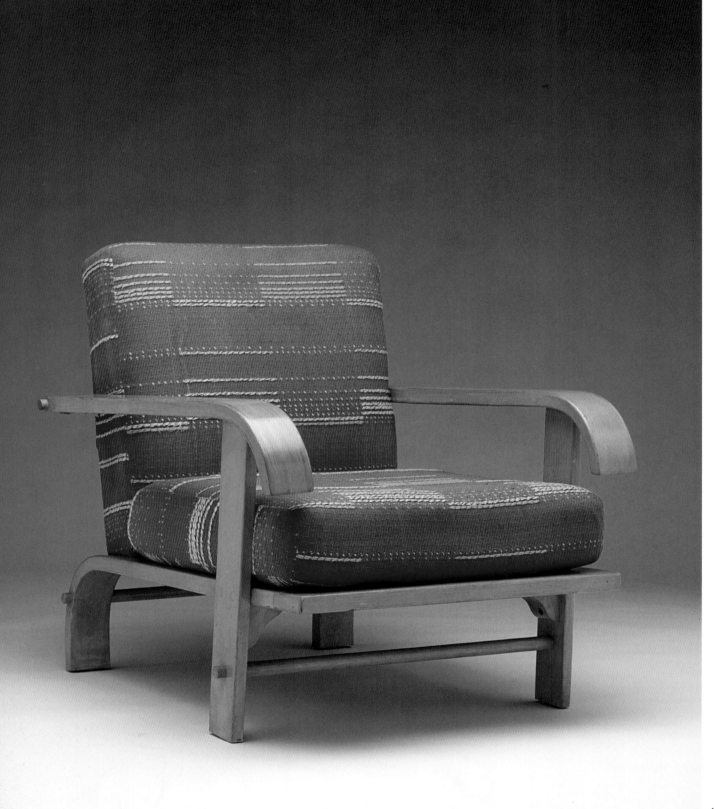

1.14

The Howell Company had provided what it called "refreshing and re-vitalizing" furniture for many of the model homes at the *Century of Progress* in 1933–34.[24] After the company hired Austrian émigré Wolfgang Hoffmann (son of the designer and architect Josef Hoffmann) to refine and expand its line of furniture in 1934, it continued to promote the appropriateness of tubular metal in the smaller homes of the 1930s: "Modern-minded men and women everywhere have turned to it instinctively, and are revitalizing their homes, often a room at a time, with Howell Chromsteel Furniture. They readily sense its unrivaled practicality, its lithe comfort, its amazingly simple beauty, and its substantial economy."[25] A 1934 advertisement best dramatized that the metal furniture was "authentically right for today's interiors"[26] by depicting a heavily furnished living room intended to satisfy a variety of functions for its inhabitants (fig. 1.15). In the photograph, the camera recorded the highlights of the reflective chromium throughout the room; it also captured the shiny, uninterrupted expanse of linoleum flooring that spills out from under the zebra-striped rug and continues beneath the sofa and armchair beside the fireplace to the bridge group on the far left. Through this constellation of reflective highlights, the photograph directs our eyes to the thin tubular legs that support the furniture, effectively creating openness between the objects and the floor. These pieces, despite their crowded arrangement, imbue the busy room with an airy lightness.

Howell produced a deeply reclined lounge chair around 1933, before the company had retained Hoffmann, which in its asymmetry seems to embody the energy of the "new, swiftly moving age" (fig. 1.16).[27] The low-slung seat nestles back onto a single tubular runner, and the front legs curve backward before landing on the ground; the object looks as if it were crouched, chafing under the brake pedal, ready to speed off with a touch to the accelerator. After Hoffmann began working for Howell, he introduced living room designs that frequently had a greater sense of serenity than the 1933 chair, yet still exploited the dramatic contrasts between the thin skeleton of the chromed steel and the dense masses of the upholstered seats and backs.[28]

1.14
AMERICAN MODERN ARMCHAIR, 1936
Russel Wright, *designer*
Conant Ball Furniture Company, manufacturer. Maple, cotton, and wool, 29 1/2 x 22 x 26 in. (74.9 x 55.9 x 66 cm). Yale University Art Gallery. Mabel Brady Garvan Collection, by exchange (2002.89.1)

1.15
ADVERTISEMENT FOR HOWELL COMPANY
In *Home Furnishing Arts* (Fall–Winter 1934), 105

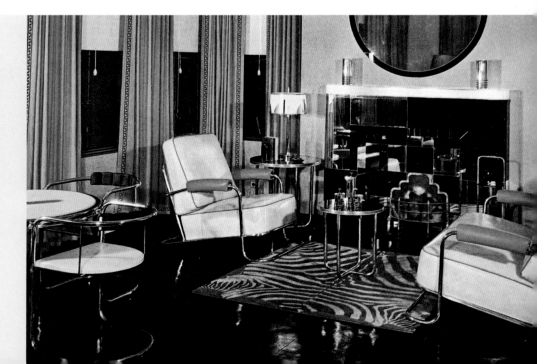

An armchair from 1934 preserves the essentially conservative, balanced, four-legged form of a club chair, but adds a bit of flair by suspending the entire uphol-stered body in a minimal tubular steel frame (fig. 1.17). Moreover, the seamlessly curved length of steel, sweeping around the arms of the chair and plunging to the floor, evokes the frictionless, streamlined energy allegedly inherent in the new mate-rial. Howell furniture retailed at prices higher than Wright's American Modern line but was still competitive with Rohde's designs for Herman Miller in the upper-middle income market.[29] Howell also marketed its designs to public establishments and cor-porations, but the presence of domestic vignettes in catalogues and advertisements from the 1930s, as well as the visibility of its furniture in the model homes at the *Century of Progress,* indicate the company's reliance on sales to private individuals.[30]

Warren McArthur's 1936 catalogue opened with a lounge chair called the "Light Lounge," also designed for a domestic environment (fig. 1.18). McArthur, trained as a mechanical engineer, founded his own furniture company in 1930 based on a patent-ed process for joining standardized lengths of anodized tubular aluminum.[31] After moving his company from Los Angeles to New York in 1933, he promoted his designs for domestic and corporate environments at selected exhibitions. At the *Century of Progress,* his pamphlet emphasized the domestic suitability of his furniture: "To be modern," it announced, "one must have one room, or at least some corner, that is distinctly 'new'...living rooms, and in fact all rooms, are becoming 'Rooms of Beauty' with Warren McArthur Aluminum Furniture."[32] Similarly, for the 1936 meeting of the Committee on Allied Arts of the American Institute of Architects in Virginia, he cited "the current modernization of the American home" as the appropriate environ-ment for his designs.[33]

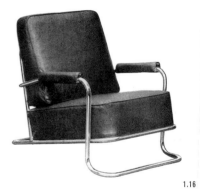

1.16

The four straight legs of McArthur's 1936 Light Lounge, capped at one end with rubber casters and at the other with screw-on rounded finials, contrast with the sledlike legs of the Howell designs. While the latter create the illusion of a seamless structure, McArthur's design, with its pronounced joints, draws attention to the sep-arateness of each aluminum segment. Despite their aesthetic differences, however, the steel and aluminum lounge chairs all attempt to dramatize the industrial energy

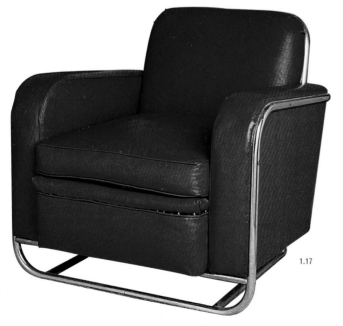

1.17

1.18

behind their manufacture. The Howell designs express taut, streamlined motion, while McArthur's chair conveys industrial strength in the standardized rings that connect each length of metal. Furthermore, the curved side stretchers of the Light Lounge are at once a playful variation on the predominant straight lines and a reminder of the flexible durability of the material: the chair looks as if it had been momentarily pulled in opposing directions as it progressed down the assembly line, but withstood the stress to retain its structural integrity. And, as Howell's advertisement emphasized the lightness of its designs, so too McArthur drew attention to the physical lightness of his lounge chair: "In this exclusive new design Warren McArthur adds distinction and lightness to precedent. Amazing comfort with half the weight of the conventional lounge chair."[34] McArthur's prices were often comparable to Howell's tubular steel, but his smaller company and lack of nationwide retailing meant that his designs were not widely available.[35] Thus, despite an ambitious-sounding appeal to the large audience at the *Century of Progress*—"Let us show you the Warren McArthur line of Aluminum Furniture. It covers a wide variety—furniture of every type for every room in the house, and designed to fit the generations now going, living and coming"—his furniture was more frequently found in the homes of the artistic and financial elite.[36]

The final design quality promoted for the living rooms of the 1930s was mobility. Mobility—that is, being light enough to be moved around a room as needed—was often a feature of objects that had a light, open appearance. Designers of livable modernism celebrated this quality because it responded well to the perceived smallness of domestic spaces: such furniture would not be rooted in a single formation, but rather could be reconfigured as the functions of the room shifted. Wright's trestle shelves, for example, could be moved around a room to serve as a table or bookshelf, and his press release even imbued them with an anthropomorphic air by announcing that they could "actually 'turn the corner'" to make a better architectural fit (fig. 1.19).[37] Similarly, the armchairs by Wright, Hoffmann, and McArthur could be moved around a living room as needed—by the window to read or in front of the fireplace to converse.[38] Furthermore, their varied forms all evoke

1.16
LOUNGE CHAIR (NO. 434-1), c. 1933
Howell Company, St. Charles, Ill., manufacturer. Chrome-plated steel and upholstery,
30 x 25 x 35 in. (76.2 x 63.5 x 88.9 cm)

1.17
LOUNGE CHAIR (NO. 360-1), 1934
Wolfgang Hoffmann, *designer*
Howell Company, manufacturer. Chrome-plated steel and leather, 31 x 30 x 33 in. (78.7 x 76.2 x 83.8 cm). Collection of Jody and Dick Goisman

1.18
LIGHT LOUNGE, 1936
Warren McArthur, *designer*
Warren McArthur Corporation, N.Y., manufacturer.
Aluminum, green vinyl, and rubber, 29 x 23.5 x 32.5 in. (73.7 x 59. 7 x 82.6 cm). Photograph courtesy of Wright Auction, Chicago, Ill.

1.19
RENDERING OF AMERICAN MODERN DISPLAY ROOM AT R. H. MACY & COMPANY, c. 1936
Russel Wright, *designer*
Conant Ball Furniture Company, manufacturer. Watercolor and graphite on board. Syracuse University Library, Department of Special Collections

1.19

kinetic energy—Wright's syncopated bent wood, Howell's streamlined speed, and McArthur's swooping side stretchers—as if they might move around a living room of their own accord.

Designers and manufacturers explicitly promoted the qualities of modularity, lightness, and mobility as evidence of the superiority of modernist designs for the living room. However, their designs and marketing reveal other motivations that go beyond—and sometimes even contradict—such claims to efficiency. While the commercial success of livable modernist furniture can be attributed in part to these allegedly objective arguments, recognition must also be made of its emotional appeal. The remainder of this chapter unearths the qualities of livable modernism that made it actually livable in this room where "every member of the family should live":[39] its respect for the gender-balanced partnership of the twentieth-century companionate marriage, and its commitment to making the living room a space of psychological retreat and physical comfort.

The Companionate Living Room

Taking their cue from concerns expressed in broader popular culture forms, designers of livable modernism attempted to offer living room furnishings that appeared neither too masculine nor too feminine. The need to balance the gendered atmosphere of the modern living room was partly a consequence of its role as a condensed library, parlor, and family room. In a larger house designed according to nineteenth-century models, a man's study, with its comfortable club chairs and shelves of books, would have offered a sanctuary for the husband returning home from work. (Lurelle Guild described such a room in his decorating guide as "the master's sanctum."[40]) Similarly, a separate drawing room or a parlor would have provided a stage for the feminine pastimes of social calling and courtship. (In her popular *Personality of a House,* Emily Post recommended that the drawing room "quite distinctly suggest the tranquil serenity of a great lady prepared to receive her friends."[41]) However, in a home where a single room served the public and private functions of the wife, husband, and children, the presentation of gender had to be carefully navigated. Indeed, American modernists embarked on unfamiliar territory as they designed for consuming women and the men they lived with; in the rational world of International Style dictums, in contrast, gender was frequently an afterthought and usually presumed to be male.[42]

Perhaps the most influential model for the relationship between the husband and wife who shared a living room in the pre-World War II period was the "companionate marriage." A companionate marriage, in contrast to a nineteenth-century patriarchal model of marriage, was based on the ideal of an equal partnership between a man and a woman. Although the man might still be expected to support the family financially and the woman might still be responsible for running the home

and raising the children, this couple thought of themselves as "friends" and placed a premium on enjoying leisure activities together and communicating openly.[43] As the spheres of this husband and wife became metaphorically less separate in the 1930s, so in their smaller living rooms did those spheres become physically less separate. The living room was not intended to be gender-neutral, but rather would ideally welcome both. In Tess Slesinger's popular 1934 novel, *The Unpossessed,* the disaffected protagonist Miles Flinders dislikes the femininity of the living room he shares with his wife, and his complaint reveals the collapse of his own supposedly companionate marriage: his wife had "furnished [their living room] so tenderly with chairs that were too little and too soft, [and she was] always struggling to draw the curtains so a man could not see out."[44] A 1925 decorating guide, in contrast, offered a Goldilocks-like account of an appropriately balanced living room. In this space, neither gender overwhelms the environment, and the stereotypical nature of the providing father and feminine mother is each given his/her own seat: "In [this living room] the comfort of the family has been provided for. There is a big easy chair for father, a medium-size 'woman's' chair for mother, and a davenport for the children."[45]

The livable modernists employed a variety of rhetorical and design strategies to ensure that their work was perceived as neither too feminine nor too masculine. As discussed in the Introduction, Depression-era designers frequently criticized the modernism of the late 1920s for its expensive prices, usually the result of one-of-a-kind construction and luxury materials. Integral to these complaints was the belief that such luxuriance was excessive, and that the dramatic angles and flamboyant patterns of 1920s modernism were superficial—a "bizarre" or "eccentric" veneer applied for cheap effects.[46] Lewis Mumford attempted to explain the distinction between 1920s modernist design and that of the 1930s when he commented in the *New Yorker* in 1934 that "Rohde is one of the few designers who realize that 'modern' is something that you are, not a theatrical effect you try to achieve."[47] His metaphor aptly referred to the artifice which is the premise of all theater. It also connoted, more broadly, melodramatic excess, a characteristic often associated in the period with Hollywood's infamous vamps such as Jean Harlow, who played the two-timing *nouveau riche* wife Kitty Packard in the 1933 movie *Dinner At Eight.* The layers of furs and outsized frills in which Packard clothed herself were an excessive veneer that highlighted, rather than hid, her underlying opportunism and deceit. A writer for *Fortune* in 1935 further cemented the association between hysterical female characters and the superficial modernism of the 1920s when he noted that, in movies at the end of the '20s, modernism had become "the inevitable symbol of female smartness, whether in gangster's moll, banker's wife, or novelist's mistress."[48]

When the modernist designers working in the 1930s claimed they had gained "wisdom" about the style and invoked the principles of functional efficiency seen earlier in this chapter, they implied that modernism had become less an extraneous

application and more a thoroughgoing transformation of the objects of daily life: that it had become less superficial and more logical.[49] Donald Deskey, who like Rohde and Wright spent much of the decade of the 1930s developing mid-market modernist designs, although with less commercial success, called the former "modernistic," and contrasted it with the "modern":

Modernistic furniture was extreme in line, elaborate in detail, harsh in colors, and using upholstery fabrics that were night mares [sic] of bad design...While modernistic merely touched the superficial aspects of a style MODERN furniture is based upon fundamental principles of design. It is the product of creative designers who are thoroughly familiar with the tradition of sound contemporary style; men who are masters of their craft.[50]

In his schema, the gendering of modern furniture becomes clear as it leaves behind the trendy and excessively feminine of the modernistic and assumes the sober rationality of "men who are masters." The *Fortune* writer corroborated Deskey's gendered associations by asserting, "The 'modernistic' is the Modern deprived of its manhood and perverted into decoration."[51] A Detroit critic made concise use of this web of gendered associations when she praised a display of Rohde's living room furniture at a local department store. She first commented that the public often "think[s] of modern interiors in the terms of ultra-smart stage settings or as rooms just a bit too theatrical for comfortable living." She then lauded Rohde, who had designed his furniture "for people living in ordinary houses," and had developed "a comfortable, homey modern that won't make the man of the house feel like a criminal if he accidentally drops his pipe or likes to strew the Sunday paper about."[52]

At the same time that these American modernists argued vehemently for the masculine rationality of their work, they were also aware that women—such as Miles Flinders's wife Margaret in *The Unpossessed,* and the countless readers of home furnishings magazines—were far more likely to make the decorating decisions for their homes. Their designs for this shared room of the house can thus frequently be interpreted as a careful negotiation across the fault lines of socially constructed gendered tastes, appealing to both halves of the companionate marriage: to a woman's supposed affinity for the decorative with pronounced stylish elements, and to the conservative sobriety that would allegedly appeal to the husband's eye. For example, the president of Howell described the company's chromed steel designs in 1933 with a surprising mix of gendered metaphors, hinting at the diverse, competing tastes he hoped his products would attract in the marketplace. "And so we have steel tubular furniture, truly expressive of modernity," he proclaimed, "as graceful as a soaring airplane, as virile as a skyscraper, as fresh and intriguing as a debutante."[53] Through this lens, Hoffmann's heavy club-chair cushions connote masculine establishment, while the seamless curve of the metal frame and its glittering, reflective surface might be glossed as feminine attributes.

Rohde's living room designs can also be interpreted as a careful appeasement of both masculine and feminine tastes. His sectional couch is hardly the overstuffed, smothering object of a feminine Victorian parlor. Its contours are simple, its cushions almost geometrically severe, and there are no deep crevices in which one could get lost. It nonetheless provides a comfortable, cushioned place to sit and can even be configured, as Rohde demonstrated in the showroom he designed for Herman Miller, in that ultimate courting device, the love seat (see fig. 1.8). The modular wall units have a similar appeal. Their prominent chrome hardware serves a practical function, but when multiplied across the facade of several units, it creates an attention-getting, playful pattern. At the same time, the cabinets have an architectonic solidity and are part of a "unit plan," a moniker that connotes order and consistency.[54]

The designers and manufacturers providing furniture to the condensed living rooms of the companionate couple understood the significance of a carefully constructed gendered ambience. While they denied that their stylistic idiom was in any way transitory or trendy—speaking to male consumers who were expected to shun fashion—they also included modest ornamental schemes and curvaceous elements intended to appeal to a supposedly feminine predilection for decoration. This balancing act was no doubt self-preservative: husbands usually earned the money their wives spent on furnishings. It was also, however, symptomatic of a design philosophy predicated on satisfying the emotional and social expectations of consumers.

Comfort in the Modern Living Room

Just as the livable modernists attempted to create living rooms responsive to the ideal of partnership in the companionate marriage, so too their designs—and the marketing of them—reflected a commitment to providing psychological and physical comfort in that space. Popular culture sources in the Depression, including popular fiction, decorating manuals, and advertising displays, consistently emphasized the centrality of comfort in the living room. As historians have documented, concepts of comfort in the American home had shifted from the eighteenth to the early twentieth centuries, ranging from a more spiritual and moral definition to one preoccupied with the needs of the body.[55] In the 1930s, the comfort that living rooms were meant to foster encompassed both psychological and physical elements. Psychological comfort derived both from the presence of familiar, historically resonant forms as well as from an aura of informality and intimacy, cultivated as a retreat from the outside world. Physical comfort was obtained through the welcoming deep cushions of armchairs and sofas as well as from the sustaining heat of an open fireplace. Margaret Flinders, in Slesinger's *The Unpossessed,* evoked these living room comforts of familiarity, retreat, and soft furniture when she mused that her and Miles's living room was "a place to hide from life," "so gay, with copies of old paintings, with books which lined the walls from floor to ceiling, with papers and cushions."[56]

The designers of livable modernism endeavored to integrate their work with this popular ideal through a variety of intellectual and formal elements meant to resonate with both emotional and bodily succor. One of the most effective ways they aimed to provide psychological comfort was to situate their work within a system of familiar historical references, often establishing firm similarities between modernism and period styles. As the fad for Colonial Revival furniture throughout the decade indicates, historical styles had a strong appeal to consumers, offering for many the reassurance of belonging to a long-standing tradition. One retailing guide cultivated this association by describing reproduction furniture of "Genuine American origin" in terms of pride in collective identity: "few indeed are the native Americans in whom this true expression of the Colonial period does not strike a responsive chord."[57] Russel Wright attempted to make use of the comforting appeal of the Colonial Revival by positioning his American Modern line in dialogue with older American furniture. He accomplished this both through repeated allusions in marketing campaigns and through specific design features. In the earliest catalogues announcing the new line, the manufacturer, Conant Ball, established a genealogy that linked American Modern to the furniture of America's mythic colonial past. Not only was the new line "built in maple, the wood of our forefathers...with [the] highest standards of craftsmanship," but it was also "ordained to become the heirloom furniture of the future, a heritage representing the best of today."[58] Wright's furniture thus claimed to insert its owners into the very continuum of American history: not only did it recall the forefathers' admirable skill and tastes, but it predicted an optimistic future in which present-day owners would be venerated as wise ancestors in their own right.

Wright evoked colonial traditions in his designs as well, most notably in the secretary bookcase, the name (Wright's appellation) and form of which refer to the massive desk-and-bookcase popular with collectors as well as consumers of reproduction antiques in the interwar years (fig. 1.20). With its desk open, Wright's secretary revealed a number of pigeonholes and ledger racks which echoed, on a lesser scale, the complex systems of cubbyholes that comprised eighteenth- and nineteenth-century desks. The older form, with its size and demanding craftsmanship, literally embodied the stature of its owner: the endless compartments bespoke the vast reach of influence. In Wright's modern living room, the owner's active use of the cubbyholes in the secretary bookcase symbolized his or her participation in American history and culture. Thus, for the audience of

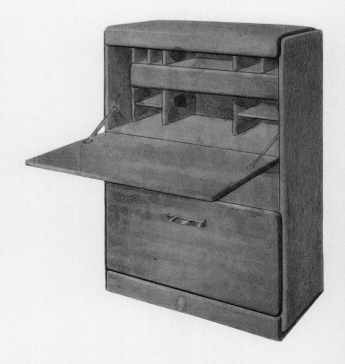

1.20
RENDERING OF AMERICAN MODERN SECRETARY
BOOK CASE, c. 1936
Russel Wright, *designer*
Conant Ball Furniture Company,
manufacturer. Watercolor and graphite
on board. Syracuse University Library,
Department of Special Collections

the 1930s, Wright's furniture resided in a well-enunciated constellation of familiar forms and values; it provided a sense of community, a club to which its owners could belong.

Gilbert Rohde also used historical references to situate his designs in a familiar context, but not through the direct genealogy formulated by Wright. Instead, Rohde reminded readers that past styles had been "modern" in their time, and proposed that consumers would be most like their ancestors if they, too, bought furniture in a modern style. Writing in a 1934 Herman Miller promotional pamphlet, Rohde began a tutorial on modernism with the declaration, "Modern Furniture is Traditional." "When Queen Elizabeth furnished her castles," he continued, "she did not order her craftsmen to imitate an Egyptian temple; when Louis XIV built Fontainebleau he did not copy what Queen Elizabeth had built. The appearance of artifacts changed according to the means and needs of the age."[59] He offered variations on this theme throughout his career promoting modern design, including in a humorous comic book published by Herman Miller during World War II (fig. 1.21), which opened:

2

But not only Chippendale

All of them were modern . . Boule, Hepplewhite, Sheraton, Shearer, Louis XIV

They didn't make their furniture look like Queen Elizabeth's or Queen Anne's or King James' or anybody else's . . .

They stole a lot of ideas from everybody else, just like Twentieth century designers. But they did not make REPRODUCTIONS.

In other words, they were all MODERN designers doing modern design . . . modern for THEIR day

People think that Chippendale designed antique furniture...
That is a mistake...
The furniture he designed is antique TO-DAY.
But when he designed it, it was NOT antique.
When he designed it, his furniture was MODERN.
Eighteenth century modern...
Chippendale was a modern designer...
(In the eighteenth century)...[60]

In both publications, Rohde went on to decry the use of modern machinery in replicating handcrafted forms and ornaments. His furniture for Herman Miller, he claimed, made "natural" use of contemporary technology: it used machines to make "large plane surfaces, and long curves of regular radii."[61] His definition of the "natural" use of modern machinery cleverly appealed to the conventional understanding that machines were best at large-scale consistency, where human hands could fail, and that they, built from diagrams and mathematical computations, could render the platonic essence of simple geometries more purely than inherently flawed hand production. Moreover, this definition put his tools in a lineage with older, "natural" technologies, enabling him to "make use of our beautiful and useful new materials honestly and directly as craftsmen have always used their materials."[62] Rohde's historical rationale valued

the newness of his aesthetics and manufacturing technologies, but it also firmly placed his work in a matrix of reassuring standards: the excellent craftsmanship and unimpeachable taste of the historical past.

Although Rohde's first designs for Herman Miller fully capitalized on the radically spare forms that he claimed could be best achieved with current technology, they still possess some features that echo historical precedent. His drop-front desk stands in illustrative comparison with Wright's similar piece (see figs. 1.11, 1.20). Where Wright's desk has cushioned edges throughout, with large-scale, almost infantile handles, Rohde's features sharp corners, its drawers and writing surface fitting flush with the cabinet frame to create an impeccable "large plane surface." The perfect symmetry of the circular chromed steel pull is a signifier of high modernism in its blatant mechanical fabrication; likewise the asymmetry of the drawer pulls in the lower portion of the cabinet announces modernity, resolutely disrupting traditions of balance. Rohde's rigid form is made less alien, however, through the familiar deployment of materials: the elaborate grain of the East India laurel veneer over the entire body of the desk recalls the dark finishes common to many eighteenth-century American objects, as well as the tradition of veneering in French furniture from the eighteenth century to the twentieth; and the chromed pull follows the American and English practice of using brass and other metals for handles and visual accents on case furniture. Another concession to historical familiarity is the pigeonholes inside the desk, suspended above the writing surface and, like Wright's, intended to situate the owner in a dialogue with American tradition. Thus, while Rohde preferred to emphasize the explicit modernity of his designs, he also cultivated a direct genealogy with historical precedent through selected formal features.

American modernists cultivated suggestions of prosperity in their designs as well, casting the objects in another well-known web of allusions. In this period of great economic uncertainty, references to financial stability and wealthy living provided a reassuring anchor for many consumers, and furniture that embodied these qualities offered a means of achieving the American myth of upward mobility and solvency. Wright and Rohde used historical connections to lend an aristocratic sheen to their own modernist designs, as Wright's repeated appeals to the "highest standards" in design and craftsmanship, or Rohde's relentless references to the furniture of Queens and Pharaohs, demonstrate. Indeed, Rohde's decision to pair the exotic East India laurel with chromium in his desk and other modular case pieces gives the entire group an aura of expense and privilege, the handles glittering as if made of precious metal against the swirling, richly colored grain.

References to luxury were not limited to these two designers, however, but rather abounded elsewhere in the modernist market. The Howell Company opened its 1936 product catalogue by proclaiming that the "distinctive beauty" and "luxurious comfort" of its designs had cemented its popularity with the buying public.[63]

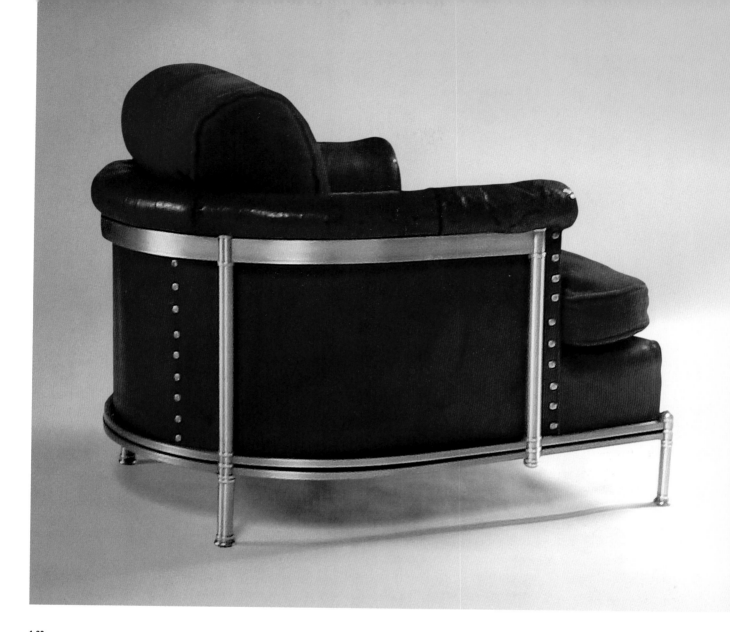

1.22

OLD POINT COMFORT LOUNGE CHAIR, 1936

Warren McArthur, *designer*

Warren McArthur Corporation,
manufacturer. Aluminum and upholstery,
32 x 31 x 39 in. (81.3 x 78.7 x 99 cm).
Collection Denis Gallion and Daniel Morris

Warren McArthur's catalogue from the same year also repeatedly invoked the icons
of a prosperous lifestyle. The introduction described anodized aluminum as "next
in hardness to the diamond, yet it possesses that velvety soft, smooth feel of satin
silver."[64] And McArthur named the heftiest lounge chair in the catalogue the "Old
Point Comfort" after a Virginia resort hotel: its deep seat, massive cushions, and
thick upholstered arms were described as "Luxury for those who can afford ease"
(fig. 1.22).[65] Yet another producer of tubular steel furniture, the Lloyd Manufacturing

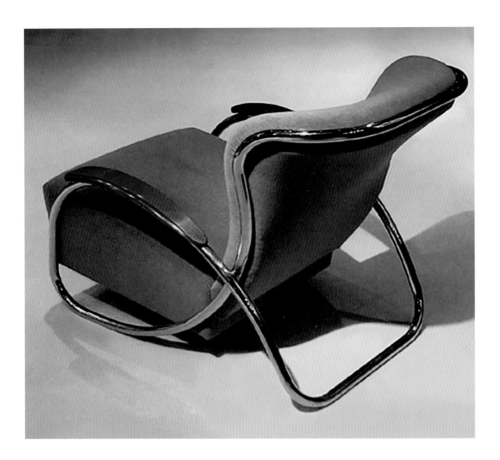

Company, routinely evoked wealthy living during the 1930s. In an advertisement featuring designs by Kem Weber—including a lounge chair with a poetically restrained metal frame formed from a single, looping length of tubular steel and a high-backed upholstered body (fig. 1.23)—the company announced, "Crisp clean-cut simple lines combine with soft lovely upholstery to provide an ease and an air of elegance that are inseparably a part of present-day American standards of luxury."[66] In promising the luxurious lifestyles of the wealthy without the expense, modernist furniture offered to consumers not only a vision of a life unburdened by economic concerns, but also, more specifically, access to the collective American ideal of financial success.

Finally, livable modernism attempted to offer a psychological salve to consumers by cultivating an informal, intimate mode of interaction in the living room. For numerous authors of decorating manuals in the 1930s, a welcoming, informal atmosphere—away from the din of the public world, where inhabitants could relax and enjoy one another's company—was the essential ingredient for a living room. "[T]he living-room," prescribed Emily Post in *The Personality of a House,* should be

"equally welcoming to us no matter what we happen to be doing, how relaxed our spines, how casual our dress, or how easy-going our character."[67] Anna Rutt emphasized the hospitality of living rooms, recommending that they express "welcome to the friends of the family." Her vision of hospitality was distinctly informal, as she encouraged readers to possess "nothing too good for use, and nothing saved for company," even painting a picture of freewheeling socializing by listing a "rug that can be rolled up for dancing" as an "ideal" component of a living room.[68] Joseph Aronson reminded his readers that the arrangement of furniture in a living room must make it "possible for a number of people to sit within easy communication of each other," hinting at a scene of relaxed intimacy not unlike Guild's vignette, sited earlier in this chapter, of "those who would sit and quietly talk as they enjoy the after dinner coffee."[69] Modernist accessories for the living room, such as furniture for card playing, smoking accoutrements, and coffee services, all participated in this ideal of a cozy, convivial atmosphere through expressive design elements.

A small table and set of four chairs, frequently called the "card group," was a common feature in 1930s living rooms. As Robert and Helen Lynd discovered in Muncie, Indiana, in 1935, card playing, especially bridge, had become "adult business-class Middletown's way *par excellence* of 'putting in an evening' with friends."[70] Game furniture tended to be easily moveable—lightweight and diminutive in scale— so that it could be brought out "when friends 'drop in.'"[71] All of the major manufacturers of tubular metal furniture, including Howell, Warren McArthur, and Lloyd, capitalized on the durability and tensile strength of their materials to produce game tables and chairs that would occupy minimal space and could be easily moved for other activities when not in use for cards. In two model living rooms filled with Howell furniture from 1934 (figs. 1.15, 1.24), card tables and chairs provide a counterpoint to the larger sofas and armchairs that anchor the fireplace. The card tables,

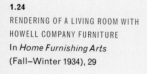

1.24
RENDERING OF A LIVING ROOM WITH
HOWELL COMPANY FURNITURE
In *Home Furnishing Arts*
(Fall–Winter 1934), 29

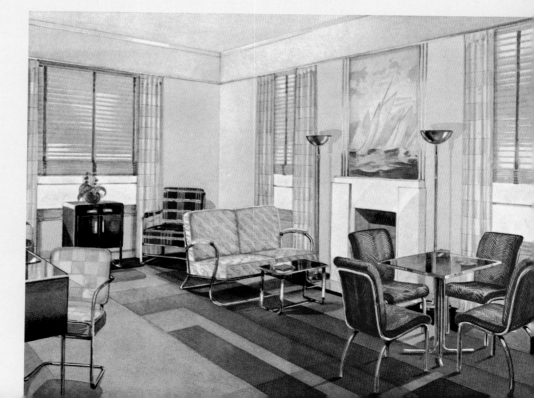

whether circular or square, are identifiable by their symmetry: no position at the table is given greater authority, but rather everyone gathers as equal competitors. The chairs in such groups also tended to be identical, with no assortment of arm- or side-chairs to designate persons of greater and lesser influence. An armchair manufactured by Lloyd and designed by Alfons Bach is typical of many chairs that were used at card tables (and is similar to the chairs in Howell's card group in fig. 1.15) (fig. 1.25). Its upholstered seat and back provide physical comfort (especially for marathon games of bridge), but its cantilevered structure ensures its light weight and understated presence. Its tubular metal arms, reaching to the ground in a single, continuous movement, would have firmly embraced the sitter, pulling him or her tightly into the community of the game at the table. "Most people's lives involve but a meager amount of sheer fun," commented the Lynds:

they are busy and preoccupied and perplexed as to what to do to make living more fun. And most people, particularly men, in an urban culture crave more human contacts out of business hours with people they like in an atmosphere that liberates spontaneity. Neither the movies nor reading supply this sense of social participation. What bridge has done is to institutionalize fun-in-small-social-groups.[72]

Modernist cigarette boxes were also designed to contribute to a playful environment in the Depression-era living room with a variety of dynamic designs that dramatized hospitality. After the Great War, tobacco companies recognized the potential strength of a female market and endeavored, as Stuart Ewen has argued, to convince women that challenging the taboo against smoking in public would be a symbol of liberation.[73] By the mid-1930s, cigarette advertisements had begun to depict women smokers less as rebels and more as elegant, seductive figures,[74] and smoking accessories began to reflect both the rebelliousness of coed smoking and its flirtatious overtones. A cigarette case made in green and black Texolite plastic, manufactured by General Electric, c. 1934, and a nickel-plated design, manufactured by Chase Brass & Copper Company, c. 1933, produced with a variety of colored Bakelite handles, were flamboyant storage vehicles that expressed the new social role of tobacco (figs. 1.26, 1.27). Although the vibrant colors and playful shapes on each attract attention, neither design has any ornament that explains its contents. They are instead alluring, mysterious objects, treasure chests that only reveal their transgressive cargo when opened. Their flashy exteriors and the drama that attends the act of lifting the chromed ball on the G.E. box, or the black knobs on the Chase boxes, contributes to the charged heterosocial dynamic of offering and accepting a cigarette. Both designs also possess a restless, kinetic energy, as if they, like writer Rutt, wanted to roll back the living room rug to dance. The semicircle of the Texolite box is anchored on each side by a chromed ball; these appear to prevent the object from rocking off balance and following the sweeping trajectory of its molded arcs. The brightly colored Bakelite motifs on the Chase boxes provide a dynamic counterpoint

1.25
ARMCHAIR (NO. C-35-E), 1938
Alfons Bach, *designer*
Lloyd Manufacturing Company, manufacturer. Chrome-plated steel, muslin, and wool, 31 1/2 x 20 x 21 1/2 in. (80 x 50.8 x 54.6 cm). Yale University Art Gallery. Gift of the designer, Alfons Bach (1991.83.1.2)

1.26
CIGARETTE CASKET, c. 1934
E. C. Sloan, *designer*
General Electric Plastics Department, West Lynn, Mass., manufacturer. Texolite plastic, chrome-plated steel, 3 3/8 x 5 x 3 3/16 in. (8.6 x 12.7 x 8.1 cm). Yale University Art Gallery. Gift of Mr. and Mrs. W. Scott Braznell, Ph.D. 1987 (2001.126.10a-b)

1.27
CIGARETTE CASES, 1933
Ruth and William Gerth, *designers*
Chase Brass & Copper Company, Waterbury, Conn., manufacturer. Nickel-plated metal and Bakelite plastic, 1 1/4 x 7 x 3 in. (3.2 x 17.8 x 7.6 cm). Collection of Jody and Dick Goisman

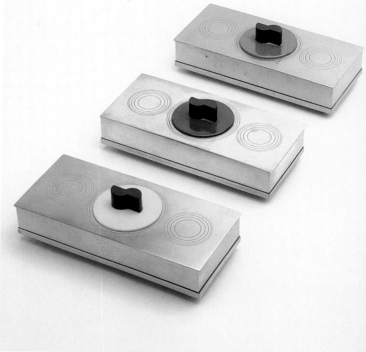

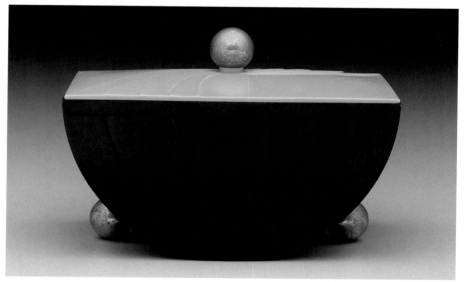

1.26

of curves and angles against the rectangle of the nickel bodies. The caskets also feature tiny chromed casters on each corner so that they may be rolled (or spun like a top) across a coffee table, inspiring the name given them in the Chase catalogue, "The Rollaround." Not only do these features reflect the buzz of tobacco and the *frisson* of a new courting tool, but they foster in the living room an atmosphere of welcoming social engagement.

Coffee services—used by Guild's fictional living room occupants who sip and talk quietly, and shown in the living room in fig. 1.15—were intended to enhance the intimate air of the 1930s living room with the warm beverage they offered at a moment of post-gormandizing relaxation. As these sources indicate, the coffee service was ideally placed on a coffee table, which was lower than a dinner or card table, and surrounded by sofas, armchairs, and perhaps a fireplace. A service such as Walter von Nessen's Diplomat Coffee Service, designed for Chase in 1932, comprised a coffee pot, creamer, and sugar bowl, the traditional elements of tea and coffee services since the eighteenth century (fig. 1.28). Although the Diplomat Service possesses an unmistakably modern sensibility—with its abstract flutes running uniformly, without moldings, from bottom to top, and its gleaming chrome finish—von Nessen clearly referenced eighteenth- and nineteenth-century American forms in his use of perpendicular handles and neoclassical vocabulary; even the combination of chrome and black Bakelite echoed the traditional use of sterling silver and ebonized wood. Such echoes, of course, imbue this service with the psychological comfort of familiarity found in Wright's and Rohde's designs. However, the service also engenders a comforting air of intimacy through its location in the 1930s living room: set on a low table, framed by upholstered furniture, the coffee service anchored an informal ritual as guests and hosts shared a warm drink and adopted more relaxed, fluid postures. Paul T. Frankl, the furniture designer whose "skyscraper" bookcases epitomized 1920s modernist design, described the effect of a low table on social gatherings in 1928: "low tables connote informality, recumbent or semi-recumbent intimacy—in a word, complete relaxation."[75] The warmth of the coffee itself, the warmth of the fireplace, and the cushioned, enveloping seats created a cradle of comfort that appeased both the emotions and the bodies of the living room's inhabitants.

The complement to the psychological comfort of the ideal 1930s living room was the physical comfort afforded by its furnishings: "restfulness," noted the editors of *Home Furnishing Arts,* "[is] an intimate part of today's contribution to living."[76] As we have seen, the Diplomat Coffee Service indirectly enhanced physical relaxation by dispensing a warm beverage; even the cigarette caskets were implicated in gratifying physical desires. For many popular interior decorators, however, bodily comfort largely resided in the soft cushions of easy chairs and sofas and in the heat of an open fireplace. Aronson directed his readers to include in their living rooms

1.28
DIPLOMAT COFFEE SERVICE, 1932
Walter von Nessen, *designer*
Chase Brass & Copper Company, manufacturer. Chrome-plated metal and Bakelite plastic, 8 1/8 x 10 1/2 in. (20.6 x 26.7 cm). Yale University Art Gallery. Stephen Carlton Clark, B.A. 1903, Fund (1982.30.1-.4)

"distinctly easy chairs of the loungey type in which the individual may take his ease."[77] Post gave similar advice, with a greater dose of rhetorical flair: "If the sofa tempts you to lie down on it, then it is just the sort of sofa that the living-room ought to have!" she exhorted, and "If [the living room's] chairs be so low and deep that getting out of them again is difficult, no matter!"[78]

Many of the livable modernist armchairs that were designed to appear light and conserve space in fact had, coupled with their skeletal frames, massive upholstered cushions. This unusual pairing can be seen as evidence of the livable modernist commitment to participating in popular ideals, in this case the ideal of enveloping comfort. The spare wooden frame of Wright's American Modern armchair (see fig. 1.14) is balanced by substantial cushions, covered in a material that is modern in its geometric pattern and bright colors, yet evocative of the irregularity of "homespun" textiles in its nubbly texture.[79] "More important," noted Macy's in an advertisement for the chair, "the piece [is] pitched so you relax." Its deep seat, along with those on the tubular metal lounge chairs manufactured by Howell, Warren McArthur, and Lloyd, all invite—or demand—a semi-reclined position. As the sitter leans far back,

1.29
ROCKING CHAIR (NO. 377)
Wolfgang Hoffmann, *designer*
Howell Company, manufacturer.
Chrome-plated steel and leather,
30 x 26 x 39 in. (76.2 x 66 x 99 cm).
Collection of Jody and Dick Goisman

LIVABLE MODERNISM

he or she adopts a pose of relaxation, and the chair itself becomes a space of retreat. Hoffmann even provided for Howell a modern interpretation of a rocking chair, the popular form that had brought comfort and relaxation through its gentle, rhythmic, back-and-forth motion since the early nineteenth century (fig. 1.29).[80] In Hoffmann's rocking chair, the rockers and arms are formed from a continuous arc of tubular steel. The abbreviated rockers not only conserve space in a smaller living room, but they also echo the object that was the original source of the rocking chair, the short rockers on a child's cradle. Howell focused on the close interaction between body and chair when it reminded potential buyers that the "Design lines" of its furniture "conform to body form."[81]

Ultimately, the anchor of the living room that provided physical comfort was "the intimate warmth of the modern fireplace."[82] While the fireplace had long since ceased to function as a primary heating source for the home, its appeal as a symbol of warmth and hospitality endured. Rutt, among other popular authors, evoked a cozy den when she noted that a living room should contain "a hearth with a fire in it whenever it is cold, comfortable chairs drawn up near it, and plenty of lamps, books, and magazines close by."[83] Rohde himself, although committed to the efficiency of new household heating systems, admitted that modernist designers should continue to include open hearths in their interiors to better fulfill the desires of the public. About his decision to keep the fireplace in the Design for Living House prominently situated in the multi-use living room (see fig. 1.5), he wrote, "Though it is generally accepted that our reactions to various forms, colors, and sounds are conditioned by habit, age-old associations cannot be easily uprooted. It is not likely that the sentiments we now feel toward the open fire will be transferred to the hot-air register."[84]

Finally, we can examine the livable modernist advertising vignettes and model living rooms (many of which were positioned around an inviting fireplace) for the ways they bring together multiple layers of reference to psychological and physical comfort. Indeed, these images offer us another perspective from which to observe how the livable modernist movement responded to popular ideals of informal, cozy interiors. Both of the Howell advertisements (see figs. 1.15, 1.24) feature deep sofas and armchairs in front of a fireplace and a grouping for a game of bridge. In fig. 1.15, the coffee service draws the room together; the light-filled room in fig. 1.24 has a desk for letter writing or bill paying (one implication being that paying bills in such a room is an unthreatening task for the owner), and a lounge chair alongside a sunny window.

Rohde's various display rooms reveal a similar disposition. In a popular image of Herman Miller's showrooms, Rohde's sectional sofa was expanded into a large L-formation, creating a lair around an open fireplace (see fig. 1.9). The firm sofa sections have been tempered somewhat by large pillows strewn casually across them, and chaos is allowed to creep in at the edges of the rational arrangement: a

thick pile of magazines adds ballast to the slender wooden wall of the glass-top coffee table, the wandering vine on the mantel reaches out as if to tickle one of the sofa pillows, and a glass canister on the side table in the foreground reaches out to the viewer, offering a jumbled cluster of cigarettes. In his Design for Living living room (see fig. 1.5), a tall, gleaming cigarette stand, again in the foreground, invites all who enter the room to smoke. Next to the fireplace, a slender lamp watches over the large armchair, as if following the advice of a 1930 decorating manual: "What an inviting little grouping! The comfortable chair and the table and reading lamp at its side seem to say, 'Make yourself cozy.'"[85]

These anecdotal details—the coffee service, smoking accessories, plants, and even streaming sunlight—hinted at a narrative, an imagined life, behind the room. For the viewing consumer, the fictional yet utterly tangible family life played out on such a stage inspired intense identification. This was a completely enveloping fantasy world, into which the consumer was intended to stumble *in media res,* as if a viewer of a movie or a reader of a novel: "Equipping rooms down to the smallest accessory has become a favorite way of showing merchandise," commented a journalist in 1934. "The customers are duly fascinated. It is pleasant to daydream about living in one or two of these ready-made rooms."[86] The daydreams inspired by these rooms featured modernist furnishings as the tools to forge a sanctuary, promising layers of welcoming respite to any family surviving the Depression and escorting them all to an optimistic future.

Conclusion

Designers in the livable modernist mode, and the companies who manufactured their work, justified modernist living room furniture with explicit assertions of practicality and efficiency. However, a close examination of their products and the ways they were intended to be used—as evidenced through formal qualities, advertisements, and model display rooms—reveals that they were also clearly motivated by the concerns and preoccupations current in the popular culture. These modernists created objects that catered to both (albeit stereotypical) masculine and feminine tastes, reflecting the new partnership of the companionate marriage. Their designs also responded to the insecurities and pressures of an economically unstable nation, creating living rooms that fostered a welcoming, inclusive social exchange and provided substantial physical comfort to the weary bodies of the modern age. However, as the next chapter reveals, modernism's embrace of nonpatriarchal, informal modes of entertaining in the dining room was far more complex and ambiguous.

back of the perfect dinner is

ALUMINUM

2

Modern Modes of Dining

A 1936 advertisement for Congoleum Rugs—featuring a smiling couple seated at their dinner table, the husband poised to carve their main dish of ham—captures the mixture of modernist efficiency and formal traditions that appeared in many popular images of Depression-era dining rooms (fig. 2.1). Throughout the advertisement are easily identified modernist elements. The rug boasts a brightly colored, Mondrian-esque pattern, and on the wall hangs an assortment of framed abstract and geometric prints. The dishes are plain, rounded forms decorated only with rings of cheery colors. The suite of dining room furniture—designed in its entirety by Gilbert Rohde for Kroehler Manufacturing Company in 1934—consists of sleek, bentwood side chairs (on which the couple sit) and armchairs (against the wall), an austere table, and two case pieces whose stark facades are punctuated with small, semi-circular drawer pulls. Even the spiky leaves of the plant on the sideboard participate in an aesthetic of simplicity (similar to the plant in the cartoon which opened Chapter 1).

Although the Congoleum couple have outfitted their dining room in a noticeably modernist style, they still adhere to certain formal, traditional practices. Jean, the wife, has arranged her dishes for display in the cupboard as if they were prized china in a manor house. The suite of dining furniture, although smaller in scale and with fewer separate pieces than a more traditional suite, functions conventionally: it provides ample surfaces for display, cupboards for storage, an expandable formal table, and an assortment of arm- and side chairs for the hosts and their guests. Even the Congoleum, which is made of a modern material similar to linoleum and can be "quickly cleaned with just a mop," is described as a rug, a more traditional floor covering. Its colored geometric pattern evokes not only modernist abstraction but also the irregularities of nineteenth-century rag rugs. Finally, the couple's meal itself is

2.1
ADVERTISEMENT FOR CONGOLEUM RUGS
In *Ladies' Home Journal*
(May 1936), 106

a contradictory mix of modern simplicity and formal ritual. It is clear from the conversation at the top of the advertisement that Jean is a dependable, intelligent manager of her household—a practitioner of the emerging field of domestic science—and is solely responsible for cooking the meals for herself and Bill, without the help of a servant. Although Jean lacks the finances and domestic help that a middle-class woman of her mother's generation probably could have relied upon, she sets a surprisingly formal, if intimate, dinner table: a flower arrangement graces one end of the table, and she presents the food in a variety of serving dishes and platters. Bill prepares to carve as if they were seated at a Thanksgiving feast.

This chapter argues that livable modernism attempted to serve a symbolic role in Depression-era dining rooms, negotiating the conflicting impulses (evident in popular sources such as the Congoleum ad) to simplify dining in response to economic hard times and, simultaneously, to maintain the standards of gracious hospitality possible in wealthier days. The chapter first examines furniture designed for dining in the livable modernist mode, including the type of small-scale dining suites illustrated in this advertisement, as well as multifunctional furniture designed for the dining corner of a living room. It then discusses the tablewares designed for two different forms of dining: formal, seated dinner parties and less formal, intermingling buffet parties. These objects all, to varying degrees, seemed to offer the means to debunk social hierarchies and simplify the excessive rituals that had characterized dining in the years before the Great War. At the same time, these designs—ranging from dining tables to wine glasses and canapé plates—revealed themselves to be complicit with the very forms of etiquette they claimed to render inconsequential. Livable modernism fashioned itself as an implement of conservative tradition even as it appeared to engender a new style of informal entertaining, and thus reveals tensions between reality and fantasy as middle-class Americans served dinner in the Great Depression.

Furnishing the Space of the Dining Room

The most significant influence on dining furniture during the Depression was the scale of the room it was meant to inhabit. During these years, architects and interior designers heatedly debated the necessity of a separate dining room for the standard middle-class apartment or house. Most families used their dining room for only a brief period every day, and its primary function for many was to maintain the formal appearances and entertaining practices of a different era. In such times of limited circumstances, when it was believed that more people lived in

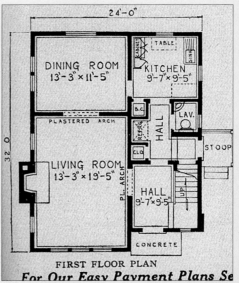

2.2
FIRST-FLOOR PLAN, THE SHERWOOD, 1929
Sears, Roebuck, and Company, manufacturer

2.2

fewer, smaller rooms, architects and designers increasingly pointed to the separate dining room as a flagrant waste of space. As a reporter in Chicago's *Official World's Fair Weekly* commented during the summer of 1933, describing George Fred Keck's House of Tomorrow, "The dining table sits in an alcove of the living room. In fact, that is the arrangement in most of the houses [in the Homes & Industrial Arts Group]. The dining room is pretty much a thing of the past in homes of average size. It costs too much in floor space, roof expense, and labor" (see fig. I.10).[1]

Designers and architects of the 1920s and 1930s adopted two strategies for modifying the dining room. Sears, Roebuck, and Company opted for the first strategy in many of its kit homes during the interwar years: a first-floor plan featuring a larger living room and a smaller room or alcove, joined together through an open doorway, creating what one trade journal called a "junior dining room" (fig. 2.2).[2] A junior dining room was an economical alternative for couples who believed that the dining room, and the objects within it, should be the "most permanent," enduring elements in a home, representing the establishment of the family around the dinner table and its hospitality to the community.[3] A survey conducted by the *Architectural Record* in 1939 discovered that a majority of respondents nationwide still preferred a separate dining room in their homes, and that 85 percent of American dining rooms were furnished with coordinated suites. The survey also reported that a suite on the West Coast typically consisted of a table, six chairs, and sideboard, while on the East Coast it also included a china cupboard and serving table. With the diminishing size of these junior dining rooms, it is unsurprising that retailers in December 1933 mentioned the need for more examples of smaller-scale dining suites, implying that full suites were impractical, both in the current retail climate and within the homes of most buyers.[5]

Dining suites in the livable modernist mode often responded to the perceived trend toward smaller dining rooms with individual elements that were less bulky overall than comparable period-styled objects.[6] For example, Rohde's suite for Kroehler and a suite designed by Donald Deskey for Valentine Seaver both included

2.3
SMARTSET DINING SUITE, 1935
Gilbert Rohde, *designer*
Kroehler Manufacturing Company, Chicago, Ill., manufacturer.
In *Good Housekeeping* (September 1936), 54

2.4
DINING SUITE, 1934
Donald Deskey, *designer*
Valentine Seaver Furniture Company, Chicago, Ill., manufacturer.
In *House Beautiful* (February 1934), 16

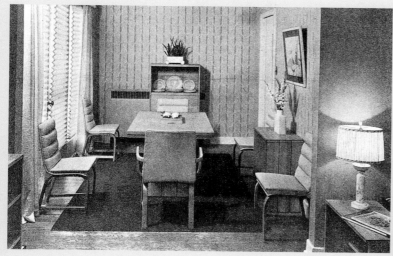

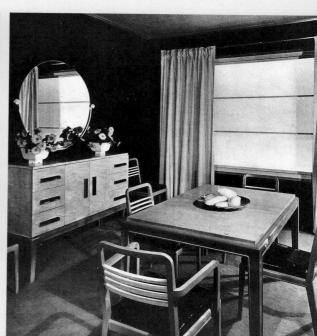

2.3

2.4

MODERN MODES OF DINING

pared-down rectangular tables and skeletal armchairs (figs. 2.3, 2.4). Both designers attempted to minimize the heft of their case pieces by adorning them with simple, geometric drawer pulls, and both elevated their sideboards on slender legs. Kroehler manufactured Rohde's furniture in a monochromatic finish (either light or dark), which enhanced its minimalist sensibility. Deskey's designs, in contrast, were produced in a cacophony of colors—white sycamore bodies with red and black enameled detailing—that gave them a dynamic energy yet also emphasized the abstract geometries of their composition. A dining group in tubular steel attributed to designer Alfons Bach for Lloyd Manufacturing Company—described as a "dinette" and consisting only of a dining table and chairs—similarly created a light-weight effect (fig. 2.5).[7] The designs capitalized on the tensile strength of Lloyd's tubular steel: the spindly lengths of steel that form the legs beneath the broad table top seem hardly sufficient to support it, while the upholstered chairs appear to hover above two sledlike tubes.

Such spare forms were intended not only to create an illusion of openness in the smaller space of a modern dining room, but were also meant to provide smooth surfaces with minimal detailing that would be easy to keep clean. With their lack of grime-catching detail, these objects reflected a twentieth-century interest in clean-liness and hygiene around the production and consumption of food in the house. The concern with safe food preparation in the first decades of the century had inspired the design of white, streamlined, apparently sanitary kitchens;[8] this attention eventually expanded to dining rooms, where postwar decorating manuals recommended furniture that was "severely chaste in design…[with] no unnecessary ornaments or construction members to gather dust and take time for care," and upholstery that could be easily cleaned, "in a material that anticipates the worst."[9]

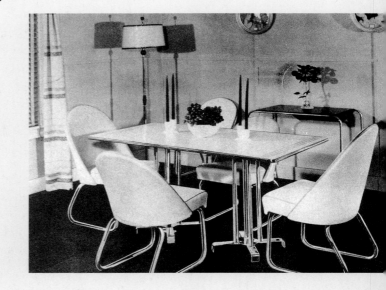

While the simplicity of livable modernist dining furniture aided the maintenance of domestic hygiene, it also promoted a subtle challenge to the traditional gender hierarchies of the dining room. In the latter half of the nineteenth century, as Juliet Kinchin has demonstrated, the dining room was often understood to embody the benevolence of the household patri-arch, who presided over meals from a position of authority at the head of the table.[10] His virility and munificence, Kenneth Ames has argued, were fre-quently symbolized in extravagant sideboards on which hunted animals and other foods were sculpted in elaborate ornamental programs.[11] Not only did the sideboard depict the husband's strength, but the

amount of work required to keep its excessive details free from dust ensured that the housewife and her servants were aware of his authority. In necessitating less labor for upkeep, livable modernist dining furniture availed itself to the Depression-era homemaker, who was unlikely to have domestic help and might be busy herself earning extra income for the family. The simple contours and minimal ornament of these objects alleviated, however slightly, the traditional patriarchal air of the dining room by transforming it into a room dedicated to easing the work of the matriarch.

Such modernist dining suites also often provided creative alternatives to the seating hierarchies that had prevailed in prewar formal dining rooms. In those spaces, the larger, presumably more comfortable armchairs were traditionally placed at the head and foot of the table, for the host and hostess, while guests, arranged in importance from the head and foot of the table, were seated at the sides in smaller, less important, armless chairs.[12] The dining groups of the 1930s often contained fewer case pieces and chairs than older dining suites—providing sufficient "utilities and comfort in less space"[13]—and retailers frequently sold them as open stock.[14] This allowed consumers to tailor their furnishings as they wished, without reference to tradition and according to the dictates of their pocketbooks: one could buy an entire fleet of armchairs, only side chairs, or any combination of the two. The publicity photograph for Deskey's suite illustrates the traditional distinction of power associated with arm- and side chairs, the head and foot secured by more substantial armchairs, and armless chairs flanking the sides. Both Rohde's and Bach's chairs, however, subvert this hierarchy. Rohde's armchairs for Kroehler are placed against the wall in the Congoleum advertisement, in a position more frequently used for a side chair; with their modest wooden arms and slatted backs, they seem far less comfortable than the side chairs on which Jean and Bill sit. The side chairs, in contrast, are generously cushioned on seat and back, and provide enough visual heft to anchor the table on any side. Similarly, Bach's dining chairs for Lloyd were neither arm- nor side chairs. Although Lloyd offered the design in a taller and lower back, both versions had sufficient substance in their upholstered bodies (covered in a synthetic named Calumet leatherette) to balance the table and, at the same time, sufficient lightness in their diminutive steel frames to sit unobtrusively against a wall when not in use. These variations on traditional arm- and side chairs provided a means to challenge entrenched hierarchies—and instill a more efficient, egalitarian social dynamic—in formal dining.

While livable modernist dining groups seemed to offer space efficiency, affordability, and a means to challenge hierarchical traditions, most, in the end, adhered to the structures that typically accompanied formal dining. All three of the dining suites discussed here, for example, provided tools for pageantry and display: multiple matching chairs and oblong tables with positions of greater and lesser importance. Rohde's and Deskey's in addition had sideboards and china cabinets.

2.5
DINETTE (T-68-B TABLE, C-48-B AND C-49-B CHAIRS), 1936
Attributed to **Alfons Bach**
Lloyd Manufacturing Company, manufacturer. In *Lloyd Furniture* (1936), 17

More specifically, these designs enabled couples or families living in the limited circumstances of the Depression to pursue fantasies of gracious hospitality and formal entertaining in the mode of middle-class households in previous generations. Rohde's suite was photographed for *Good Housekeeping* with a set of china prominently displayed in the china cupboard, similar to the arrangement in the Congoleum advertisement. *House Beautiful* depicted Deskey's suite with a generous bowl of fruit as the table centerpiece. Even the ultra-spare forms of Bach's dinette, which looked less traditional than either of the other two suites, acquired associations of wealth and plenty through astute marketing. One industry critic described the dinette table as having a "two pedestal base": although the thin tubes of steel are a far cry from the massive classical forms that supported grand nineteenth-century dining tables, the allusion cast the suite as an heir to formal furnishings of the past.[15] Lloyd also promoted its dinette as a symbol of hospitable indulgence by asserting in its catalogue that the design would please the "True epicureans [who] know that complete relaxation makes any meal more pleasant and enjoyable."[16]

The second strategy for economizing the space of the dining room in Depression-era homes was to simply eliminate the dining room altogether and instead incorporate the tools and furnishings of eating into a section of a larger, free-form living room (fig. 2.6).[17] In these larger "living-dining rooms," the dining table and chairs might be arranged permanently in one end of the room or, alternatively, serve as a side table and chairs for the living room until needed for dining, at which point table leaves could be opened and the objects converted to a dining group. The popular *Modern Priscilla* decorating manual flattered the housewife who adopted such a practical approach by pointing out that the dining room "is a room which has only occasional use. For this reason many sensible women are beginning to question whether it is necessary to continue its maintenance. In some new houses the area formerly occupied by the dining-room has been added to the living-room to make a gracious space for the varied interests which center there."[18]

Dinettes such as that manufactured by Lloyd, which occupied less space than a full dining suite, were a popular choice for those apartments and houses in which the dining room was but a section of the living room.[19] However, the living-dining room could also be outfitted with multifunctional furniture—objects intended both to blend in with a larger living room environment and to provide a full apparatus for dining—a design challenge to which Rohde devoted an unprecedented amount of energy.[20] For Kroehler, he designed an oak "convertible table" with massive dropped leaves (figs. 2.7, 2.8). When its leaves were collapsed, it could be flawlessly integrated into the larger plan of the room as a pier table, placed against a living room wall. Expanded, the leaves formed a broad table top and provided ample space for four to dine. A cabinet formed the base of the table: two of its drawers were lined for silver, one for linen, and the larger lower space could hold bottles or, as one reviewer

2.6
FLOOR PLAN FOR A COUNTRY HOUSE
Eleanor Raymond, *architect*
In *House Beautiful* (May 1934), 56

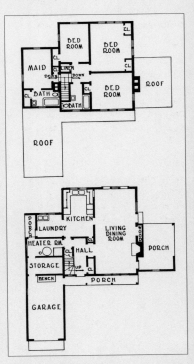

LIVABLE MODERNISM

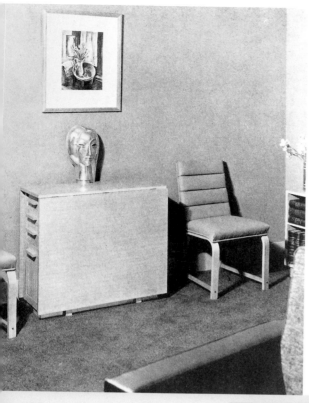

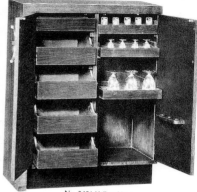

No. 3426 Utility Chest
Closed

No. 3426 Utility Chest
Open

2.7
CONVERTIBLE DINING TABLE, 1935
Gilbert Rohde, *designer*
Kroehler Manufacturing Company,
manufacturer. In *Architectural Record*
(May 1935), 308. Hedrich Blessing,
photographer. Chicago Historical Society

2.8
CONVERTIBLE DINING TABLE, 1935
Gilbert Rohde, *designer*
Kroehler Manufacturing Company,
manufacturer. In *Architectural Record*
(May 1935), 309. Hedrich Blessing,
photographer. Chicago Historical Society

2.9
UTILITY CHEST (NO. 3426), 1934
Gilbert Rohde, *designer*
Herman Miller Furniture Company,
manufacturer. East India laurel,
41 x 32 x 15 in. (104.1 x 81.3 x 38.1 cm)

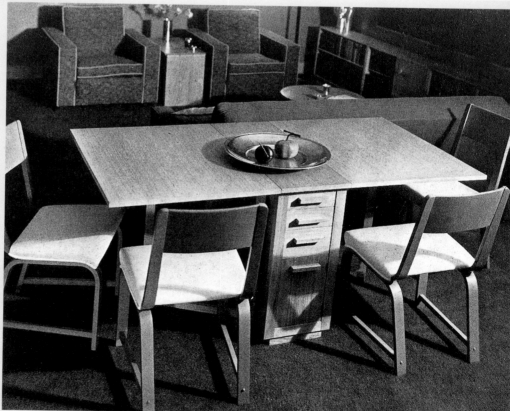

2.8

noted, a toaster.[21] Thus the table held within it all of the accessories necessary to convert it from a pier to a dining table—"so handy in the double-duty living-dining room" one critic proclaimed—and exemplified the modernists' claims to functional efficiency.[22] Rohde applied similar principles of aesthetic integration and practicality in a utility chest designed for Herman Miller in 1933 (fig. 2.9). This object had the same proportions, contours, and distinctive C-shaped chrome handles as the living room cabinets and drop-leaf desk discussed in Chapter 1. It could thus be seamlessly combined with the other case pieces as part of the larger decorative organization of the living room. Inside, however, it had various drawers and shelves designed specifically for silverware, linens, and glassware (the cork-lined drawers for glasses could be removed and used as a serving tray).[23] Their chameleon-like existence enabled the room to completely hide its dining function when needed.

Despite its claims to better suit the spaces of Depression-era homes, the less formal, smaller-scale efficiency of livable modernist dining furniture remained a small portion of the dining room market for most of the decade.[24] Its position in a field dominated by period-styled objects may explain the persistence of a vocabulary

2.10

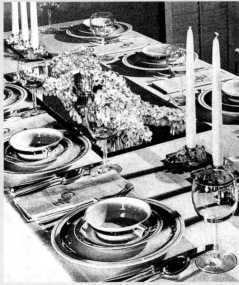

2.11

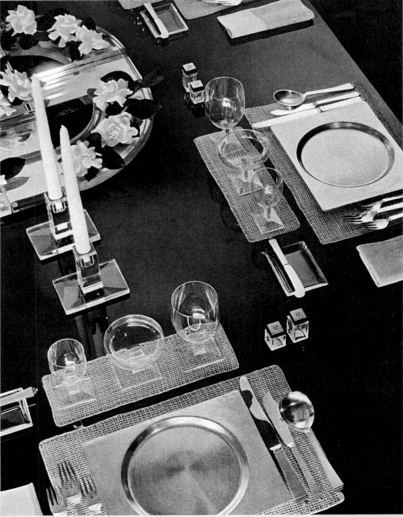

2.12

of formality and tradition in these designs—encoded, for example, in the array of arm- and side chairs, or in the publicity photographs that conjure up associations to munificence and sociability. Even Rohde's convertible table opened out into an oblong form with head, foot, and sides when its leaves were lifted, and was photographed with a platter of fruit—albeit a minimalist selection—meant to indicate its place in a tradition of hospitality (see fig. 2.8). To reach a consumer audience during the years of the Depression, the livable modernists appear to have found less acceptance of innovation, and instead attempted to cultivate the public's desire for forms that embodied a legacy of fine dining and generosity.

Formal Tables in the Modern Style

The Depression imposed severe restrictions on the hospitality budgets of many American households, and has led several scholars to speculate that fewer formal dinner parties were held over the course of these years than previously.[25] Not only did a formal dinner party imply an expensive, multi-course meal for many guests, but it also required matching sets of stemware, plates, and silverware for every place at the table, an extensive dining infrastructure that would have been a luxury for many households during the 1930s. Despite the ostensible impediments to seated dinner parties in these years, however, magazines regularly featured large, glossy photographs of model dining tables set as if for a formal meal. Appearing in magazines ranging from the mass-circulation *American Home* to the higher-end *House and Garden* and *Arts and Decoration,* these photographs illustrated a wide variety of decorating styles, including many examples of modernist tablewares (figs. 2.10, 2.11, 2.12, 2.13).[26] Such model tables, set with impeccable order and featuring gleaming new place settings, actively recalled a tradition of gracious dining and hospitality from the first decades of the twentieth century. While these staged

2.10
PERIOD TABLE SETTING
In *American Home* (November 1935), 478.
F. M. Demarest, photographer

2.11
MODERNIST TABLE SETTING
In *American Home* (November 1935), 478.
F. M. Demarest, photographer

2.12
MODERNIST TABLE SETTING
In *House & Garden* (April 1933), 44.
Anton Bruehl, photographer

2.13
MODERNIST TABLE SETTING
In *Arts and Decoration* (November 1933),
11. Wynn Richards, photographer

2.13

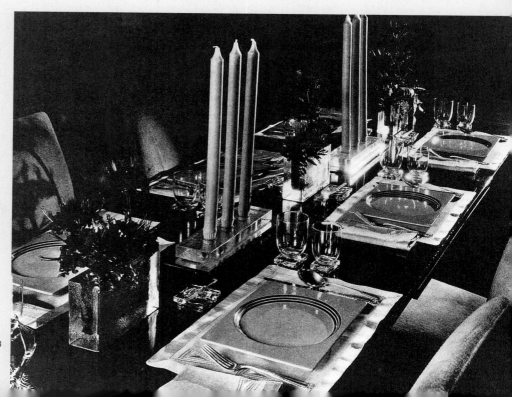

images should not be taken as a sign that all middle-class housewives in the 1930s were still hosting dinner parties in the manner of their prewar counterparts, they do offer a nuanced view of Depression-era formal entertaining. For some middle- and upper-middle- class families whose incomes were not significantly diminished by the Depression, these formal dining photographs may have served as models to strive for. For those housewives who suffered more substantial setbacks, these tables instead offered a fiction of sociable living that stoked consumer fantasy. The subtle messages of the photographs, as both models and fantasies, reveal much about the aspirations of domestic life during the Great Depression.

The formal tables photographed for women's and shelter magazines demonstrated an unflagging variety. They illustrated endless permutations for arranging the objects on the table, and, equally important, countless styles in which to outfit one's table. The variations on carefully placed butter-knives, goblets, and other implements seemed to offer innumerable alternatives for setting an appropriate table and had a particular appeal to those living through the financial and social fluctuations of the period. Instead of dictating a single standard for formal table arrangements, the images ensured that every housewife could find a configuration of silverware, stemware, and china that reflected the potential of her own cupboard and her husband's wallet. (Indeed, setting a table with new accessories may have represented to some consumers a more affordable way to update a dining room than buying a new dining suite.) Within this constellation of options, modernist wares were often celebrated as a particularly effective means for departing from "hide-bound, monotonous tradition" at the table.[27] As two table "stylists" for Macy's advised: "The setting of the modern table offers many intriguing advantages, for with the contemporary design movement has come a freedom of conception and expression that discards all set rules...all the originality one possesses may be expressed."[28]

Fostoria Glass Company's three-tiered Plume candlestick, designed by George Sakier around 1934, provided an affordable example of the individuality and taste of the "unexpected" that these stylists celebrated (fig. 2.14).[29] The Fostoria Glass Company of Fostoria, Ohio, had hired Sakier to develop a line of modernist tablewares in 1929 in an effort to enhance its competitive presence in the middle and upper levels of the market. Sakier had previously worked as an art director for several fashion magazines, including *Harper's Bazaar* and French *Vogue;* he had traveled to Europe regularly in the 1920s and was already familiar with various modes of modernist art, fashion, and design at the time he began working for Fostoria.[30] In his Plume candlestick, the abstracted tendrils of the feather have been frozen in an exuberant, upward sweep, yet their smooth, almost biomorphic contours remind the viewer of their real-world malleability, as if they might momentarily bend under the weight of the three candles. The clear glass itself evokes both the lightness of a feather and the weight of crystal. Sakier's design exemplifies many qualities of the livable modernist mode in

2.14
PLUME CANDLESTICK, c. 1934
George Sakier, *designer*
Fostoria Glass Company, Moundsville, Ohio, manufacturer. Glass, 7 3/4 x 6 3/4 in. (19.7 x 17.1 cm). Yale University Art Gallery. Gift of Randall Garrett, B.A. 1972, M.A. 1975 (2003.49.2)

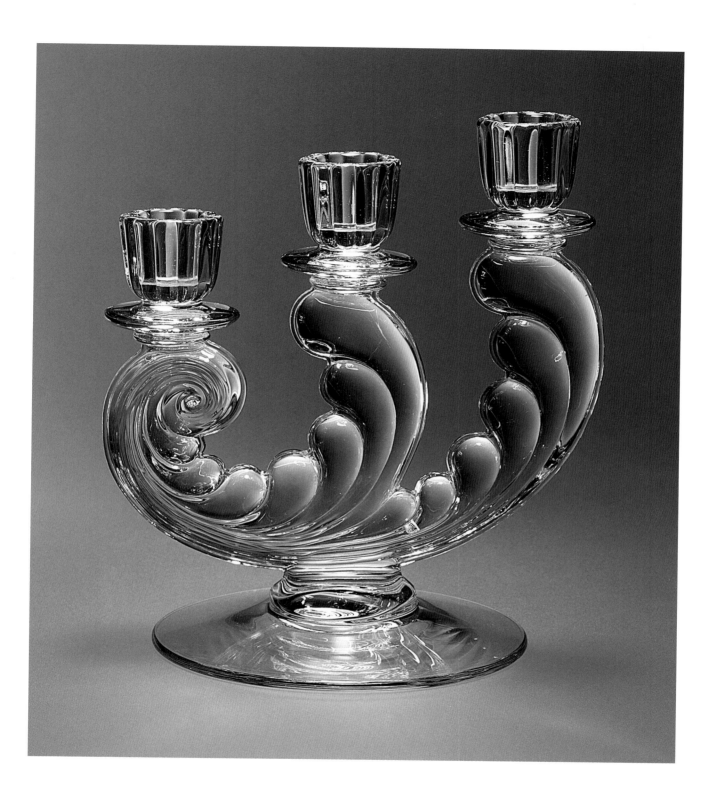

MODERN MODES OF DINING

tablewares: making clever use of abstraction and surrealism, it transformed necessity (not possessing, or being able to afford, all the detailed trappings of tradition) into a virtue celebrated in popular culture (individuality and creativity).

As they embodied divergence from tradition, livable modernist tablewares, like livable modernist dining furniture, seemed to facilitate a new mode of dining that could challenge old conventions and establish a new social order around the dinner table. With their unadorned forms, modernist wares often created the impression of greater openness across the dinner table, a quality that some decorating experts encouraged. Fewer dishes and less elaborate centerpieces, Joseph Aronson counseled in his decorating manual, would allow guests to "see each other comfortably...The dining table is the most sociable place in the world, and the decorations must not absorb any of the sociability."[31] A writer for the magazine *Arts and Decoration* corroborated Aronson's advice, explaining that a more open table would facilitate a freer style of social interaction: "Contemporary dining is a matter of diets, reduced courses and an insistence on the part of those present that they not only see those who sit across, but that they can converse with them in some easy fashion. This takes care of the age old problem of the wrong dinner partner."[32] A less cluttered table thus not only saved the hostess from the chagrin of poor seating arrangements, but it also destabilized the hierarchy to which guests submitted when taking their places. The host, for example, would not be able to monopolize the attentions of the most important female guest, traditionally seated to his right, if she could also see and hear guests further down the table.

Cambridge Glass Company introduced a set of candlesticks and flower bowls in late 1937, priced somewhat higher than the Fostoria candlesticks and called "Table Architecture," that would have contributed to a more open-feeling dinner table (figs. 2.15, 2.16).[33] The stepped candlesticks and bowls (offered in various sizes and shapes) were composed only of right angles and simple geometric forms, as if

2.15
PRISTINE TABLE ARCHITECTURE CANDLEHOLDERS, 1937
Attributed to **Wilber L. Orme**
Cambridge Glass Company, Cambridge, Ohio, manufacturer. Glass, each 5 3/8 x 5 1/4 x 1 3/4 in. (13.7 x 13.3 x 4.5 cm). Metropolitan Museum of Art, New York. John C. Waddell Collection, Gift of John C. Waddell, 2002 (2002.585.9-.12)

2.16
PRISTINE TABLE ARCHITECTURE CANDLEHOLDERS AND FLOWER BOWL, 1937
Attributed to **Wilber L. Orme**
Cambridge Glass Company, manufacturer. Glass. Collection of John C. Waddell

2.15

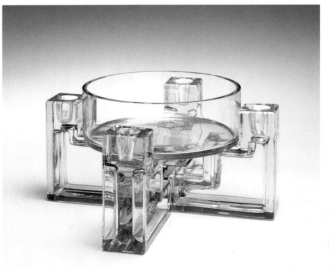

2.16

intent on offering minimal distractions to the guests seated around them. The Table Architecture pieces could be arranged in a number of configurations to suit the table and the hostess, as an advertisement explained: "Table Architecture, the new vogue in home decoration, possesses infinite possibilities for arrangement...a different table setting every time you entertain. You 'build' the centerpiece to your taste, using the interchangeable candlestick and flower trough units."[34] The spare lines of livable modernism thus appeared to be agents that could subvert older conventions and bring about an egalitarian community at the table.

Yet even as livable modernist tablewares offered alternative aesthetics and seemed to challenge the social hierarchies encoded in traditional formal dining, the glossy magazine photographs reveal the extent to which these objects were complicit in the perpetuation of certain elements of formal social etiquette. The magazine images were, firstly, dramatized versions of the table setting diagrams that had been featured in etiquette manuals since the eighteenth century: both the diagrams and photographs, with their minute detail, were intended to serve as models of taste and propriety that readers could copy on their own tables. Moreover, the prevalence of these photographs in monthly magazines coincided with the general popularity of etiquette manuals during the interwar years. In publications such as Emily Post's *Etiquette* (first published in July 1922 and in a sixteenth edition by November 1926) and Lucy G. Allen's *Table Service* (published in 1915, revised in 1924 and 1933), readers could find detailed guidance on various aspects of social protocol: how to issue (and accept) an invitation to an afternoon tea or a formal dinner, and how, with the help of rulers and basic principles of symmetry, to set the table accordingly. Consumer demand for these books reflected the swelling ranks of the middle class in the 1920s, as readers sought advice about social practices they had not experienced in their childhood homes. The popularity of these books also indicated the general elevation of middle-class social aspirations, as readers sought, through rules, to emulate more aristocratic lifestyles. Allen's 1933 edition offered a concession to the realities of Depression-era entertaining in a diagram that illustrated the proper table for hosting a party without the help of a servant; her choice implied that readers would want a set of guidelines to follow that would infuse their limited dinner party with the imprimatur of tradition (fig. 2.17). According to her directions, "the carver" served the meat, "the vegetable dishes may be passed from one [guest] to another, each helping himself," and the hostess was allowed such timesaving techniques as setting all of the utensils, including those for dessert, at the beginning of the meal and clearing two places at a time.[35]

Allen's diagram as well as the table laid with food in the Congoleum advertisement (see fig. 2.1) illustrate the type of service known in the United States in the nineteenth century as Old English (Allen referred to it as the "English" or "Home Style"):[36] the male host himself carves the primary dish of meat, and all of the various courses of food are presented on the table at once, for guests to select as they

HOME DINNER TABLE.

2.17
DIAGRAM FOR TABLE SETTING WITHOUT SERVANTS
In Lucy G. Allen, *Table Service* (1933), 67

wish. Historian John Kasson has argued that for the Victorians, the Old English service foregrounded both the magnanimous hospitality of the host, who symbolically served everyone at his table, and the bodily hungers of the guests, whose desires were sated with the plentiful array of food.[37] Kasson documents the decline of the Old English service in the late nineteenth century in favor of the Service à la Russe, in which servants prepared a serving of each course outside of the dining room, then brought them in on individual plates for each guest. The Service à la Russe (which had its mythical origins in the household of the Russian ambassador to France) highlighted the wealth of the host because it required extensive accessories—new plates, silverware, and glasses for each course. It also effectively minimized the presence of food on the table, transforming it from heaping dishes intended to satisfy hunger into a series of discreet, aesthetically arranged plates. In Kasson's interpretation of Victorian culture, the Service à la Russe allowed diners to transform the "'low,' elemental need for food," through manners, "into high art."[38]

While Allen's diagram and the Congoleum table are set in the tradition of the English service, the model tables portrayed in magazine photographs often appear to follow the conventions of the Service à la Russe, or "Russian Service," as Allen referred to it (see figs. 2.10–.13). In keeping with the Russian style of service, the model tables do not usually feature, nor seem to have space for, serving platters. Their perfectly symmetrical arrangements instead imply that a "Head waitress" or even a "second waitress" will be serving each course directly to guests, and that serving dishes from which one might take a second helping will not be easily available.[39] The presence of both the English and the Russian table-setting traditions in the etiquette manuals and popular images of the Depression demonstrates two closely intertwined social ideals. On the one hand, the references to the English service emphasize the generosity of the host and hostess and their ability to provide for all: the full plates of food at Bill and Jean's table seem more than plenty for the two of them, and, positioned on the side of the table closest to the camera, they invite the viewer into the dining room to join the meal. On the other hand, depictions of tables set in the Russian service conjure up a world of effortless wealth, where guests are given a full complement of tools—multiple forks, knives, and glasses—and all can afford to focus on the art of refined dining. As the alternative name "Home Style" indicates (and as the Congoleum advertisement demonstrates), the English service was often associated in the Depression years with serving the family, while the Russian service was usually reserved for guests; housewives were most concerned, one might speculate, with providing food for their families, and were more interested in displaying wealth to friends. Despite these apparently distinct motives, however, the two service styles both partake of a larger Depression-era fantasy of providing.

The seamless decorative schemes within the glossy photographs of tables—their undivided focus on accessories, almost as if divorced from human use (and

hunger)—made them favored tools of retailers in these years. Like the model living rooms discussed in Chapter 1, these model dining tables spun a coherent, self-sufficient narrative that encouraged the viewer to leave aside the demands of her real table and join an imaginary world of wealth. The tables existed not only in the photographs, however, but also in department stores, where salespeople routinely showcased goods on formally set tables. Both the store and photographic model tables were meant to encourage consumption: the ideal customer would not only be impressed by seeing the full array of a specific line of china or stemware, but would also be seduced to buy the other tablewares and decorative accessories on display so that she could recreate the superlative table in her own home.[40] In addition, sales-people used these tables for various public events, ranging from lectures on style to demonstrations of proper table-setting etiquette; many department stores also sponsored table-setting "competitions," in which members of the public as well as professional "home economists" judged the handiwork of various ladies' clubs according to standards of aesthetic taste and "correctness."[41] While housewives, according to such event organizers, eagerly debated appropriate ways to set a for-mal table and evaluated the varied tastes of table settings, their activities must be viewed in the same light as the fantasy tables of the photographs: some consumers purchased items to create a "correct" table at home, while for others the debate served as a compensation for the fact that they could not afford to author such tables themselves.

The glass industry's modernist stemware designs from the years of the Great Depression serve as a potent case study for livable modernism on the formal dinner table. The Repeal of Prohibition in 1933 influenced the fiscal health of the industry and affected its use of modernist design. Not only did manufacturers and retailers attempt to capitalize on the Twenty-first Amendment to boost sales, but they also campaigned for a return to the "refined" appreciation of alcohol, made possible by drinking out of new, varied types of "correct" glasses.[42] Many examples of livable modernist stemware produced both before and after Repeal had untraditional ele-ments, such as square bases in lieu of circular, or faceted stems instead of round. However, the designs of the glasses as a whole tended to fall within established parameters, adhering to a base-stem-cup format that could be reproduced in specialized forms such as water goblets and wine glasses. A closer study of the marketing of three popular designs—one from before Repeal and two after it—demonstrates how livable modernist stemware embodied shifting tensions between informal irreverence and adherence to the rituals of pre-Prohibition, pre-Depression dining traditions.

In 1929, George Sakier designed for Fostoria a water goblet, the outstanding features of which were a ribbed, accordion-like stem and a square-footed base (fig. 2.18). The basic form of the goblet followed convention, but the ribbed stem and

square base were unconventional variations on the theme. Both details were visual metaphors for their origins in machine manufacture: the ribbed stem recalled the bellows on a massive machine and the thick, compact base evoked a metal nut, while the crisp, regular angles on both elements bespoke the rigidity of mass production. Over the next few years, Sakier and Fostoria's in-house designers developed several different versions of the original glass.[43] Not only did they design additional forms and sizes—such as tall sherbet bowls which showed off the accordion ribbing—but they also introduced assorted colors for the stems and a wide range of engraved and enameled patterns for the bowls. Some of these alterations—for example, an attenuated, leafy pattern entitled "Fern" coupled with a clear glass base, or the ornate, baroque engraving "Queen Anne," paired with a translucent amber base—cast the glasses in a distinctly backward-looking, traditional light (figs. 2.19, 2.20). Other versions, however, confirmed the glasses as bold expressions of an avant-garde sensibility. An opaque ebony stem, when contrasted against the clear glass of the bowl, echoed the stark black-and-white forms of modernist graphic designs. The concentric black enameled rings of the "Club" pattern extended the strong graphic sensibility of the ebony stems through the clear crystal bowl (see fig. 2.18); and the swirling lines of the "Comet" pattern referenced the futuristic frontier of outer space with a dynamic design that almost seemed to lift the glass off the table (fig. 2.21).[44] To one critic, the play of black and clear glass exemplified the pace of modern living, as he wrote in 1930:

"Smart people"...contend that nothing in the way of table service can be more modern in spirit than a dinner table set with glossy black plates...[and] black-footed tumblers, goblets and sherbets of clearest crystal decorated with fine black lines. "There you have it!" they exclaim proudly. "There is a festive board that expresses modern life itself, its startling contrasts, its subtle harmonies; or, if you prefer a simpler analogy, expresses noonday and midnight!"[45]

With each additional pattern and color option, Fostoria was better able to capture disparate pockets of the market, appealing to both conservative and avant-garde tastes.[46] Priced squarely in the middle of the market, the stemware was affordable to middle-class consumers, but still expensive enough to represent a substantial investment.[47] In addition to its varied personalities, Sakier's basic design seems to have attracted consumers for its clever balance between formality and informality. It evoked the elegant dinner tables of the past with its stemmed form and specialized shapes and sizes. Yet it also embodied a bold sensibility with its multiple colors and almost kinetic, accordion-like design, which gave the glasses the appearance of being poised to hop off the table if dinner became too dull. The editors for *Advertising Arts* summarized the allure of Sakier's designs in January 1933: "casual sophistication lends to the gay tumblers a semi-formal air, not too formal for luncheon, not too informal for dinner. Here, in crystalline form, is caught the airy informality of

2.18

2.19

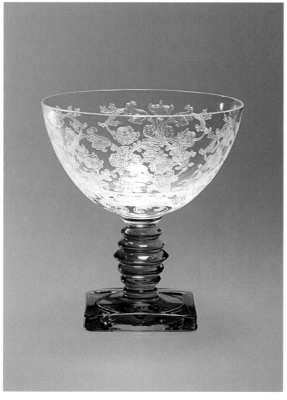

2.20

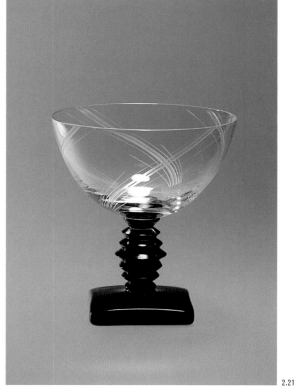

2.21

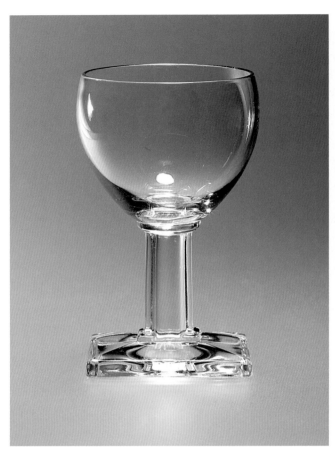

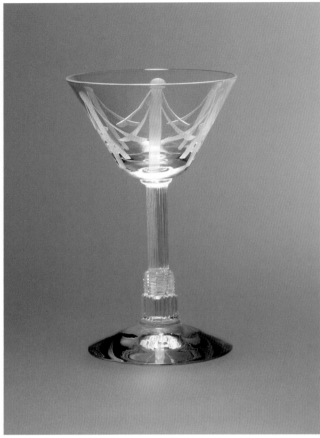

2.22 2.23

those 1929 days when this glass was designed. The days when furniture and cars were low slung, when pomposity was anathema."[48]

The success of Sakier's mass-produced, "simpler, friendlier" modernism inspired other major American glass producers to introduce modernist designs in the 1930s.[49] Yet few of those produced for the mid-market audience possessed the dynamic, playful sensibility of the Fostoria stemware. Instead, as exemplified in products from the Heisey and the Libbey Glass Companies, these designs frequently had an air of greater restraint and tended to be marketed as accessories for the refined life of post-Repeal society.[50] The Heisey Glass Company introduced its New Era line in early 1934, just months after the Twenty-first Amendment had been ratified. The name "New Era" (the line had originally been christened "Modern," but was changed by the company after a few months[51]) referred to the New Deal and the hopeful future of the country, as well as to the enlightened new era of entertaining with legal liquor (fig. 2.22).[52] The New Era glass borrows the angular base of the

2.22
NEW ERA COCKTAIL GLASS, 1934
attributed to **Rodney C. Irwin,**
Heisey Glass Company, Newark, Ohio,
manufacturer. Glass, 4 1/2 x 2 1/2 in.
(11.4 x 6.4 cm).
Yale University Art Gallery. Purchased with
a gift from Davenport Wheeler (2003.95.3)

2.23
COCKTAIL GLASS, MALMAISON PATTERN
(STEM NO. K13), 1933
A. Douglas Nash, *designer*
Libbey Glass Company, Toledo, Ohio,
manufacturer. Glass, 5 x 3 in. (12.7 x 7.6 cm).
Yale University Art Gallery (2004.8.1)

Fostoria glasses, but exudes a classicizing, architectonic sensibility. The base is rectangular and rises with modestly angled planes to the stem; the stem evokes classical columns with its stepped shaft, pedestal below, and rounded capital above. Heisey produced the line with an expanded assortment of glasses to complement every kind of alcohol, including wine, pilsner, cocktail, cordial, champagne, and others. Model tables set with New Era stemware were repeatedly praised in trade journals (from which salespeople often took their cues for marketing vocabulary) for their "tasteful simplicity," even when they included two or three glasses per setting. The description imbued the design with an air of sophistication and also made its infinitely specialized forms seem an appropriate tool for the return to a "period of dignified drinking."[53]

Libbey Glass Manufacturing Company introduced its own variations on squared stemware in 1933, designed by in-house art director A. Douglas Nash. For its mid-level line of "staple" products, Libbey offered a design (the K-13) with a circular foot and a squared stem incised with alternating vertical and horizontal lines (fig. 2.23).[54] The design recalled the silhouette of a stepped-back skyscraper, as an industry journal noted in 1934: "The stem is definitely modern, having the tall, square structure typical of our present-day architectural spirit."[55] This slender stem was paired with thin-walled conical bowls for cocktail, wine, and other glasses, which were engraved in various patterns. The "Malmaison" pattern of abstracted, neoclassical swags was among the most popular, bringing together period ornament with modernist form in a particularly explicit example of livable modernism's negotiations with tradition.[56] Libbey promoted the K-13 stemware and other items in its staple line as the Repeal amendment was ratified, proclaiming that "The return of wine has kindled that already eager interest in the refinements and delights of gracious dining," which the "eloquent correctness" of their "gay modern designs" would satisfy.[57]

Behind this idea of "gentle drinking and dining" was the assumption that citizens of a post-Repeal society would be driven no longer by deprivation and would be freed from the "vulgar habits of drinking and...low standard of what constitutes polite entertaining" that had characterized "the Great War, Prohibition, and the Depression."[58] Indeed, Heisey's and Libbey's modernist glasses seemed to echo the theme of a "revival of the art of dining" in their very forms: the New Era design possessed the symmetry and solidity of a Doric column, while the K-13 evoked the feminine gracefulness of the Ionic order.[59] When viewed in contrast to both of these lines, Sakier's vibrant, attention-getting designs for Fostoria appeared not only nonconformist, but perhaps also tinged with an air of desperation; their comparative informality revealed a "vulgar" side of dining in which hunger and the search for satiation were not fully cloaked behind traditional manners. And, in fact, most versions of Sakier's 1929 stemware were discontinued by 1934, indicating their poor performance in a Repeal market. (Fostoria launched a new Sakier design, number

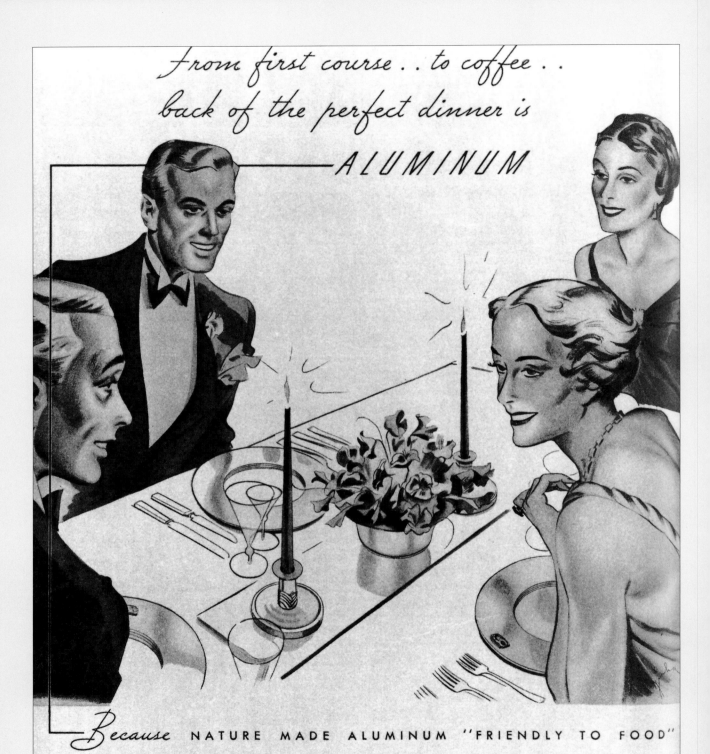

from first course .. to coffee ..
back of the perfect dinner is
ALUMINUM

ℬecause NATURE MADE ALUMINUM "FRIENDLY TO FOOD"

Nature gave to Aluminum unique qualities that make it ideal for cooking foods. Aluminum safeguards food flavors, colors and *purity*, . . and helps to make each course of your dinner delicious and wholesome. It actually protects Vitamin C in foods. Scientists use it to keep distilled water

pure. That is why *Aluminum,* for instance, brings out the true deliciousness of coffee, crowning glory of your perfect dinner. For over thirty-five years the name "Wear-Ever" has been a *guarantee* of highest quality in cooking utensils. Look for that name on the utensils you buy.

"Wear-Ever"
ALUMINUM
COOKING UTENSILS
MADE AT NEW KENSINGTON, PENNA.

6011, in clear glass in the spring of 1934, featuring a slender, fluted, neoclassical stem; the company also offered to consumers at this time a pamphlet entitled "Correct Wine and Table Service."[60]) The Fostoria, Heisey, and Libbey glasses demonstrate how, over the course of a few years, livable modernism negotiated innovation and tradition to different ends. Sakier's accordion-stem design emphasized informality and originality within the tradition of the formal table. At a point a few years later, when popular sources emphasized that standards of dining and entertaining had not been irreparably compromised by the Depression, livable modernism provided the tools for elegant dining—for setting a formal table in the Russian service, with "the water goblet at the point of the knife and any other beverage glass placed diagonally just below it"[61]—through which hosts and guests could enact their rightful place in a tradition of middle-class dining.

The aluminum tablewares designed by Lurelle Guild and manufactured by Kensington Incorporated (a subsidiary of the Aluminum Company of America) in the middle years of the decade provide a final case study of the strategies by which livable modernism integrated innovation with a respect for formal ritual on the dining tables of the Depression. Aluminum had gained popularity in the United States during the first decades of the twentieth century as the exemplification of technological modernity: it was lightweight and tensile, and it conducted heat well. The metal was first used for cooking implements, such as Alcoa's "Wear-Ever" line, and for building construction, such as the curtain wall on New York City's Empire State Building.[62] In the 1930s, designers such as Russel Wright (see p. 89) began to experiment with decorative accessories made out of aluminum; to ensure a competitive presence in this new market, in 1934 Alcoa introduced "Kensington Metal," an aluminum alloy that could be finished in a matte, light gray surface. As an advertisement from 1936 makes clear, Alcoa hoped that aluminum would become the material infrastructure for both preparing and serving foods (fig. 2.24). The advertisement announces that aluminum is "ideal for cooking foods…[it] safeguards food flavors, color and purity," while the illustration shows a dinner table set with Kensington plates and candlesticks, proving that "From first course…to coffee…back of the perfect dinner is Aluminum." Yet even as the text explicitly touts aluminum as a symbol of efficiency in the modern era, the illustration provides a different set of associations. The elegant foursome gathered at the table are clearly expecting a formal dinner, their multiple knives, forks, and wine glasses representing the belabored ritual of the Russian table service. The lack of serving dishes on the table indicates the presence of a servant who will bring in the food from the kitchen, and the diners' convivial demeanor suggests they are in no particular hurry to eat their meal. From the illustration, the potential consumer might glean that aluminum, despite its modernity, has the material value and symbolic weight to carry traditions of wealthy dining into today's homes.

2.24
ADVERTISEMENT FOR WEAR-EVER ALUMINUM
In *Ladies' Home Journal* (March 1936), 118

The executives at Alcoa who oversaw the Kensington brand intended that its designs be innovative and affordable in the mid-level tablewares market. Despite the potential of this durable, cheap material to transform the protocols of dining, however, countless advertisements, internal memos, and letters demonstrate that Kensington Incorporated intended to position its products as an affordable means to maintain the formality and hierarchies of tradition. The quartet in the advertisement, dressed in formal evening wear, fostered an aura of elitism around Kensington's products, as did the Kensington name itself, which elicited associations to the establishment grandeur of Britain's royalty. Typical Kensington advertising copy from *American Home* reinforced this constellation of references: "Kensington for Elegance without Extravagance. Luxurious beauty is superseding frivolous glitter. Kensington's beauty is rich, substantial, aristocratic."[63] Similarly, Kensington encouraged comparisons between its aluminum alloy and sterling silver by describing its logo as the Kensington "hall-mark," which, stamped on each item, was meant to serve as "the guarantee of its maker," just as hallmarks functioned on pieces of silver.[64]

The Kensington line differs from others discussed in this chapter because the company never explicitly described the style of its products as "modern." Guild's designs do have an unmistakable modernist sensibility: without exception, the Kensington objects feature smooth, uninterrupted surfaces, uncomplicated geometries, and stylized, abstracted decorative motifs. However, they also embody the

2.25
KENSINGTON TABLEWARES, 1934
Lurelle Guild, *designer*
Aluminum Company of America,
Kensington Incorporated Division,
New Kensington, Penn., manufacturer.
Syracuse University Library,
Department of Special Collections

LIVABLE MODERNISM

contradictions that accompany the marketing of aluminum as an alternative to sterling silver. The most popular item when the line was first introduced was a series of dinner plates, each adorned with a single cast brass plaque of a zodiac symbol (fig. 2.25).[65] These plates embodied modernist simplicity with their plain, concentric circles and called attention to their industrial production with their cool, lightweight forms. This modernism was, nevertheless, married to a conventional china form— a round plate with a large border on which is located the decorative ornament— and was reproduced in various sizes to provide a full set of coordinated accessories for formal dining.

And, just as the Zodiac plates are modernist in their extreme simplicity yet traditional in their round form, so do many other Guild designs appear modern through one set of lenses and conventional through another. The Vanity Fair candlesticks, illustrated in the Wear-Ever advertisement, are composed of industrial tubes of aluminum and brass ornaments with an angular, modernist flair. Yet they also evoke the forms of classical architecture, and Kensington proclaimed that the ornament was made of "exquisite...old brass."[66] The Northumberland canapé platter, for serving hors d'oeuvres, is an austere, only slightly concave circular form (fig. 2.26).

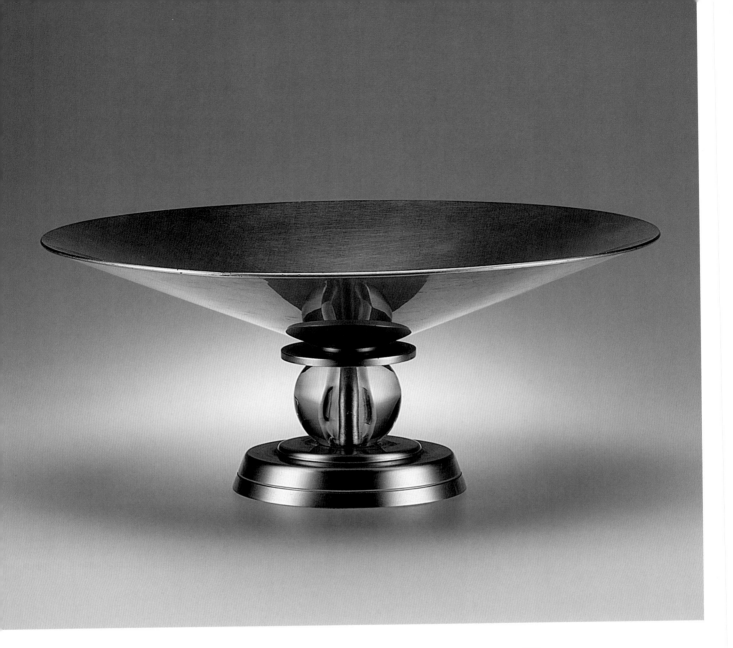

Its name, however, evokes the aristocrats of old England, and the engraved stag in the center of the platter is a reminder that Kensington Aluminum, like fine silver, can be engraved with personal coats of arms.[67] Even the perfect, broad cone of the Stratford compote (again a name resonant with anglophilic history) seems to celebrate the geometric precision possible with industrial manufacturing, yet is balanced by a clear glass sphere that was advertised as crystal, a material that connoted

2.27

STRATFORD COMPOTE, 1934

Lurelle Guild, *designer*

Kensington Incorporated, manufacturer. Aluminum and glass, 5 1/2 x 13 3/4 in. (14 x 34.9 cm). Metropolitan Museum of Art, New York. John C. Waddell Collection, Gift of John C. Waddell, 2000 (2000.600.9)

LIVABLE MODERNISM

wealth (fig. 2.27).[68] Each of these designs provides an (affordable) infrastructure to host an elaborate meal, one where all guests have the luxury to focus on ritual rather than food.[69]

Finally, these examples of livable modernist designs for the formal dining table—both in glass stemware and in Guild's work for Kensington—demonstrate an interest in replacing something familiar with the unfamiliar. The stemware designs substituted squares where circles often reside, and Guild rendered in aluminum forms that are usually made of ceramic or silver. This displacement of the familiar has a distinctly uncanny effect on the user and might have resonated with Depression-era consumers in two interconnected ways. On the one hand, the square form or aluminum plate becomes a witty diversion from the normal, a pun on the expected form. Such a replacement could have represented a welcome change for consumers, a variation within the oppressive, unending days of the Depression. On the other hand, the square stem or aluminum dinner plate is a disconcerting replacement of the familiar. These substitutions are almost, but not quite, what guests expect to see and touch when they sit down at the table. From this perspective, the squared glasses and aluminum wares are an expression of unease, a symbol of the disruption that occurs when a familiar form—such as the prosperous society of previous decades— is not replicated as expected. These livable modernist designs externalized the social disruptions caused by the Great Depression, transforming psychological unease into pleasantly diverting new forms. Furthermore, they offered testimony to the persistence of tradition. Although it looked different, this livable modernism could still be deployed in support of the hierarchical formalism of the dining tables of old, and thus provided the semblance of social coherence at a time of great disruption.

The Buffet Party: Modern Entertainment

The most prominent innovation in dining parties during the Great Depression was the buffet dinner. At a buffet dinner (or buffet luncheon), a hostess arranged all of the food for the meal on a variety of serving dishes, and presented them on a table. She provided plates, cutlery, and glasses for her guests, but instead of seating them each at a place at the table, she invited them to pick up the utensils they needed, serve themselves, and sit or stand and mingle as they pleased. This new style of party resolved many of the limitations to the art of hospitality imposed by the Depression. For those whose dining room and dining table were too small (or non-existent) to host a large dinner party, the buffet was an appealing alternative: one's table need only be large enough to present the food—in the tradition of the English service—and guests, far from being inconvenienced, would expect to look for seating in other rooms, such as on the sofa and armchairs of the living room. The buffet party was, in addition, convenient for the many hostesses who could not hire servants, as guests filled their own plates.

The buffet party eased many of the awkward social requirements of formal dining. Not only did it free the hostess from the challenge of timing each course of the meal, but it also saved guests the embarrassment of not liking a particular dish: they could survey the plentiful options and satisfy their hunger as they desired. They could even return for second and third helpings, thanks to various appliances and accessories that kept food hot or cold. Moreover, the buffet dinner absolved the hostess of the difficult task of arranging her guests according to personality and importance around a single table and liberated them to speak with whom they wished. An editorial from a trade newspaper in 1933 attempted to offer some explanation for the ever-growing popularity of the form: "The modern housewife, hampered by her little apartment, or perhaps a small suburban home, finds that the buffet solves a great problem. She can invite more people to casual gatherings and the whole mood of the occasion is informal and gay."[70]

The buffet party provided an ideal forum for designers and manufacturers of tablewares in the livable modernist mode. First, they could argue that because the buffet party was a new mode of dining, unique to the modern day, its accessories would be best outfitted in a modernist style. Guild arranged a model buffet table for *Better Homes and Gardens* in 1935 which featured several of his chromed buffet designs for Chase Brass and Copper Company. The magazine editors celebrated the appropriateness of his "modern chromium pieces" for the buffet party by exclaiming that his "buffet service, in its appointments, is as modern as Today!"[71] Similarly, *House and Garden* featured in 1935 a "modern-minded, style-conscious" spun aluminum buffet serving dish designed by Russel Wright. The editors noted that Wright's "concoctions [are] so popular wherever dining is informal, modern and fun," reinforcing an association between the modernist aesthetic of his designs and the new attitude toward entertaining embodied in the buffet party.[72] Second, the buffet party appealed to livable modernist designers because it seemed to be predicated on certain principles of efficiency and functionality, ideas which these practitioners self-consciously supported. The buffet party claimed to be efficient by obviating the need for the multiple, cumbersome accessories of an individual place setting. It called for specialized, functional serving dishes that could keep main courses warm, keep drinks cool, and in general display large quantities of food. In performing these functions, the dishes enhanced the overall efficiency of the party: the hostess was not forced to spend her entire evening replenishing the table, and the late guest, or the extra-hungry guest, or the guest who decided to eat his entrée last (and most of the uncouth guests at buffet parties in how-to articles and popular literature seemed to be male[73]) could all be accommodated. The social order of the buffet party was itself a model of efficiency, as guests were liberated from the hierarchy of the table and could travel the crowd with the minimum necessary eating implements. In designing to meet the explicit functional requirements of buffet accessories—for both serving

and consuming—livable modernists were thus given the opportunity to exercise their commitment to utilitarian adaptability.

Beginning in 1932, the Chase Brass and Copper Company employed a coterie of designers, including Guild and Walter von Nessen, to develop a group of innovative, chrome-plated buffet accessories. A 1934 advertisement showcased the extent of its buffet line after only two years (fig. 2.28): it depicts a lively party where ample food and drink are served on a variety of recognizable Chase objects, including an electric food warmer, individual canapé plates, a wine cooler, cocktail shaker and glasses, and the Diplomat Coffee Service (see fig. 1.28). Chase occasionally boasted that the allure of its products, and consumers' desire to show them off to guests, had actually created the fad for buffet entertaining: the text accompanying the 1934 advertisement proclaimed, "Ever since clever hostesses discovered Chase chromium articles that were designed especially for buffet suppers, smart informal entertaining has been the vogue."[74] This assertion points to the role of the manufacturer in the symbiosis between social need and product. Without the desire to serve food casually and let guests mingle, there would be little need at all for specialized servers that kept food warm. Yet the electrical food warmers made the party possible—even, perhaps, mandated its existence. One critic wrote of the role such new designs played in shaping social habits and mores, announcing that "the modern designer has been ingenious in inventing new ways of doing things which suit our present sixty-mile-an-hour, no-time-but-much-to-see, type of living. A whole coterie of new manners is being launched—through things."[75] Mary Wright, Russel's wife and the marketing strategist behind his success, also claimed that her husband's buffet accessories had influenced social practice in a 1934 catalogue of informal serving accessories: "With his 'Informal Serving Accessories,' Mr. Wright is directly responsible for bringing this type of informal service [i.e., buffet service] into its present vogue. Mr. Wright's work here is significant, largely since it marks the beginning of a new American etiquette—a new manner of serving and entertaining that is rapidly finding acceptance."[76] The types of social interactions that these buffet wares prompted, as well as the picture of plenty that they created when arranged on a table, echo the dual preoccupations with bountiful food and respectable etiquette that surrounded the formal dinner table. The ideal of the buffet party itself reveals additional insight on the Depression-era fantasies of providing.

The centerpiece of Chase's line of buffet accessories was the large Electric Buffet Server, designed by Guild and retailed at a price more appropriate for major household appliances, $40 (fig. 2.29).[77] It consisted of four porcelain containers for serving food, set into a large chrome-plated copper body; a reservoir around the containers was heated electrically to keep the food warm. Guild gave this behemoth an austere, architectonic form: its canted corners featured vertical incised lines, giving the impression that the body was supported by four fluted classical columns; the

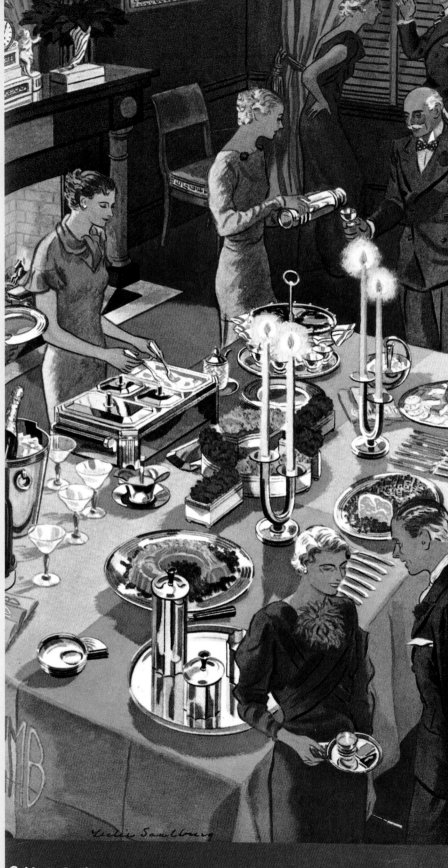

CHASE BRASS & COPPER CO.
— INCORPORATED —

2.28
ADVERTISEMENT FOR
CHASE BRASS &
COPPER COMPANY
In *House Beautiful*
(May 1934), 123

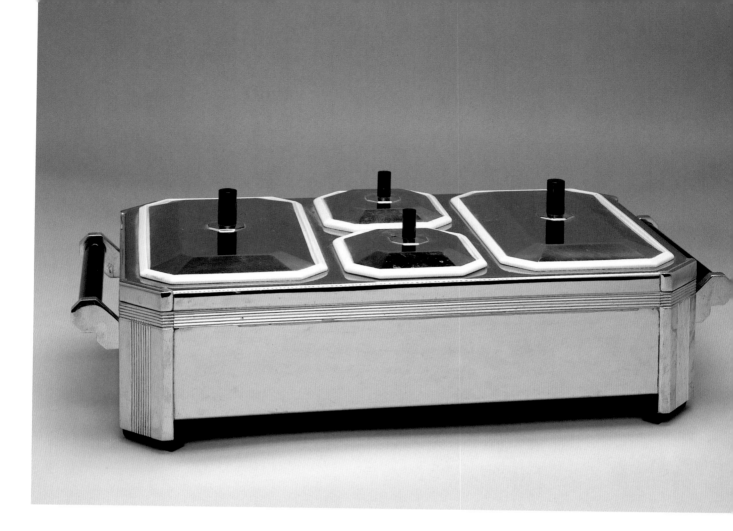

angled covers for the porcelain containers created a varied roofline for the top of the structure. The sharp contrast between the "brilliant chromium" of the body and "lustrous black" handles imbued the object with both a modern, dramatic allure and, conversely, an aura of establishment wealth, recalling the ebonized black handles of many eighteenth- and nineteenth-century sterling silver vessels.[78] Indeed, the Buffet Server, with its sophisticated detailing and technological innovations, embodied the very qualities found in the appliances of the newly glamorized interwar kitchen. Similar to Norman Bel Geddes's 1933 stove for Standard Gas Company (see fig. I.7), Guild's Buffet Server possessed a streamlined body in which all complicated machinery was enclosed within a seamless exterior, ornamented primarily by the careful placement of handles and finials. In the form of Chase's Buffet Server, modern efficiency stepped forth from the functional zone of the kitchen into the social zone of the dining room, expanding the vision of a domestic sphere ordered by tech-

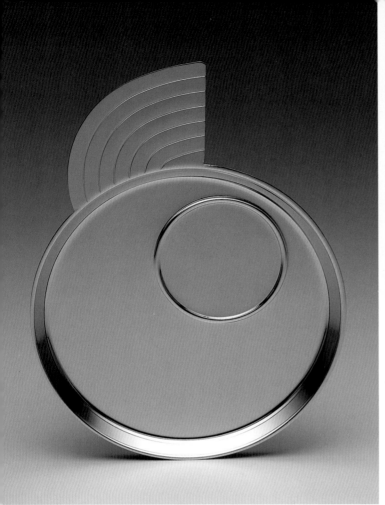

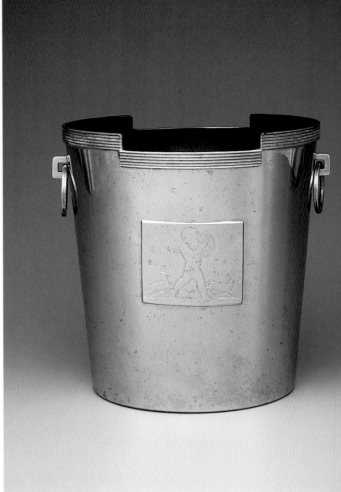

nology. As modern kitchens could systematize the messy work of food preparation, now the modern buffet server could organize the disrupted lives of Depression-era hostesses and guests by anchoring harmonious parties with well-fed guests.

 Guild's canapé plate for Chase provided essential infrastructure for the buffet party (fig. 2.30). His design, at first glance, appears to be a work of abstract art, a one-winged dynamo with a single large eye that has alighted only briefly on this planet through the channels of the artist's imagination. However, each element of the plate is a particular design feature intended to fulfill a specific function. As the designer recognized, guests often wanted to hold both a canapé and a drink (and perhaps a cigarette) as they stood chatting at a party, leading inevitably to an awkward balancing act. His plate solved this problem with its asymmetrically placed raised disc in which one could anchor a cocktail glass. Guild also added a winglike handle to facilitate holding the plate, resulting in functional apparatus that streamlined the social

2.30
CANAPE PLATE, 1933
Lurelle Guild, *designer*
Chase Brass & Copper Company, manufacturer. Chrome-plated copper, 1/2 x 8 1/4 in. (1.2 x 21 cm). Yale University Art Gallery. Gift of Mr. and Mrs. Edgard I. Moreno, B.A. 1979 (1986.72.1)

2.31
WINE COOLER, 1934
Lurelle Guild and Rockwell Kent, *designers*
Chase Brass & Copper Company, manufacturer. Chrome-plated copper, 9 3/16 x 9 in. (23.3 x 22.9 cm). Yale University Art Gallery. Gift of Mr. and Mrs. Richard Stiner, B.A. 1945W (1995.22.1)

act of standing, eating, and drinking. "With this smart looking canapé plate," the Chase catalogue instructed in 1935, "you can hold a cocktail, a canapé and a cigarette in one hand and shake hands with the other."[79]

In addition to the various tools for eating at a buffet party, Chase offered implements for drinking. Central to the line of drink accessories was a large wine cooler, which would keep an open bottle of wine or champagne chilled over the course of a party, readily available to guests who wanted to serve themselves (fig. 2.31). Guild designed the form of the cooler, while the painter and illustrator Rockwell Kent designed the figurative relief panel. Together, their designs infused the drinking of wine with the dignity of classical tradition, in keeping with post-Repeal rhetoric of a return to the "art" of dining: the cooler's form, with its pair of ring handles, recalled classical Greek urns, while Kent's panel depicted Bacchus, "homeward bound with wine grapes, symboliz[ing] the spirit of wine."[80] In contrast, accessories for cocktails—which had been popularized during the years of rebellion against Prohibition—were more aggressively modern. Howard Reichenbach's cylindrical "Gaiety" cocktail shaker with rings of enamel (available in black, red, or green) evoked the towering monolith of modern skyscrapers in its silhouette (fig. 2.32). A popular cocktail cup, frequently pictured with the shaker or nestled on Guild's canapé plate, married the pure geometry of the hemispherical cup with a squat, rounded foot. Its form was an explicit revision of a stemmed cocktail glass: the lightweight, industrial body, which looked as if it could roll away if tipped on its side, embodied a less precious, more dynamic style of social interaction.

Russel Wright's spun aluminum serving wares from the early 1930s—both the "Stove to Table" and "Informal Serving Accessories" groups—were another popular contribution to the tools of the Depression-era buffet party. Wright's own pieces are informed by a markedly different aesthetic sensibility than the Chase wares. While the Chase objects as a group (including Wright's designs for the company) are defined by their gleaming chromium surface and the aggressive contrast of black and colored detailing, Wright's own buffet wares are dominated by spherical shapes, gentle arcs, and the more nuanced, textured contrast between the brushed aluminum bodies and the light-brown detailing of cork, rattan, or wood. Thus, whereas the Chase buffet line created a dynamic, incessantly rhythmic aesthetic, Wright's line—for all the crystalline perfection of its spheres and cylinders—possessed an earthy, tactile aura and a platonic sense of balance. In spite of these differences, however, the two groups of objects were motivated by a similar commitment to functionalist efficiency.

Wright's aluminum serving pieces persistently emphasize their practicality and their ability to serve particular needs. For example, a spherical punchbowl embodies dual functions (fig. 2.33): the punch can be conveniently ladled into small cups which sit on a rim encircling the bowl like one of Saturn's rings; the hostess can then lift

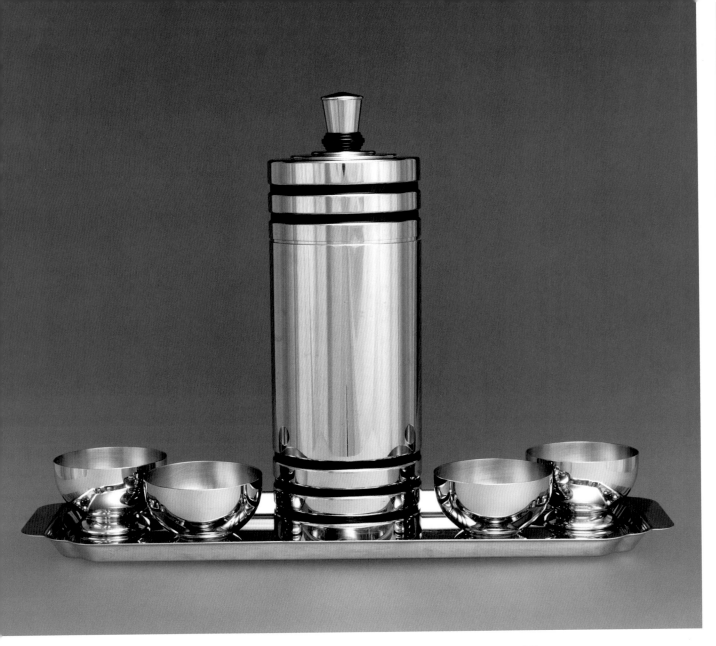

2.32

Howard Reichenbach, *designer*
Chase Brass & Copper Company, manufacturer. Chrome-plated copper and enamel, 12 x 16 x 5 3/8 in. (30.5 x 40.6 x 13.7 cm). Yale University Art Gallery. Gift of Paula B. Freedman in honor of Judith and Aaron S. Freedman and Annabelle and Robert Schackne (2003.48.1.1-.6)

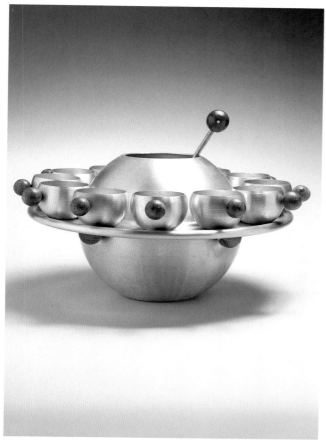

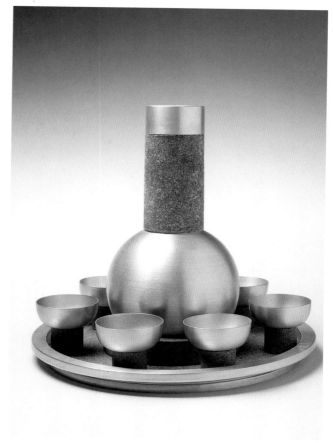

2.33

2.34

2.33
PUNCH BOWL WITH LADLE
(WITHOUT LID), c. 1932
Russel Wright, *designer*
Spun aluminum and maple,
12 x 19 in. (30.5 x 48.3 cm).
Collection of Dennis Mykytyn

2.34
COCKTAIL SET, c. 1932
Russel Wright, designer
Spun aluminum and cork,
13 1/2 x 17 in. (34.3 x 43.2 cm).
Collection of Dennis Mykytyn

the entire ring, with the cups full of punch on it, off the bowl, "thus forming a tray upon which the cups can be passed around."[81] (Lest a customer be intimidated by the size of some of Wright's contraptions, his publicity statements assured that with "aluminum, a durable but featherweight material, even the frailest hostess finds no difficulty in handling the larger pieces."[82]) Even a set of cocktail glasses with a shaker on a round tray—similar in basic form to the Chase shaker and glasses—acquired additional practical features through Wright's designs (fig. 2.34). The cork feet of the cocktail glasses provided stability and grip to the otherwise top-heavy vessels, as well as a readymade coaster for sweating iced drinks, while the cork-covered neck of the shaker doubled as an insulated handle with which to grasp and pour those chilled cocktails.

On a buffet table choreographed by Wright, the assortment of accessories was designed to give the display of food the effect of bounteous supply. The relish rosette, which looks like a target when not in use, is composed of a series

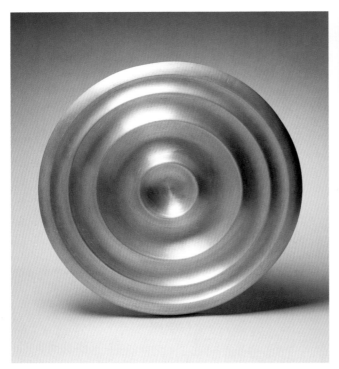

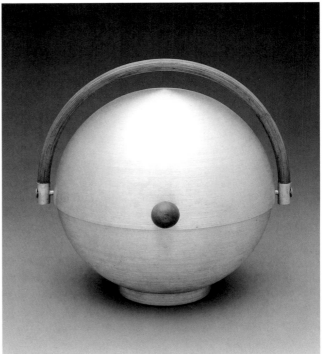

2.35 2.36

of concentric grooves in which devilled eggs, olives, or other hors d'oeuvres can be nestled (fig. 2.35). Lying on a table with each groove filled, the rosette seems to be a center of energy from which endless rings of food might be generated. In a spherical bun-warmer, the lid slid open to reveal an interior filled with buns "brought in piping hot from the kitchen at the last moment" (fig. 2.36).[83] The two tiers of the "tid-bit trays" provide double the space for the presentation of canapés (fig. 2.37). Both the bun-warmer and the trays sit readily enough on a buffet table, but as their wooden and rattan handles make clear, Wright also designed them to be portable: both serving items can easily transport food from the kitchen to the buffet table, and then, when gracefully carried around a crowded room by a dutiful hostess, deliver that food directly to guests.

Although Depression-era modernists such as Guild and Wright designed buffet accessories with an almost excessive attention to functionality, and despite their interest in efficient modes of living liberated from tradition, several aspects of these buffet wares indicate a lingering connection to past standards of entertaining. Many objects, for example, allude to historical forms and materials. Chase items, such as the buffet server or wine cooler, repeatedly echo classical forms, thus grafting their newness onto the established respect for history and tradition. Similarly, Wright explicitly linked his serving accessories to a colonial American tradition of

2.35
RELISH ROSETTE, c. 1932
Russel Wright, *designer*
Spun aluminum, 1 1/4 x 18 1/2 in (3.2 x 47 cm).
Collection of Mazal and Robert Schonfeld

2.36
BUN WARMER, c. 1932
Russel Wright, *designer*
Spun aluminum, maple,
and bamboo, 9 x 9 in. (22.9 x 22.9 cm).
Milwaukee Art Museum, Gift of Daniel
Morris and Denis Gallion, M1992.190

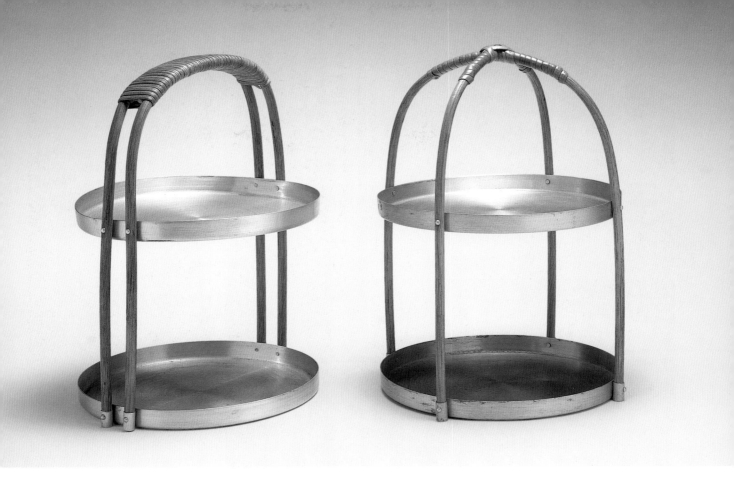

2.37
TIDBIT TRAYS. c. 1932
Russel Wright, *designer*
Spun aluminum, rattan, and maple,
each 12 1/2 x 8 1/2 in. (31.8 x 21.6 cm).
Collection of Mazal and
Robert Schonfeld

handcrafted, practical wares. He emphasized, for example, that the "wood and cane" used in the detailing were "centuries old" materials.[84] He also capitalized on the limited resources he had for production—the original group of objects were made in his own studio—by proclaiming his work a modern-day variation on the colonial craftsman's shop: as his first wholesaler, Mary Ryan, announced, "*Russel Wright is a modern Paul Revere.*"[85]

In addition to these references through form and material, the buffet accessories themselves fostered a level of polite manners that were distinctly based on past forms of etiquette. Guild's winged canapé plate, for example, is convenient to use when standing and talking, and is clearly not intended to be balanced on one's lap, should one choose to sit while talking. The design of the plate encourages an active, extroverted sociability on the part of buffet guests, and discourages a more retired social affect. Wright's "tid-bit" trays have handles that, while certainly convenient, also foster the expectation that the tidbits will be carried around the room to guests, rather than sitting on a table for the guests to find. Similarly, the Saturn-like punch bowl presumes that guests will not fill their own glasses or even

walk themselves to the buffet table: rather, the hostess will carry the punch to them. The trays and the punch bowl both create a task that the hostess is expected to complete. In so doing, they establish a standard of engaged hospitality that not only contradicts the alleged ease of hosting such an informal event, but at times also transforms the hostess into a servant.

As the objects prescribed ideal behaviors for both guests and hostesses, so too a series of etiquette manuals and articles contributed to the codification of buffet party conventions. The buffet party, intended to provide a more casual mode of entertaining, instead became enveloped, through accessories and written paraphernalia, in an armor of social and physical prescriptions. Emily Post's pamphlet, *How to Give Buffet Suppers,* published in 1933 for Chase and given as a free gift with every

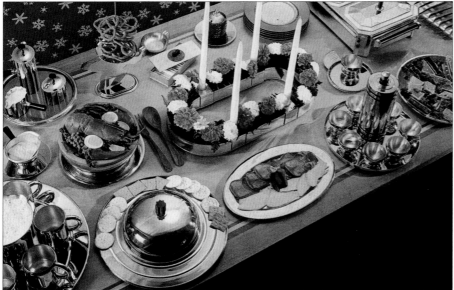

Table arranged and photographed in actual colors by Anton Bruehl

IT'S SMART TO BE INFORMAL *and* CHASE MAKES INFORMALITY SMART

EMILY POST, in her new book on buffet suppers (see coupon at right), says: *"The well-known depression gave us one thing, anyway—the buffet supper. It's new, popular, and easy to do. For Sunday lunches and suppers, after football games—in fact, at any time you want to entertain your friends simply—the buffet meal is inexpensive and easy to prepare. People like to go to an attractive table and choose the food they like best. It makes a party more friendly.*

And for such occasions I think these new Chase chromium products are appropriate and irresistibly attractive."

The picture above shows some of the chromium table articles made by Chase. They were designed by well-known artists for informal entertaining.

For example, notice the Electric Buffet Server in the upper right-hand corner of the picture. It has four deep porcelain casseroles, and the electrically heated water in the chromium base keeps food hot for the late guest.

This Server and other chromium articles shown above will help you in easy entertaining. Their chromium finish saves your time.

It never tarnishes. It never calls for polishing.

You will find Chase Chromium at smart gift shops and department stores.

Electric Buffet Server with four porcelain casseroles . $40.00	
Cocktail shaker	4.00
Cocktail cups—set of four	2.00
Flower and candle centerpiece—10 pieces to arrange in different designs	20.00
Cheese and cracker dish—with cover and wooden plate	10.00
Pretzel man	1.75
Salad bowl with wooden shell, wooden fork and spoon.	6.00
Cocktail and canapé tray (next to buffet server) each	1.00
Cigarette box	2.00
Beer mugs, each	1.00
Beer tray	6.00
Beer pitcher	3.50

(These articles and many others are on sale at better gift and department stores. Prices may be slightly higher West of the Mississippi.)

A NEW BOOK *"How to Give Buffet Suppers,"* by *Emily Post.* Twenty-four pages, illustrated. How to arrange the table. What to serve. Suggested menus and many new receipts for simple and inexpensive foods.

PRICE—10c IN STAMPS

CHASE BRASS & COPPER CO., INC., WATERBURY, CONN.

GENTLEMEN: I enclose 10c in stamps for a copy of "How to Give Buffet Suppers," by Emily Post. Please send it right away.

Name_____

Street_____

City & State_____ HG-10

CHASE BRASS & COPPER CO., INCORPORATED, WATERBURY, CONN.
COPPER WATER TUBING AND BRASS PIPE

2.38
ADVERTISEMENT FOR CHASE BRASS &
COPPER COMPANY
In *House & Garden* (October 1933), 89

Super

Supper

by MRS. RUSSEL WRIGHT

RULES of etiquette are changing. Not so long ago entertaining was either stripped down to picnic level or swathed in all the trappings of ceremony. Today, many of the most distinguished parties span the two extremes and owe their success to the kind of special table appointments that make it possible to carry off a formal after-the-theatre supper party in a delightfully spontaneous way.

Russel Wright, who has brought aluminum out of the kitchen, is responsible in a large measure for this agreeable change in entertaining, for his "stove-to-table" ware was created to meet the demands of the manner in which we are now living. His things have the additional advantage of enabling a hostess to serve the supper single handed.

What's more, many are designed on the ensemble basis; they not only match each other, but can be combined and interchanged to make all sorts of fascinating new sets. Many of them may be used for a variety of purposes. Scores of uses and combinations will occur to an enterprising hostess. They are modern not only in design and convenience, but also in that aluminum is a lightweight, unbreakable material.

The table illustrated here was planned for an after-theatre party. Oyster stew was prepared in the large punch bowl in the foreground. It is now ready to be served from this same container. The rim is detachable, thus forming a tray upon which the cups can be passed around. Rice, curry sauce and chicken were prepared late in the afternoon in the Bain Marie and left to stay warm (this electric Bain Marie has two heat controls, one for cooking and one for keeping the food hot). A large, inviting salad was prepared in the oval wood salad bowl and left in the ice box until the guests arrived. Relishes and hors d'oeuvres look particularly festive in the relish rosette. Hot buns are served in the bun warmer, brought in piping hot from the kitchen at the last moment. On the large tray is a highball setup. Ice cubes last longer when kept in the insulated thermo dish. For those who prefer it, there is a magnum of champagne in the large champagne cooler.

Both the highball and champagne glasses, of crystal trimmed with alternating bands of liquid platinum and frosted glass, are distinctly in keeping with the service.

There are salad plates to match. The Lenox china, in the terrace pattern, establishes friendly relations with its companion pieces. An eggshell-colored satin damask tablecloth was chosen for its utter simplicity—it lends modern support to the appointments it so smartly upholds. The beautiful sterling silver flatware, modern-classic in design, adds the final touch to an effective table.

Besides being perfect for super suppers, these informal serving accessories are ideal for Sunday morning breakfasts, bridge and cocktail parties, as well as all outdoor affairs. They are also indispensable for impromptu occasions, for even the simplest everyday food takes on a festive air when served in such a lighthearted manner.

These bright utensils, by virtue of good design, may be used for both cooking and serving. The trend in entertaining today is toward a short cut from stove to table, and these pieces accomplish just exactly that.

Editor's Note: The buffet table set by Mrs. Russel Wright for FASHIONS OF THE HOUR may be seen now on the second floor, Wabash.

2.39

"SUPER SUPPER"

By Mrs. Russel [Mary] Wright

In *Fashions of the Hours*, Marshall Field and Co. (Spring 1935), 23

purchase of a Buffet Server, was, along with Russel and Mary Wright's demonstrations and articles about contemporary entertaining, among the most influential guides for consumers and hostesses of the period. Post's advice ranged from such basic information as how to set a proper buffet table—"The two most important items of equipment are placed precisely in the center of each end"—to guidelines about the physical act of eating at a buffet supper and appropriate menus: "Every dish at a buffet without set tables must be chosen to eat easily with a fork held in one hand while holding the plate in the other—the menu of every buffet meal should include spaghetti or scalloped potatoes" (fig. 2.38).[86] Finally, in an apparently unintended ironic twist, she directed her readers to liberate themselves from restrictive formalities by taking advantage of the casual seating arrangements of a buffet party. "If people are not sitting beside those they like," she advised, "women as well as men are free to move elsewhere. An attractive woman can even escape a tiresome talker by going to the table and then joining whomever she chooses."

Russel Wright promoted his buffet accessories in the mid-1930s in part through a series of store displays, frequently choreographed by his wife, Mary.[87] However, rather than emphasizing the improvisation and flexibility supposedly inherent in buffet gatherings, the Wrights' display tables repeatedly illustrated highly specific theme parties: "Beer Buffet," "Swedish Spread," and "Tennis Refreshments."[88] In lectures and articles that accompanied many of these displays, the Wrights offered detailed directions for copying their table and party concepts. For shoppers at Marshall Field's in 1935, Mary Wright proposed that it was "possible to carry off a formal after-the-theatre supper party in a delightfully spontaneous way," and then detailed a day's worth of preparations necessary to make the spontaneity happen (fig. 2.39).[89] Thus, from Post's pamphlet and the Wrights' displays, hostesses and guests of the 1930s received extensive guidelines for how to properly hold and participate in a casual, informal buffet party.

The buffet party challenged some of the gender hierarchies that had accompanied formal dining in previous generations. It publicly emphasized the wife's role as hostess, and hence her authority within the house. While at a formal dining table the man of the house presided, regardless of the preparatory work done by his wife (or servants), at a buffet table the woman's role as author of the dinner and hostess was enhanced as she greeted and, in the case of the uncultured male guests about whom Emily Post warned her readers, directed them to the food ("*Please* go into the dining room and help yourself to what you like").[90] Similarly, guests were no longer confined to their place at the table, and women guests in particular were given license to choose their own dining partners. Even as the buffet party celebrated the wife's authority, however, it also neutralized her labor, transforming it from "work" into "entertaining." Thus she did not pass the tidbit trays as a servant, but rather as a "hostess [who can] serve the supper single-handed."[91]

As the prescriptive buffet accessories and literature indicate, consumers maintained an interest in etiquette and attempted to codify the new, buffet-style hospitality in reference to its patriarchal predecessors. The persistent echoes of traditional forms and manners in the allegedly radical, modern realm of the buffet party reveal consumers' lingering attachment to the past, the mythic place in national memory where prosperity and freedom from want could be guaranteed. By importing elements from a time when gracious hospitality prevailed and guests and hosts alike had the luxury of dwelling on manners rather than hunger, manufacturers attempted to cast the buffet party as a contemporary expression of such extravagant social generosity and well-being. As numerous articles and advertisements reminded readers, the buffet party would enable them to entertain on the grand scale of former times: "Does the very idea of having fifteen or twenty people for dinner send cold shivers up your spine? Then you don't know the ease of a buffet supper, where the more guests you have, the better the party."[92]

Conclusion: Modernism and Tradition at the Table

As the pared-down dining furniture, spare formal tables, and buffet parties of the 1930s indicate, many designers and etiquette experts during the decade sought to simplify the rituals that had previously made dining an elaborate, patriarchal institution of high artifice. Yet in this time of social uncertainty and economic setbacks, the vision of plenty that had been the foundation of those outdated rituals had a strong appeal. The presence of two established nineteenth-century table-setting modes in images of popular culture signify two particular fantasies about this past world without want. The images of English settings, featuring serving dishes of bountiful food, portray a hostess who is able to provide for all the wants of her family and guests. The images of the more elaborate Russian service settings depict a world where hosts and guests are able to focus on manners and not on their hunger as they await the arrival of the food at the table.

In many respects, the perseverance of these traditional modes of dining can be interpreted as a profoundly conservative social trend. For all of the liberation of female guests at Emily Post's buffet party, the hostess alone (not with a liberated husband) was still responsible for cooking and laying out the meal. Moreover, the continual emphasis on the correct way to act and to set one's table bears vestiges of older social orders where every guest—and the host and hostess—knew their place in the hierarchy. Yet these belabored modes of dining clearly meant more to Depression-era consumers than just social retrenchment. The glass industry's Repeal campaign raises the possibility that so-called "refined" dining might have represented freedom for consumers, an escape from the confines of "vulgar" hunger. If homemakers embraced modernist simplicity and efficiency in the dining room for its practicality, they may also have associated any difference from tradition with

inadequacy as a hostess, based on a standard of generosity established in previous generations. Designers in the livable modernist mode provided the means for consumers to maintain traditional forms of entertaining if they wished. The persistence of tradition in Depression-era dining rooms must be seen as complex and, in the end, ambiguous: it represented, in turn, both a lingering social conservatism and a society's desires to be liberated from the limitations of the Depression.

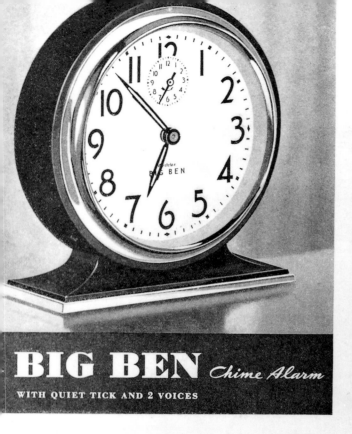

BIG BEN *Chime Alarm*

WITH QUIET TICK AND 2 VOICES

. . Slim, trim, modern. Finished in lustrous black and gleaming
guaranteed for two years by Western Clock Company, La Salle, Ill.

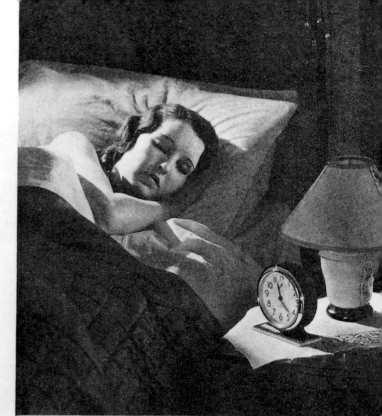

QUIET AS A WATCH: No noisy "tick, tick, tickety tickety tick"
disturb your rest. This new clock keeps quiet—quiet as a watch—all night lo

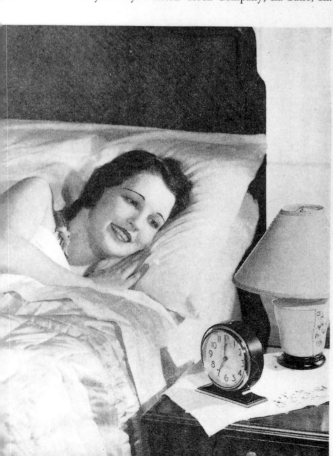

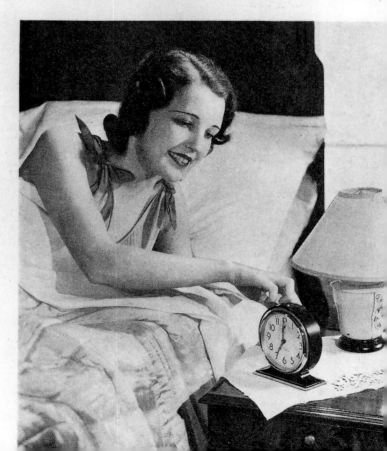

3

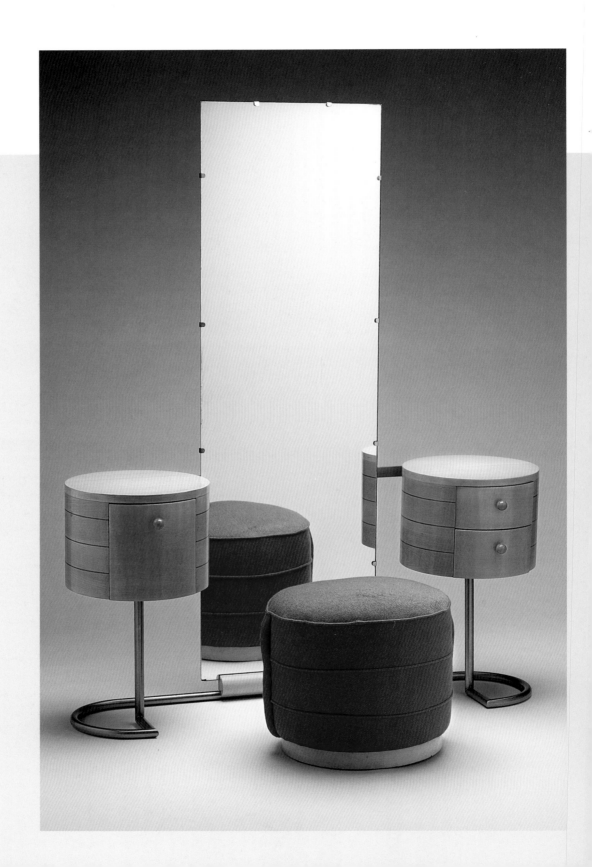

Privacy and Self-Expression in the Bedroom

Gilbert Rohde's vanity table and ottoman, manufactured by Herman Miller from 1933 to 1937, express many of the contradictory principles that informed livable modernist bedroom designs of the 1930s (fig. 3.1). On the one hand, the set contributes to an atmosphere of respite and retreat that many decorators and magazine writers believed the bedroom should possess. There are no harsh angles to bump into on these objects; rather, the continuous curves, clean lines, and cushioned seat offer a welcoming perch for the busy housewife as she pauses to check her appearance before going out into the hubbub of her daily routine, or as she dresses for an evening event. Despite its overall height and width, the set is surprisingly light in appearance, helping to create a sense of openness in the smaller bedrooms of interwar America: the two wooden drawer drums are suspended in midair above a thin tube of chromed steel, and the mirror is held erect not by any visible frame but rather by a system of hidden brackets. With Rohde's vanity set, the bedroom might become an airy, spacious oasis of quiet away from the din of the public world.

In addition, neither the table nor the ottoman possesses elaborate, extraneous ornament that would mask its underlying form. The only ornament on the table, aside from the small spherical drawer pulls, is the chaste series of inlaid lines that ring the circumference of the drums. In its modesty, the table projects

an understated moral code—it is an honest piece with nothing to hide—that could be interpreted as a lesson about how to live one's life.

Yet even as it offers respite and a touch of moralizing simplicity through the soothing cadences of its geometries, Rohde's vanity and ottoman set possesses an undeniable flamboyance. The unusual shape of the vanity recalls both the energy of an enormous pair of industrial pistons, arrested at the top of their cycle, and the understated strength of a flower stem, tensile but thin, proffering up a remarkably large blossom. The large, cushioned ottoman has its own drama as well. It invites its owner to sit low to the ground, just below the rational height of a desk chair at a level suggestive of relaxation or seduction. In their atypical forms, the vanity and ottoman participate in another set of guidelines for the modern bedroom: that it should be a place where one is free to truly express one's individuality, away from the public scrutiny and social conventions that shaped the living room or dining room.

This chapter examines the multiple faces of the Depression-era bedroom and argues that despite its status as a sanctioned zone of retreat and personal expression, popular images of the bedroom nonetheless promoted strict societal conventions such as gender-normative identities. I suggest further that livable modernism, for all of its aspirations to free society from the status quo, actively reinforced those social standards. A vanity table, for example, is the most highly gendered piece of furniture in a bedroom, and Rohde's attention-getting design replicates the attention-getting make-up and dress that are evaluated in its mirror. All of these contradictions—restful and modest yet flamboyant, self-expressive but gender-conforming—indicate the paradoxical status of the twentieth-century bedroom, a room that the public agrees is private.

The Bedroom in the Twentieth-Century Home

As Elizabeth Collins Cromley has demonstrated, by the turn of the twentieth century, middle-class domestic floor plans in the United States usually segregated the rooms of the house into three distinct zones: a public zone (such as the living room and dining room), a service zone (such as the kitchen and pantry), and, separate from both of these, a private zone (comprising bedrooms).[1] This style of floor plan, organized around the concept of privacy, represented a shift from an older floor plan based on the notion of status. In the seventeenth and eighteenth centuries, a bed with elaborate textiles might have been a family's prized possession; it therefore would have been placed in the most important room of the house, where guests were received and wealth was displayed. This pattern persisted in middle-class urban and rural homes throughout much of the nineteenth century, gradually being replaced by floor plans that reflected a new concern with the privacy of the individual and the nuclear family. In the years after the Great War, the bedroom zone, now fully segregated from public and service zones, often included one or more smaller rooms for

children or guests and a larger room, intended to be the "master bedroom," with more closets, windows, and fewer shared interior walls than the others.[2] The bedroom zone was also expanded in these years to include bathrooms: a minimum of one for the entire zone, and in more extravagant plans, one en suite with the master bedroom and others accessible from the junior bedrooms. Architects generally placed the bedroom/bathroom zone on a second floor above the public entertaining spaces, as exemplified in a design for a modest modern home published in *House Beautiful* in 1934 (fig. 3.2). In another common alternative, seen in many houses at the *Century of Progress International Exposition,* architects grouped the bedrooms and bathrooms to one side of the main floor, separated by a hallway from the constellation of public and service rooms (fig. 3.3).

En suite bathrooms provided an airtight cocoon of privacy: in 1930, *House and Garden* asserted that the "private bath...has become essential to modern living," and optimistically predicted "the day...when, in speaking of a house, we will refer to it as 'five bedrooms, five baths.'"[3] However, for economic reasons, such acreage of bathrooms was rarely built.[4] Instead, the arrangement of shared bathrooms among bedrooms—often a single bathroom opening onto two separate bedrooms—offers a more particular definition of the privacy enacted in these houses. Privacy in a house or apartment of the first decades of the twentieth century was comprised not merely of the individual's body and its needs and desires, but also of the bodies closest to that individual, be it spouse, child, sibling, or dear friend. A critic writing in 1934 aptly captured the sense of privileged community behind a wall of privacy when describing a model house designed by the architect Frederick Kiesler. He observed that "The living or main congregating space has a high ceiling" in contrast with the "Bedroom spaces [which] are intimate private places, and again imply low friendly

3.2
FLOOR PLAN FOR A MODERN HOUSE
Evans, Moore, and Woodbridge, *architects*
In *House Beautiful* (May 1934), 56

3.3
FLOOR PLAN, MASONITE HOUSE, *CENTURY OF PROGRESS,* 1933–34
Frazier & Raftery, *architects*
University of Illinois at Chicago Library, Special Collections Department

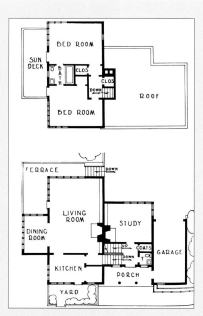

3.2

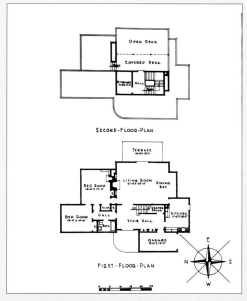

3.3

ceilings."[5] His choice of the word "friendly" to describe an "intimate, private" space infused the room with a select yet welcoming air.

As shared bathrooms and "friendly ceilings" indicate, more activities than merely sleeping or dressing occurred in bedrooms, with more than just the occupant of the room. Bedrooms were routinely furnished with items to facilitate reading, writing or studying, and small gatherings. A teenage boy in *Better Homes and Gardens* described for readers his ideal bedroom: "Doing homework occupies much of our time. We can do our best in the quiet and peace of our rooms, but a good place to work should be provided."[6] Furthermore, as he explained, his desk should double as a "table...for those card parties with the gang," illustrating the small-scale socializing bedrooms often accommodated. According to his female counterpart, a necessary item for her bedroom was "a comfortable chair that's deep enough to tuck up into, where I can scribble, like Jo in 'Little Women,' or read and read by the hour."[7] Indeed, as Cromley has observed, the armchair so important in the girl's room also frequently appeared in master bedrooms in the early decades of the twentieth century. It served as a place for a troubled family member to sit while engaged in a confidential chat, as depicted in a model master bedroom from the *Century of Progress,* and contributed to the stereotype of the mother as a "nurturing" figure (fig. 3.4).[8] While none of these occupations—reading, studying, playing cards, or talking—were related to sleeping or dressing, they still fell within the circumscribed realm of quietude, contemplation, and intimacy dictated by this zone of privacy.

A Zone of Respite and Morality

In the magazines and decorating manuals published during the Depression, writers and designers repeatedly associated particular qualities with the bedroom. Among the basic characteristics attributed to the bedroom— whether furnished in a modern or revival style—was its ability to provide respite from the frenetic pace of modern life. In this way, the zone of privacy was also understood as a zone of retreat from the public world. Lurelle Guild explained to readers of his 1936 decorating manual that a bedroom should have a "restful, satisfying...untroubled atmosphere," which could be achieved, in part, through the "tranquility of the color scheme."[9] Joseph Aronson similarly recommended a bedroom scheme that would not tax the sensory experiences of its inhabitant: he advocated "clean, subdued tones...which [do] not reflect light harshly," and warned that "busy" wallpaper patterns "may

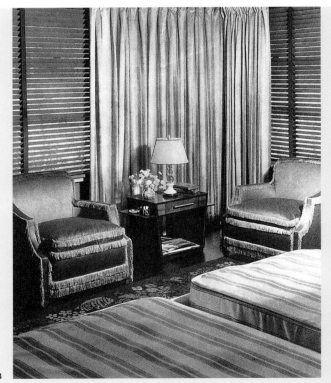

3.4

become intensely annoying."[10] The teenage decorator in *Better Homes and Gardens* aptly summarized the ambience of respite that the ideal bedroom was intended to foster: "This room is going to be a place for my own belongings and the retreat I've been longing for."[11]

Proponents of livable modernism frequently extolled its unadorned forms and streamlined contours as soothing elements that would be appropriate and effective in a contemporary bedroom. A 1935 manual for retailers explained, "The fussy furnishings of the nineties…are finally beating a reluctant retreat. Present day life is hurried. It moves in a fast tempo, demanding greater simplicity and more restfulness in the home." The author continued by describing a model bedroom outfitted with furniture by the Widdicomb Furniture Company (fig. 3.5). Despite the dramatic grain of the Widdicomb objects, the author explicitly cast them as emblems of a restful atmosphere: "This pleasing modern bedroom, with its quiet symphony of color and wood tones, provides the rare peace of spirit that comes when resting under blue skies, and on sun swept heather. Here, the inviting beauty of finely figured walnut furniture, is a friendly summons to rest."[12] So biased was this description—resolutely suppressing any of the vibrancy or energy encoded in the grain or sharp edges of the footboards—that one gleans the commercial value of cultivating an aura of peacefulness in bedroom furnishings: to sell bedroom furniture, manufacturers and retailers attempted to forge an association with an oasis rather than a skyscraper.

Several aspects of Russel Wright's bedroom furniture for the American Modern line of 1935 (manufactured by Conant Ball, see Chapter 1) seem to be motivated by a similar desire to create an atmosphere of repose.[13] In one of his original bedroom

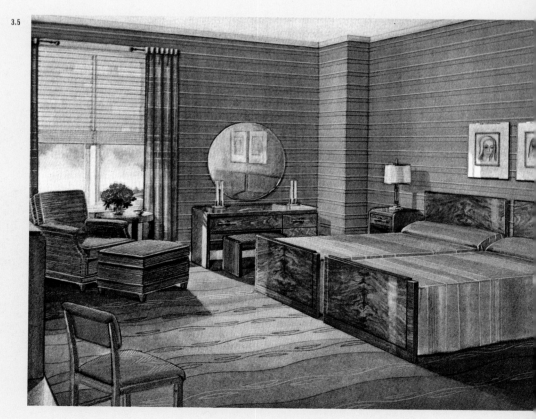

3.4
MASTER BEDROOM, FLORIDA TROPICAL HOME, *CENTURY OF PROGRESS,* 1934
Kroehler Mfg. Company, Chicago, Ill., manufacturer. Hedrich Blessing, photographer. Chicago Historical Society

3.5
RENDERING OF A BEDROOM WITH FURNITURE BY THE WIDDICOMB FURNITURE COMPANY, GRAND RAPIDS, MICH. In *Home Furnishing Arts* (Fall–Winter 1935), 57

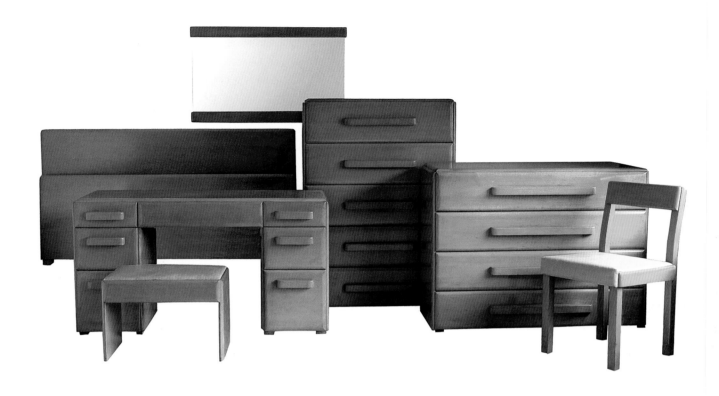

sets, the man's chest and the woman's dresser were large, simple cubic shapes, featuring only a single, slightly protruding, long, and narrow handle for each drawer (fig. 3.6). These almost platonically pure forms had little visible grain and were a studied exercise in restraint: with no distracting details, they promoted a zenlike calm. Furthermore, Wright finished every corner of every object in the set with his trademark "cushion edge." The detail not only served a psychological service, to "soften the geometric harshness of modern design," but also, according to Wright's promotional material, a practical one: it eliminated sharp edges and thus "prevent[ed] [the] tearing of many a gown."[14] While such an occurrence may have been uncommon in real life, Wright's language conjured up a fear of psychosexual harm lurking in the bedroom and infused his "cushioned" furniture with a protective air. His description of the "slab leg" bed for another suite made a similar appeal (fig. 3.7): the leg, he pointed out, "keeps bed clothes from being 'kicked' out at the feet and pillows from slipping off at the head." He thus anthropomorphized the object as a benevolent, watchful figure, evoking perhaps a nanny or mother.

3.6
AMERICAN MODERN BEDROOM SUITE, 1935
Russel Wright, *designer*
Conant Ball Furniture Company, manufacturer. Maple; chest, 46 1/2 x 32 x 19 in. (118.1 x 81.3 x 48.3 cm); dresser, 33 x 42 x 19 in. (83.8 x 81.3 x 48.3 cm); mirror, 18 x 34 in. (45.7 x 86.7 cm); chair, 30 1/2 x 16 x 16 in. (77.5 x 40.6 x 40.6 cm). Collection of Bill Straus

His designs for a third bedroom suite, introduced in 1936, offer even more pronounced formal expressions of comforting respite (fig. 3.8). This group of furniture, including a chest, dresser, vanity, and bedside table, was distinguished by its cartoonlike, oversized drawer handles. These broad rectangular slabs, again with rounded corners, offered an explicitly unchallenging means for opening drawers and implied that one's hand-eye coordination, dulled by the pace of modern life, could be relaxed in the safe zone of the bedroom without punitive consequence. Wright also designed more pronounced cushioned edges for this suite, giving each of the case pieces a top surface that spilled over the front corner as if it were an overstuffed cushion, truly soft and pliant to the touch, that could not be contained. Macy's drew attention in its advertisements to these "Soft *rounded* corners," noting parenthetically that "(good Modern is through with bizarre sharp angles)."[15]

Many domestic commentators of the period also viewed the bedroom as an influential site where taste and virtue could be instilled in a child and reinforced in an adult. *Parents' Magazine* presented a set of guidelines for an up-to-date nursery in October 1934, stressing foremost the hygienic standards required by such a room. The editors advised mothers to outfit these important first rooms with easily washable floor- and wall-coverings, and to select sturdy, unadorned furniture that would not catch an undue amount of dust: as they demanded, "Everything must be washable."[16] According to their philosophy, cleanliness would not only benefit a child's health, but moreover would accustom him (or her) to keeping his living spaces clean later in life.

Various designers offered livable modernist nursery furniture that was not only easy for parents to maintain but also taught children, interactively, to keep their rooms in order. Rohde, for example, designed nursery furniture for his sons, Lee and Kurt, in 1934, and sold the line at Macy's department store; included among the objects were "accessible shelves and...low easy-opening drawers [to] make it possible for even a very small child to get his own things and put them away without adult help" (fig. 3.9).[17] Rohde also planned for growing children in his designs, offering coordinated objects in a variety of sizes: both

3.7
AMERICAN MODERN BEDROOM FURNITURE, 1935
Russel Wright, *designer*
Conant Ball Furniture Company, manufacturer. Syracuse University Library, Department of Special Collections

3.8
AMERICAN MODERN BEDROOM FURNITURE, 1936
Russel Wright, *designer*
Conant Ball Furniture Company, manufacturer. Syracuse University Library, Department of Special Collections

.7

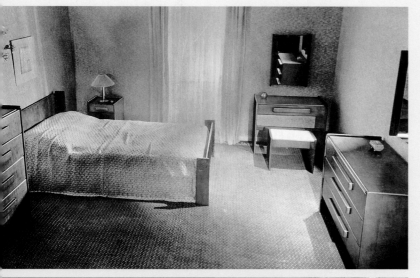

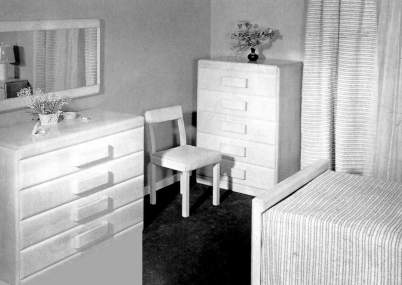

3.8

a crib and a bed, smaller and larger sets of tables and chairs, and wall units conceived according to the modular principle which were intended not only for side-by-side placement but also to be stacked (for when a child grew taller). Thus, as a child grew, his or her furnishings would "preserve a unity of design," which contributed to the consistency and order that educators and psychologists believed was essential in a nursery.[18]

Ilonka Karasz, the Hungarian-born modernist who built her reputation in the 1910s and 1920s as a graphic and textile designer, also designed nursery furniture in the mid-1930s in keeping with the teachings of child psychologists.[19] Her designs, produced under Deskey's short-lived Amodec line, trained children to keep order: a chest with differently colored drawers, for example, taught organization by ensuring that "it will not be difficult for [the child] to keep his...socks in the red drawer, his shirts in the blue. He will naturally remember where these things are."[20] Karasz even asserted that her modular designs would teach children abstract reasoning and taste: from living with units of furniture,

someday, let us hope, [the child] will discover that in reality all things in Nature are built up of just such units, that trees, flowers, animals and even people are related to such forms...best of all, that such things are organically more sound and capable of life than the monster creations of persons who exist on the wave of fashion.[21]

Ultimately, the child experts and decorators alike reminded mothers that the nursery instilled "habits of taste as well as of health and character."[22] The simple forms of livable modernist designs were deemed appropriate in such a room not only because they were easy to clean, but because they provided a nursery with a "most sane and wholesome" atmosphere, in marked contrast to the excessive "bows and...cute frills" that, these experts claimed, had previously inhabited children's rooms. A child could "understand and appreciate" such simplicity, and the furniture

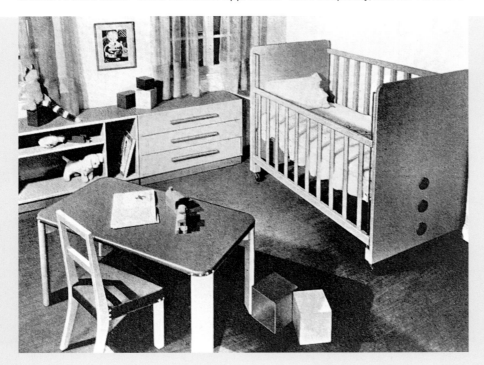

3.9
NURSERY FURNITURE, 1934
Gilbert Rohde, *designer*
Trimble Incorporated, manufacturer.
In *Better Homes & Gardens*
(November 1934), 18

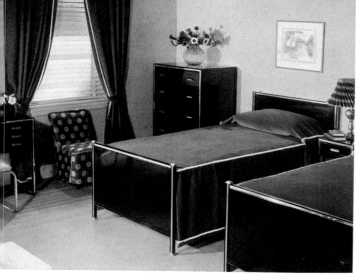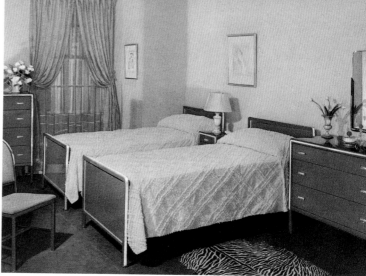

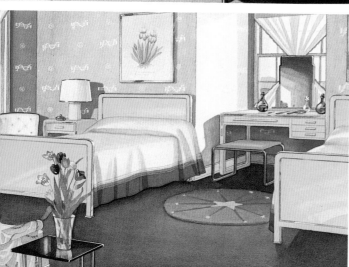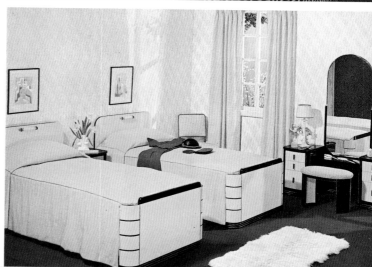

3.10 (top, left)
ADVERTISEMENT FOR SIMMONS COMPANY
In *House & Garden* (May 1933), 66

3.11 (top, right)
ADVERTISEMENT FOR SIMMONS COMPANY
In *House Beautiful* (May 1933), back cover

3.12 (bottom, left)
ADVERTISEMENT FOR SIMMONS COMPANY
In *House & Garden* (November 1933),
back cover

3.13 (bottom, right)
ADVERTISEMENT FOR SIMMONS COMPANY
In *Saturday Evening Post*, 12 May 1934, 70

would in turn "stimulate his imagination."[23] In keeping with this philosophy, Karasz encouraged parents to surround children with "elemental forms and colors of all kinds in shades and intensity," in order to broaden their aesthetic horizons. The child, she asserted, "will thereby develop taste, discrimination."[24]

Designers and manufacturers of livable modernist bedroom furniture for adults also regularly appealed to the fantasy of a self-improving room of one's own. The Simmons Company, which launched several groups of modernist bedroom furniture through large-scale ad campaigns in 1933 and 1934, promoted both the hygienic and moral qualities of its products (figs. 3.10, 3.11, 3.12, 3.13).[25] Although Norman Bel Geddes had provided the company with modernized designs for a bed and night-stand in 1929, no archival or manufacturing evidence exists to suggest that he actually

authored the final version of the popular designs of the early 1930s, as collectors have often assumed. These later designs are based on Geddes's 1929 schemas but were clearly reworked, probably by a team of in-house artists lead by engineer Charles A. Stuart.[26]

Simmons alluded to the sanitary features of its designs indirectly, capitalizing on an established association between metal beds and germ-free environments. Metal beds had been used in hospitals for their allegedly hygienic properties since the nineteenth century, a fact that Elsie de Wolfe called upon in her influential decorating manual of 1913, *The House in Good Taste*. De Wolfe used well-crafted rhetoric to conflate personal hygiene with such virtues as modesty, decrying "people of ostentatious tastes" who had popularized the "vulgar brass bed."

Why we should suffer brass beds in our rooms, I don't know! The plea is that they are more sanitary than wooden ones. Hospitals must consider sanitation first, last, and always, and they use white iron beds. And why shouldn't white iron beds, which are modest and unassuming in appearance, serve for homes as well? The truth is that the glitter of brass appeals to the untrained eye.[27]

Simmons did not explicitly tout the sanitary features of its metal beds, dressers, and vanity tables, but rather emphasized their physical incorruptibility: "[The new bedroom furniture by Simmons] cannot warp. In any climate, the drawers always fit, they slide smoothly, noiselessly. Its magnificent, softly lustrous finish is practically crack-, peel- and chip-proof."[28] By portraying Simmons objects as immutable in the face of climate change or extensive use, the company conjured up an image of furniture that would not become bloated from the heat or decayed with age: of furniture that was healthy and, as the ads claimed, "imperishable."

Simmons followed de Wolfe (and nursery designers more generally) in associating the practical, healthful benefits of metal furniture with the virtues of modesty and good taste. Beneath the vibrant colors of the enameled finishes (which will be discussed below), the Simmons furniture forms themselves were fundamentally simple, even plain: the bed frames pictured in figs. 3.10 and 3.11 are basic rectangular shapes with the occasional rounded corner, and the vanity table in fig. 3.13 is merely composed of two (slightly bowed) symmetrical blocks of drawers on either side of a tall mirror. The Simmons Company took pains to draw attention to this minimalism by describing the objects as "beautifully proportioned," "distinguished in line," and possessing a "clean-cut" look.[29] By further asserting that the "simplicity" of the designs "gives character and beauty," the company claimed for its products an air of understated elegance quite distinct from de Wolfe's "vulgar" brass beds and implied that consumers could exercise their own good taste by purchasing these new designs.[30] A retailing manual echoed this interpretation when it praised a Simmons group in 1933 for being "subtle and sufficiently restrained in its charm," and also lauded the company's intelligent use of color "without stepping outside the pale of good taste."[31]

Finally, the Simmons Company also positioned its modernist designs as props for a peaceful bedroom retreat. The obvious highlight of the new line was its array of colored enamel finishes: black, yellow, and turquoise, to name a few. Simmons consistently described its palette in terms that recall the advice given by Guild and Aronson for creating a soothing retreat in one's bedroom. As the manuals called for "tranquil" and "subdued" colors, so Simmons advertisements touted the "soft glow" of the enamel finish, its "life-bringing yellows and blues," and "the cheer of warm color on smooth shining surfaces."[32]

Although Simmons promoted its bedroom furniture as tools of cleanliness, tasteful modesty, and sustenance to the frayed nerves of Depression-era society, the "soft" tones of its enamel finishes were also undeniably lively. Not only did the combination of "gleaming white metal" against black, turquoise, and yellow (figs. 3.10, 3.11, 3.12) give the designs greater flair than the ad copy suggested,[33] but the color scheme in each advertisement image was designed to give the most dramatic contrast possible to the furniture hues: green against black, pink against turquoise, blue against yellow, and, in fig. 3.13, yellow walls to frame the yellow and black of the metal. Between its self-consciously soothing verbiage and the vivid, unusual colors in its illustrations, the Simmons ad campaign reveals a two-part marketing strategy which accounts, in part, for the line's notable success.[34] It capitalized, on the one hand, on an interest in the self-improving qualities of the practical, modest bedroom, yet on the other hand evoked an idea of the bedroom as a place of individuality and self-expression. From the ample choices of color combinations, Simmons encouraged consumers to select the hues that best expressed themselves: "treat yourself to an intriguing note of color—of modern smartness—in Simmons furniture. You may choose your own pieces—suit your group to your room. Your whole room will come to life!"[35] Even in its claims for unwarpable, chip-proof construction, the Simmons line hinted at an unrestrained side of life in the bedroom: by asserting its strength in the face of heat and climate change, the furniture almost implied that some activities in the bedroom would bring about such conditions. Just as the brilliant colors of the Simmons enamel emerged from modest metal frames, so the excitement and passions of the bedroom leaped forth from the incorruptible construction of the furnishings. Both the color and the climate of the Simmons bedrooms offer glimpses of an arena of expressiveness—perhaps even tinged with indulgence and rebellion—preserved within a realm of privacy into which the dictates of polite society cannot quite reach. This arena is the subject of the remainder of the chapter.

The Modernist Bedroom as Expressive Personality

As the latent drama of the Simmons advertisements demonstrates, in popular images throughout the decade the bedroom served as a space where one could fully express one's personality through furniture and decorations, safely removed from

the pressures of societal expectation that informed the decor of more public rooms. Although the vision of the bedroom as a site of robust individuality stands in apparent contradiction to the nursery-room ideal of simplicity and modesty, an exploration of this oppositional role will lead us to a more nuanced account of the Depression-era bedroom. In decorating manuals from the turn of the century, as Cromley has documented, experts encouraged their readers to consider the bedroom as a retreat devoted to the full expression of the occupant's individuality.[36] After the Great War, decorators maintained this interpretation of the bedroom, insisting that "the individual tastes of the occupant of the room should be reflected in every detail of the furnishing until the room seems a personal part of its owner."[37] For these writers, the bedroom differed in kind from living or dining rooms, which were spaces where social obligations were met; the personality expressed in those rooms was ideally that of the family collectively, rather than an individual.[38] The bedroom, in contrast, was occupied only by one or a few people and could be furnished to suit their preferences, as *Modern Priscilla* explained: "since the bedroom is almost the only room in the house devoted to the use of one person, and therefore the only room in the furnishing of which the personal note may properly be emphasized, it affords the main opportunity for the kind of treatment that is most interesting and appeals most directly."[39] Even Emily Post graciously abdicated her authority as arbiter of taste as she approached the threshold of the bedroom. "So many questions of individual preference enter into the plan and furnishing of your own bedroom," she mused, "that little is possible in the way of suggestions."[40]

The emphatic belief that the bedroom should be the seat of the fullest expression of the self may have arisen, in part, as a response to the complex demands set by the public rooms of the house. Beatriz Colomina, meditating on the concept of privacy in the modern, urban world, has quoted the Viennese architect Adolf Loos about the symbiotic interaction between public faces and private worlds: "Obedience to the standards of the general public in all externals [is] the conscious and desired means of reserving [one's] personal feelings and…taste."[41] She proposes, via Loos, that the only truly private space is the one hidden behind an unquestionable public face—that by giving the outer world a thoroughly conforming facade to gaze upon, the world behind becomes genuinely private, protected from prying eyes. The decorating advisers of the interwar years established a similar interdependent relationship between the public and private rooms of the house. As Aronson noted in his 1936 manual, the living room "is our interior front, more exposed to the judgment of our friends and the rest of the social world than all the rest of the house put together."[42] Thus, after having walked their readers through the rigorous standards of public spaces, advising them on the best ways to achieve comfort in the living room and elegant hospitality in the dining room, writers such as Aronson approached the bedroom wing as a reward, a zone for which the rule books could, and should, be thrown out.

Designers, manufacturers, and retailers tended to promote livable modernism in the 1930s as a style of originality. The publisher of the trade journal *Creative Design* helped to establish this understanding of modernism when, in 1935, he lamented the glut of period styles on the market, noting that manufacturers could no longer "sell the idea of changing one period for another, of throwing out Chippendale and substituting Louis Steenth. But," he added optimistically, "we *can* sell the idea of self-expression, of throwing out all dated stuff and substituting furniture and decoration fitting to this exciting new age."[43] Livable modernism, in this line of reasoning, not only connoted originality, but more specifically the marked presence of the individual in lieu of the various degrees of social conformity encoded in revival styles. It is thus unsurprising that manufacturers and retailers marketed livable modernism as a style for the bedroom more frequently than for any other space in the house; for the room meant to embody individuality, livable modernist furnishings claimed to create the most appropriate setting.[44]

It was in the fantasy world of Hollywood movies, however, that modernism became more than merely a sign of individualism. In movies such as *After the Thin Man* (1936) and *Trouble in Paradise* (1932), modernist interiors not only signified the

3.14
FILM STILL, *TROUBLE IN PARADISE*
(PARAMOUNT), 1932
Hans Dreier, *set designer*

nonconformist independence of the protagonists, but also literally aided and abetted their full self-actualization. The characters in these movies operated from a psychological place of complete confidence (and superior social and economic status), assured that their acts of social rebellion were justified by a higher code of personal honesty; the fact that they launched their activities from modernist bedrooms and living rooms imbued the sets with an irreverent, true-to-oneself sensibility. In *After the Thin Man,* Nick and Nora Charles (played by William Powell and Myrna Loy) return from New York to their home in California, a hilltop modernist villa with vast windows and bare white walls, sparsely furnished with low-slung geometric armchairs and sofas. Although the villa, at the moment of their arrival, is overflowing with a riotous crowd of New Year's revelers who do not even seem to know them, the suggestion of immorality among the Charleses and their guests soon pales in comparison to the highly wrought scenes of deception, ultimately leading to murder, that take place at the densely furnished Victorian mansion of Nora's aunt. Nora's family members disdain her choice of husband—a working-class former detective with expensive tastes—but are forced to ask for her and Nick's help solving the murder.

During the pause in the plot preceding the denouement, Nick and Nora retreat to their modernist bedroom, fatigued from their mystery-solving efforts. They lock the unpaneled, unmolded door and place the telephone in the drawer of their sleek bedside table and proceed to sleep for an entire day. When they ring for their breakfast at 6:30 in the evening, their status as rebels is further confirmed: they will not conform to society's schedules if they have other needs. Their bedroom not only expresses their nonconformity, but also more importantly provides the sanctuary in which they can fully act out their rebellion. Ultimately, Nick and Nora are the film's favorite characters, and they gain sympathy not only for being misunderstood by Nora's family, but also because their dynamic, affectionate relationship outshines all other romances in the movie. The lesson they leave for the audience—and which they encode in their furniture—is that not all social conventions are worth obeying, and they celebrate the personal gratification that comes from adhering to one's own sense of right and wrong.

In *Trouble in Paradise* (directed by Ernst Lubitsch), Mariette Colet's lavish modernist house is the setting for a love triangle involving herself (a wealthy heiress to a perfume company, played by Kay Francis), Gaston Monescu (an accomplished thief, played by Herbert Marshall), and his pickpocketing girlfriend Lily (Miriam Hopkins). Gaston is hired as Colet's personal secretary, and he and Lily conspire to rob Colet's home safe. Although Gaston approaches his working relationship with Colet oozing with charm and hoping to seduce her, Colet herself is an independent woman with an impulsive streak, and she pursues him with equal forwardness. Colet installs Gaston as her secretary in a pair of rooms—an office and a bedroom—next to her own bedroom, and as their flirtation grows, the camera plays on the proximity of these rooms:

the broad, unpaneled doors of each are identical, opening on either side of a modernist grandfather clock, and as the characters pass between them with increasing frequency the viewer loses track of whose bedroom is whose (fig. 3.14).

Colet's modernist bedroom is the setting of the movie's most important scenes. Viewers first see her room, furnished with streamlined, low-slung armchairs, a chaise longue, and a wide bed, when Colet invites Lily in for a private conference. Lily has been hired as Gaston's typist, and Colet bribes her to leave work early so that she, Colet, can spend the evening with Gaston. The movie next enters Colet's room on the evening that she and Gaston consummate their flirtation; the camera captures their passionate embrace in a reflection in the mirror above her modernist vanity table. In the film's denouement, Lily, Colet, and Gaston all converge in Colet's bedroom, where the two women confront Gaston for his financial and sexual betrayals.

Although each of the characters in *Trouble in Paradise* is morally flawed in a way that Nick and Nora Charles are not—Colet engages in an affair with her secretary, Gaston and Lily are thieves—the audience is given reason to condone their actions nonetheless. Gaston and Lily have a passionate, enduring romance, and their acts of thievery are specifically motivated by their love for one another (and, indeed, they are joyfully reunited at the movie's end). Colet is a witty, rebellious socialite who refuses to be cowed by her company's elderly board of trustees or to be coerced into marrying one of the wealthy bores who pursue her. With its conveniently placed bedrooms, Colet's modernist house literally facilitates her rebelliousness and welcomes Gaston's ulterior motives. Colet's modernist bedroom is the seat of her power as she negotiates female possession with Lily, the sanctuary that provides privacy when she embraces Gaston, and finally the meeting ground, veiled from the prying eyes of her social circle, where the competing desires of these three flamboyant personalities are laid bare and where the original romantic couple, Gaston and Lily, are reconciled.

In movies such as *After the Thin Man* and *Trouble in Paradise,* modernist design is used to represent the individuality, and even rebelliousness, of the characters whose lives are surrounded by it. More concretely, modernism becomes the instrument through which these characters defy existing social conventions. While the five figures discussed here are presented as essentially sympathetic, and their modernist decor is likewise celebrated as a liberating (if occasionally risqué) presence in their lives, many other movies of the 1930s used modernist design as the chosen style of fallen women or otherwise immoral characters. In movies such as *Susan Lenox: Her Fall and Rise* (1931), *Baby Face* (1933), and *Possessed* (1931), as Lea Jacobs has argued, sugar daddies kept their women, whose souls were apparently unsalvageable, in modernist bedrooms and penthouses.[45] Yet even as modernism appears as a style of sin in these films, it is also still a style of social nonconformity;

and even as the women who live in modernist penthouses are reviled for their immorality, they also elicit admiration for their boldness and sympathy for their sacrifices. Indeed, the vice codes of the mid-1930s were motivated in part out of fear that female audiences would be so impressed by such women characters that they would attempt to emulate their sinful lifestyles.[46] Thus even when cloaked with immoral associations, Depression-era movies cast modernism as a style of uniqueness, defiance, and self-fulfillment.

Many livable modernist bedroom suites invested themselves with this ideal of self-expression through a variety of unusual, dramatic designs. Making use of such qualities as strong colors, asymmetries, and odd combinations of materials, these often surprising pieces of furniture were intended to be understood as different from the norm, and therefore expressing the individual. The Simmons bedroom sets exemplified such an approach with their rainbow of brilliant colors. As design historians have noted, the auto industry pioneered the use of color as a design feature in the 1920s, offering the same car in a variety of hues and thus creating options for consumers out of essentially identical products.[47] By the late 1920s, color was frequently celebrated as an enlivening force, bringing variety to daily life and casting the past in a dim, muted shadow. A commentator in the *Saturday Evening Post* sketched a picture of a world transformed by color, as if awoken from a deep slumber: "Color in the garage and color in the living room; color in the bathroom and color in the kitchen… color has come to set our world aglow."[48] Design critic C. Adolph Glassgold, writing in *The Arts,* likewise approved of the effect that color had precipitated in modernist furnishings and interiors: "Color used in a higher key, and in strong contrasts…has banished the mustiness of dimmed parlors and antimacassars."[49] The colors of the Simmons bedroom furniture were touted with the same transformative capabilities. "Just the colors alone," bragged one advertisement, "are enough to make an entirely new room out of your present bedroom."[50] Moreover, like the automobile colors, the Simmons colors provided consumers with a choice and thus became the agent for expressing consumers' individual tastes. For those seeking "to bring a lovely new note" to their bedrooms—those who agreed with the advertisement that asked, "Aren't you sick of your bedroom, really?"—Simmons's assortment of "more than a dozen different color combinations" in an intensity "never before…available" provided the appropriate creative outlet.[51]

Donald Deskey also frequently dressed his bedroom furniture for the retail market in uncommon palettes, using color as a tool to create consumer options and, in combination with asymmetrical designs, to cultivate an aura of originality.[52] For the Widdicomb Furniture Company in 1934, he designed a two-toned bedroom set, available in either blonde maple with a trim of "robin's egg" blue lacquer or gray maple with a black trim (fig. 3.15).[53] In the blonde and blue version, Deskey's carefully calibrated off-balance designs lend maximal visual impact to the contrasting colors.

The three-sided blue frames on the twin footboards, for example, oppose each other in a mirror-like reflection. Similarly, on the facade of both the bedside table and the vanity, the drawers are framed to one side with blue, but along the other side the white maple is left unframed; as the white bleeds around the corner of both objects, the unbalanced use of color gives them an animated sensibility, as if they are each just pivoting off axis. Deskey's purposely asymmetrical designs continually surprise the viewer and create a jaunty, syncopated rhythm—as *Home Furnishing Arts* described it, "trig smartness"[54]—that courses throughout the room, insisting on its difference from traditional patterns. That his designs were considered unusual by his contemporaries is reflected in a critic's comment on the "particularly striking" effects of his combinations of color and wood.[55] That his blonde and blue bedroom set was understood as a prop that could be used to cultivate a unique persona is demonstrated in *Arts and Decoration,* where the editors noted that the furniture would not be appealing "for fuss-budgets, or for those people who insist on displaying every snap-shot, picture post-card, and Christmas greeting card collected in a lifetime."[56] The consumers thus implied are those confident enough in their social status not to advertise from whom they receive Christmas cards or where they travel on vacation: in short, those liberated from the conventions and confines of polite society.

Gilbert Rohde's 1933 bedroom suite for Herman Miller, including the vanity that opened this chapter, is another example of the playful strain in livable modernism that promoted the idea of the bedroom as a zone of individuality. Like the vanity, the dresser and side table in the suite elegantly flaunt their unusual materials and apparently gravity-defying compositions (fig. 3.16). The massive, four-drawer dresser perches on two delicate lengths of chromed tubular steel, running front to back like two sled runners. Above the dresser, anchored on just one side, hovers an unusually large round mirror. The side table, despite its diminutive size, packs a dramatic punch as well: the glass top hovers boldly, held in place only by a small groove along its back edge. *Home Furnishing Arts* described the set as "anything but commonplace," assuring potential consumers that their uniqueness would be evident should they choose to furnish their bedrooms with it.[57] As the set was installed in

3.15
RENDERING OF A BEDROOM WITH FURNITURE
BY THE WIDDICOMB FURNITURE COMPANY
Donald Deskey, *designer*
In *Home Furnishing Arts* (Fall–Winter
1934), 50

3.16
RENDERING OF A BEDROOM WITH FURNITURE
BY THE HERMAN MILLER FURNITURE COMPANY
Gilbert Rohde, *designer*
In *Home Furnishing Arts* (Spring–Summer
1934), 54

3.15

3.16

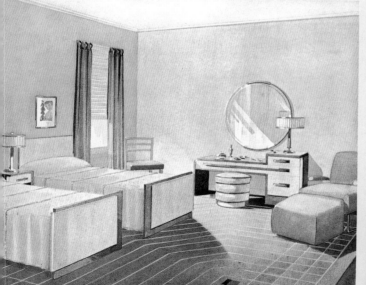

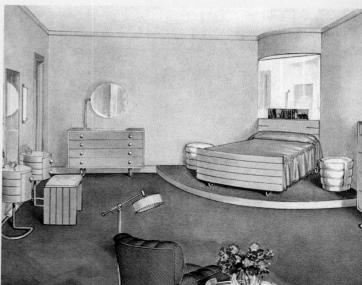

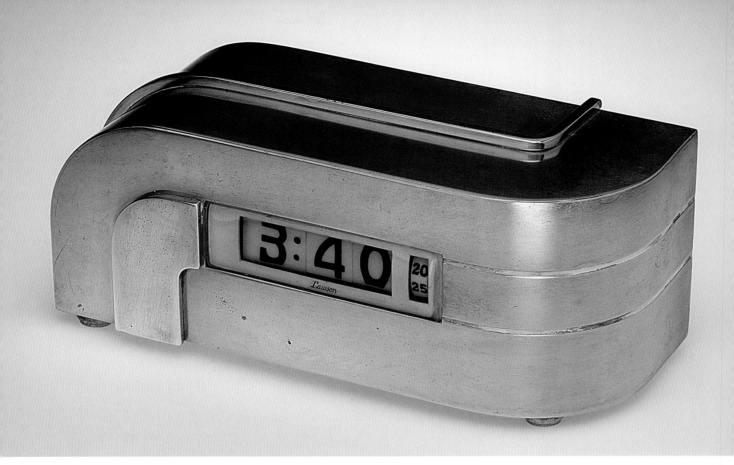

the House of Tomorrow at the *Century of Progress* in 1934, its flamboyance acquired an air of indulgence through the luxurious assortment of textiles that accompanied it: a shiny, quilted bedspread, floor-to-ceiling floral curtains, and thick pile rugs (see fig. I.13). To further underscore this reading—in which the livable modernist bedroom is not just a den of self-expression, but is also a retreat for self-indulgence—Herman Miller published the following commentary to accompany the bedroom suite in its 1933 catalogue. Excerpted from the critic Marta K. Sironen, the passage lauded the pursuit of "contentment" and praised modernist design for aiding in that pursuit:

Modernism will, of course, endure…With our 40-hour weeks, which may at any moment be reduced to 30 hours, there will be more leisure time. This time will not be used to dust carvings or polish large surfaces of wood. It will be used in the "pursuit of happiness"—in recreation, in playing. Our work-day and play-day will be more evenly balanced, and we shall require those objects around us that will not over balance the work-day and shorten the time during which we should be pursuing contentment.[58]

Even as Sironen celebrates leisure, however, she demonstrates a concern with marking the amount of time that citizens of a modern society can devote to such

3.17
ZEPHYR ELECTRIC CLOCK, c.1934
Attributed to **Kem Weber**
Lawson Time, Incorporated, Pasadena, Calif., manufacturer. Brass and Bakelite, 3 1/4 x 8 x 3 1/8 in. (8.3 x 20.3 x 7.9 cm). Metropolitan Museum of Art, New York. Gift of David A. Hanks, 1986 (1986.418.2)

3.18
ELECTRIC CLOCK (NO. 4093), 1933
Gilbert Rohde, *designer*
Herman Miller Clock Company, Zeeland, Mich., manufacturer. Chrome-plated metal and glass, 6 3/4 x 6 1/2 in. (17.1 x 16.5 cm). Collection of John C. Waddell

3.19
ELECTRIC CLOCK (NO. 4081A), 1933
Gilbert Rohde, *designer*
Herman Miller Clock Company, manufacturer. Black maple and plate glass, 8 1/2 x 9 1/2 x 2 1/2 in. (21.6 x 24.1 x 6.4 cm). Collection of Denis Gallion and Daniel Morris

indulgence. The relentless passage of time in the modern world was a constant refrain in the decades after the Great War when technology, suddenly omnipresent in daily life as never before, seemed to possess the power to literally alter how quickly society experienced the succession of hours, days, and years. Countless editorials and articles routinely evoked "before and after" vignettes—before the war and after the war, before the stock market crash and after—hinting that such anecdotal comparisons, easily understood, would help one to better grasp the dizzying pace with which society was changing.[59] By placing Sironen's commentary in its catalogue alongside Rohde's bedroom suite, Herman Miller implied that bedrooms, as a site of self-expression, played a role in preserving time devoted to contentment. Indeed, an individual's daily experience with time often began in the bedroom, with the ringing of an alarm clock. Bedroom clocks—whether alarmed or not—thus became the embodiment of the precious hours one spent away from public responsibilities, outside of the "work-day," in the zone of personal expression, the realm of the "play-day."

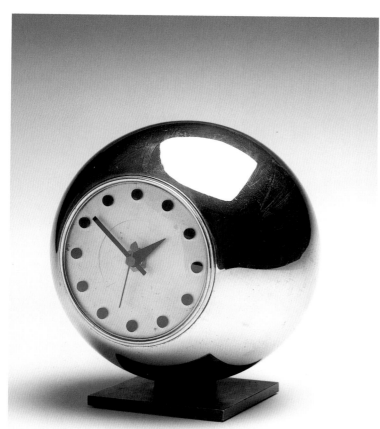

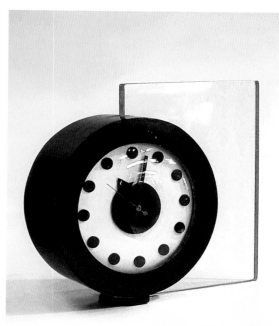

3.19

3.18

Several designers in the early 1930s styled clocks that seem to express this symbolic role as a marker of time spent for oneself.[60] In a design attributed to Kem Weber, Lawson Time, Inc., manufactured one of the earliest digital clocks—each second, minute, and hour marked by a number scrolling through its small window—called the "Zephyr" (fig. 3.17).[61] The experience of time conveyed in a digital clock differs from a traditional face clock: when looking at a face clock, one sees the present time in the context of the continuum of time, whereas when looking at a digital clock one sees only the present moment. The effect can be either exhilarating—time freed from the past and future and the responsibilities they connote—or unbalancing—time wrenched from the continuum of time itself. The design for the Zephyr, made of brass, is composed of interlocking curving planes. The raised band on the front plane appears to emerge from below at the left, then glides past the time window, becomes a recessed version of its previous form, and whips around the right edge to disappear at the back of the object; its path is mimicked by a thin band that courses along on the left and top planes of the clock. With its continuous curves, the Zephyr, whose name refers to the ancient Greek god of the west wind, seems to be existing just in the present second, always on the verge of disappearing, much like the experience of reading time in its digital face. For the 1930s livable modernist bedroom, this clock dramatized the escape from the "40-hour week" world by creating an eternal present, suspended between past and future commitments.

Rohde designed numerous alarm clocks for the Herman Miller Clock Company, which always appeared prominently in Herman Miller's own display rooms.[62] He retained the traditional clock face in all of his designs, but abstracted each element: in many of his designs, the hours are designated simply by anonymous dots, and none mark the minutes. The effect of his minute-less faces is a somewhat blurred sense of time, less specific than the digital clock but anchored within the larger sweep of hours. In a few, the case is in the shape of a chrome ball, giving the clock the appearance of a shiny toy (fig. 3.18). And many are supported by asymmetrical bases, as with the clock whose face is framed on one half with a plate of glass, while the other half hovers in open air (fig. 3.19).[63] Each of these characteristics transforms Rohde's clocks from rigid time-keepers into nonthreatening, whimsical accessories. Their imprecise marking of time further makes them

3.20

ADVERTISEMENT FOR BIG BEN ALARM CLOCK
In *Saturday Evening Post,* 12 April 1932, 1

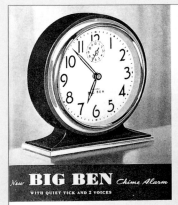

New **BIG BEN** *Chime Alarm*
WITH QUIET TICK AND 2 VOICES

350 . Slim, trim, modern. Finished in lustrous black and gleaming [...]. Guaranteed for two years by Western Clock Company, La Salle, Ill.

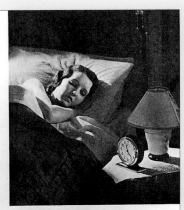

QUIET AS A WATCH: No noisy "tick, tick, tickety tickety tick" to disturb your rest. This new clock keeps quiet—quiet as a watch—all night long.

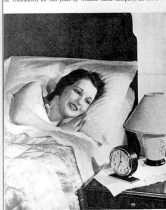

FIRST HE WHISPERS: In the morning Big Ben's first call is a series [...] gentle chime-like "please get ups." The first polite alarm clock in history.

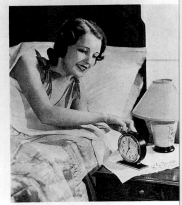

THEN HE SHOUTS: If you won't pay attention to his first polite call, Big Ben uses his second voice. "Get up", he shouts. And you do [...]

appropriate for the bedroom, the room where one should be able to retreat from the demands of the public sphere.

Among the more pragmatic designs for an alarm clock are those of Henry Dreyfuss, who redesigned the Big Ben alarm clock for the Westclox Company between 1930 and 1932 to give it a slimmer, modest black case and easily legible face (fig. 3.20).[64] He introduced a notable innovation to the clock's alarm system by giving it two volume levels: "In the morning Big Ben's first call is a series of gentle chime-like 'please get ups'…If you won't pay attention to his first polite call, Big Ben uses his second voice. 'Get up,' he shouts. And you do."[65] At the end of the decade Dreyfuss redesigned the Big Ben again, giving it a more rounded case that recalls Rohde's ball clocks (fig. 3.21).

Although Dreyfuss's various designs have less of the avant-garde flair of the Lawson Time and Rohde designs, all of these clocks share a common attitude about time in the bedroom. None seek to impose the rigorousness of schedules in the daily world on one's personal life in the bedroom. Rather, they try to contain and diffuse the relentless pace of minutes and hours passing. The early Dreyfuss design attempts to do this by offering a less jolting awakening, anthropomorphizing the clock as a polite servant. The designs by Lawson Time and Rohde and, to a degree, by Dreyfuss later in the decade, convert timekeeping into a plaything, proposing that in the bedroom, where individuality takes precedence over social responsibility, one can literally shape time into anything that suits one's fancy. The grandfather clock outside Colet's and Gaston's rooms in *Trouble in Paradise* serves such a function: it is the sentinel that stands guard over the zone of sex and money. When the camera lingers on it, marking time during a romantic interlude between Colet and Gaston, it protects them: we see it, not them, and they pass away the hours without a care for the world outside.

Gender in the Bedroom

The expressive colors, asymmetry, and syncopated patterns that characterized many livable modernist designs for the bedroom provided consumers with a sense of self-expression, departure from convention, and perhaps a taste of self-indulgence. However, with few exceptions, designers and manufacturers chose not to break with traditional

3.21
BIG BEN ALARM CLOCK AND BOX, 1938
Henry Dreyfuss, *designer*
General Time Instruments Corporation, Westclox Company Division, La Salle, Ill., manufacturer. Metal, chrome-plated metal, enamel, and printed cardboard; clock, 5 3/4 x 5 1/8 x 3 in (14.6 x 13 x 7.6 cm); box, 4 x 6 1/8 x 6 1/2 in. (10.2 x 15.6 x 16.5 cm). Metropolitan Museum of Art, New York. John C. Waddell Collection, Gift of John C. Waddell, 2002 (2002.585.1ab)

gendered stereotypes in their bedroom furniture, offering designs that seemed to be inspired by the ideal of a practical, efficient, upright man and a fashionable, fragile, languorous woman. Robert and Helen Lynd described such gender conventions in 1937: "Men are stronger, bolder, less pure, less refined, more logical, more reasonable...Women are more delicate, stronger in sympathy, understanding, and insight, less mechanically adept, more immersed in petty detail and in personalities, and given to 'getting emotional over things.'"[66] While the Lynds continued by explaining that the residents of Muncie, Indiana, had experienced various shifts in these cultural expectations brought about by the Depression, livable modernist furniture from these years tends to reflect no such change.

For example, in describing a 1935 modernist bedroom set designed by Anton Bruehl for the large manufacturer Kittinger, a critic for *House and Garden* emphasized that it was "designed by a man for a man" and possessed "all kinds of interesting tricks—a sliding panel in the bed which opens to reveal a reading light and a space at the bottom of the chest for shoes, reached by doors which work like a roll-top desk."[67] These "tricks" shed light on the stereotypical masculine mind: this furniture presumed that the man living with it was clever, a good problem-solver adept at finding uses for all sorts of hidden-away spaces.[68] Similarly, the "Lady's Room" in the Crystal House at the *Century of Progress* in 1934 featured elements that played to the stereotype of the woman for whom "sympathy" and delicacy were essential qualities (fig. 3.22). The room included an armchair and tea table arranged as if for a conversation between a friend in the chair and the Lady on her bed. The bed, placed against the wall, was transformed with a casual pile of pillows from a sleeping vehicle into a daytime chaise longue, an object frequently recommended for women and informed by the idea that the female race was fragile and needed to take a nap during the day. "Nothing adds quite so much to the pleasant comfort of the room," advised the popular *Modern Priscilla* to her female reader, "as a couch or day-bed where you can

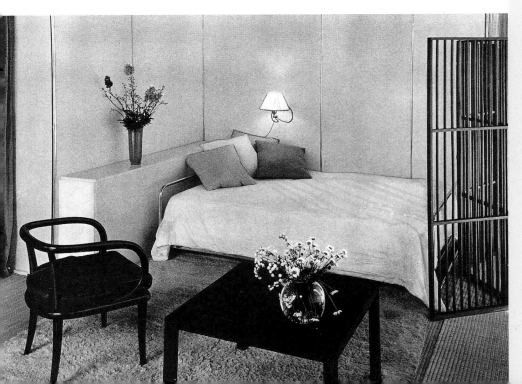

3.22

stretch out for a few moments' siesta."[69] In assuming a reclining position on a chaise, the woman draped her body as if it were an object laid out for display, to be gazed upon by her rational male partner.[70] In examples such as these, livable modernism's gendered conservatism reinforced the status quo. However, these traditional identities may not have seemed confining to Depression-era consumers. Instead, they offered a portrait of family life that would have been reassuringly familiar to many, calling forth the roles of competent husband and nurturing, sensuous wife that had characterized prototypical middle-class homes in previous generations.

Rohde offered one of the rare challenges found in livable modernist design to these gender stereotypes. Throughout his career, he designed numerous pairs of uniform chests of drawers, beginning with a pair for Herman Miller in 1933. Standard bedroom suites for several decades had included a taller, narrower "chest" for men and a lower, longer "dresser" for women. However, as Rohde explained, modern bedrooms were frequently too small to have adequate space for each of these distinct objects, resulting in an overcrowded room or insufficient drawer space.[71] His pairs of chests, in contrast, were identical in height—slightly lower than most chests but higher than a dresser—and could be put together to form a single unit in a bedroom. In the pair that he displayed in the Design for Living House at the *Century of Progress*

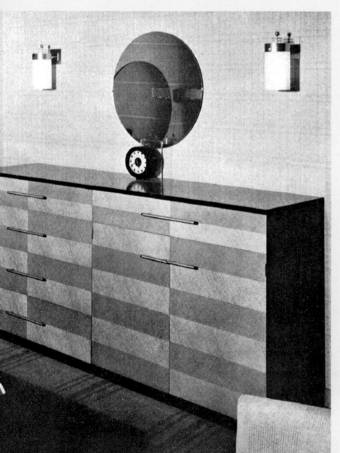

3.23

during the summer of 1933, the herringbone pattern of the gray ash veneer marched without interruption across the two objects, effectively wrapping them as one (fig. 3.23). The radicalism of his innovation should not be underestimated: he robbed the "chest" of its masculine body and the "dresser" of its feminine garment—robbed the chest of its upright logic and the dresser of its long, low display surface—rendering them each unisex. In an installation photograph from the Design for Living House, one of Rohde's clocks presides over the seam between the two objects, as if to propose that only in a bedroom that is safely ensconced away from the demands of the public sphere can one venture into such a radical obliteration of socially dictated gender types.

As the most specifically gendered object in the bedroom, the vanity table deserves particular scrutiny. In its basic form, the vanity is comprised of a surface on which to keep cosmetics and perfumes, a few drawers to store more of the same, a large mirror, and an ottoman or stool. Essentially, every part of the vanity from a Depression-era bedroom was about display: display of the tools for beauty, display of the woman in the mirror, making herself up for

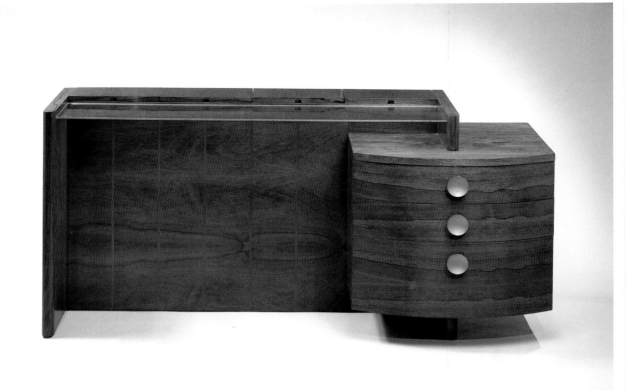

3.24

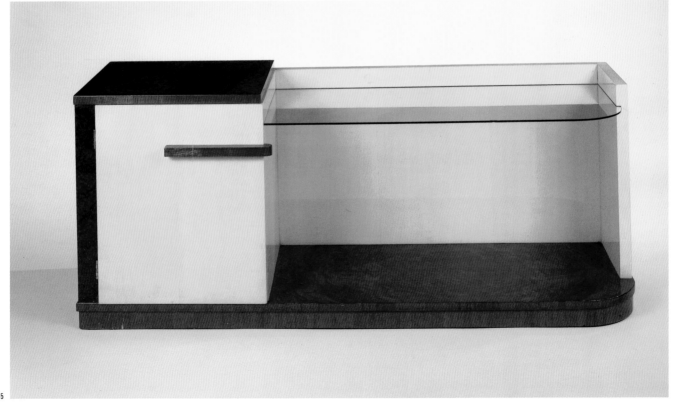

3.25

LIVABLE MODERNISM

display before others. Furthermore, because vanity tables were, almost without fail, designed with greater flair and flamboyance than any other object for the bedroom, they became display pieces themselves—drawing attention to themselves much the same way the woman who sat before one would go on to draw attention to herself. In this way the vanity table can be seen as complicit with the social stereotypes that informed the chaise longue, which, by taking a woman's feet from under her, immobilized her, removed her agency, and rendered her an object for viewing.

Many vanities designed in the 1930s had a partial or complete glass top, which served both practical and dramatic purposes. Practically, it protected the body of the vanity, often made of wood, from the "attacks of perfumes, cosmetics, and considerable wear."[72] As a design feature, it contributed an element of surprise and drama. Suspended within a frame of wood, as in a 1937 vanity designed by Rohde for Herman Miller, glass could be used to create a semi-invisible display surface on which cosmetics and perfumes would sit and appear to be floating in midair (fig. 3.24). Deskey anchored an expanse of glass to one side of a single, block-shaped cupboard in a 1935 vanity design for Estey Manufacturing Company (fig. 3.25). The cosmetics and bottles collected on this glass surface would have created a visual counterpoint to the solid form of the drawers, emphasizing their small size, random assortment, and ultimate impermanence.[73] The glass top that was so common on vanity tables of the period can be seen to embody many of the ambivalent attitudes toward women's use of makeup. Although mass-market cosmetics had thoroughly infiltrated mainstream middle-class society by the end of the 1920s, makeup retained connotations of superficiality and mendacity, as a 1934 advertisement revealed: contrasting "wrong" and "right" makeup, the Angelus Rouge Incarnat company claimed that the former created "a 'hard' and 'cheap' look," while the latter provided "a natural seductiveness—free of all artificiality."[74] The glass top on a vanity table created a surface for display and provided dramatic effects, as makeup did. Yet it was clear—"free of all artificiality"—creating a more "natural" drama. Moreover, it protected the natural wood of the body from corrosion: that is, it did not allow the residue of the makeup to penetrate the structure of the object, thus preserving its integrity.

Vanity tables appeared in two standard heights: at the level of a desk (for example, the vanity no. 16085 by Simmons) or, more popularly, lower to the ground (for example, Simmons no. 171) (figs. 3.26, 3.27). A lower table and stool were, in practice, more awkward for sitting, asking the woman to adopt a somewhat precarious position, balancing with care as if on a child's chair. Furthermore, a low stool removed the woman from the rational height of a desk—the height that a man would comfortably occupy—and put her in a zone that was closer to the floor, to the zone of childhood regression, thus reinforcing the intellect/emotion dichotomy between the stereotypical masculine and feminine characters of the period. A low stool allowed

3.24

VANITY TABLE (NO. 3770), 1937
Gilbert Rohde, *designer*
Herman Miller Furniture Company, manufacturer. Brazilian rosewood, mahogany, and brass, 26 x 56 x 18 in. (66 x 142.2 x 45.7 cm). Collection of The Newark Museum, Gift of Herman Miller, Inc., 1989

3.25

VANITY TABLE, c. 1935
Donald Deskey, *designer*
Estey Furniture Company, Owosso, Mich., manufacturer. White holly and burl walnut, glass. The Wolfsonian-Florida International University, Miami Beach, Florida, The Mitchell Wolfson Jr. Collection (87.967.11.4.2)

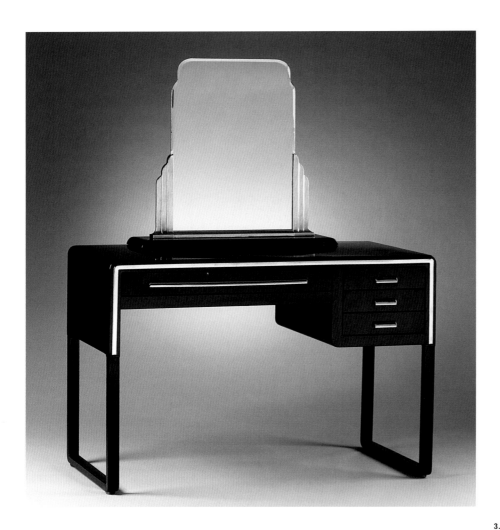

its owner to perch temporarily—without a proper back, the stool made it easy to sit down quickly to check her makeup during the day—yet this too reinforced gendered types by promoting the idea of a woman who did not have the ability to concentrate or focus as would be demanded at a desk. Indeed, even modernist vanity tables at desk height were often coupled with a stool (as in the Simmons advertisements for suite 16085; see figs. 3.10, 3.12), underscoring the less permanent nature of the work performed there.

The most successful attention-grabbing element of any vanity was its mirror. Commandingly tall or generously round, the mirror reflected large portions of the bedroom and every person who crossed in front of it. In a small room, the world reflected within the mirror could create the impression of a considerably larger space. And regardless of the size of the bedroom, the tableau produced by the

3.26
VANITY TABLE AND MIRROR (NO. 16085), 1933
Simmons Company, Chicago, Ill.,
manufacturer. Enameled and chrome-plated
steel; glass, aluminum, and enameled steel;
table, 29 5/8 x 44 x 19 in. (75.2 x 111.8 x 48.3);
mirror, 26 x 27 5/8 x 6 5/8 in. (66 x 70.2 x 16.8).
Metropolitan Museum of Art, New York.
Gift of Paul F. Walter, 1984, and Purchase,
Paul F. Walter Gift, 1985 (1984.263, 1985.165)

3.27
VANITY TABLE (NO. 171), 1934
Simmons Company, manufacturer.
Enameled and chrome-plated steel, and
mirrored glass. Collection of Ellie and
Richard Wilson

LIVABLE MODERNISM

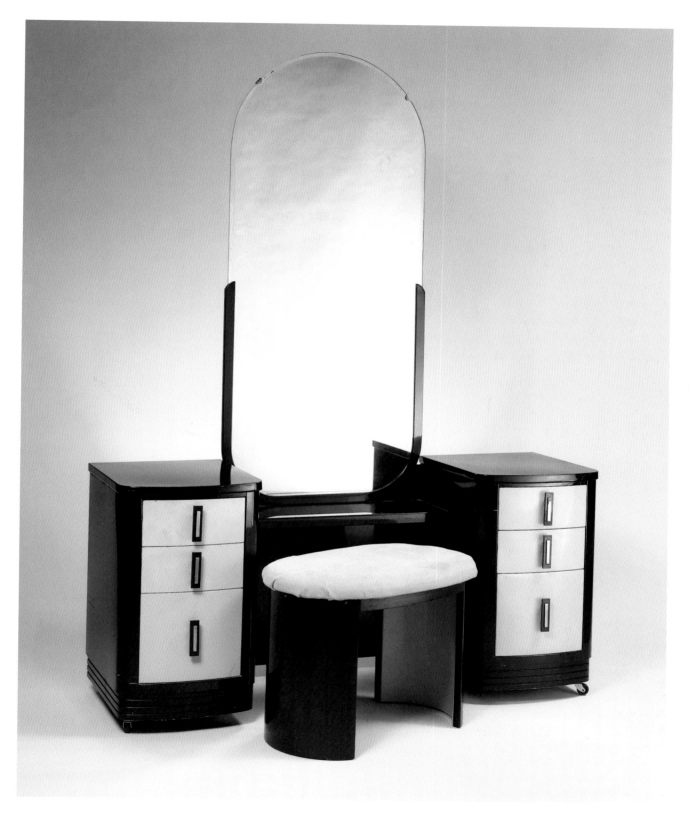

PRIVACY AND SELF-EXPRESSION IN THE BEDROOM

mirror's reflection, framed just as if it were a picture, had the effect of dramatizing the movements and scenery of daily life. The lives of the bedroom were radically defamiliarized when captured in part through the cropped frame of the mirror (as is the partially reflected bedroom in the Herman Miller publicity photograph, fig. 3.28), or when recorded in perfectly reversed gestures (as is Colet and Gaston's embrace in *Trouble in Paradise*); they were turned into a private film where every frame and all action were invested with great import. Such large mirrors created a kind of voyeuristic window in which the people in the bedroom performed for their own reflection. In one 1934 advertisement (for the popular hybrid style of "classic modern" furniture, more classic than modern, sold at Hathaway's furnishings store), the photographer captured the woman of the house as she gazes at her reflection in her vanity mirror (fig. 3.29). She performs a ritual of beautifying, acting out a fantasy of transformation for her own gratification, for that of her maid, and for that of the camera. The mistress of the bedroom will, in a short time, leave the spectatorship of the mirror, the maid, and the photographer to greet the spectators that are her husband, children, and friends.

Despite the fact that a vanity table appeared to coddle the vanity of just one person—the woman who sat before its mirror—in practice it was always involved in a larger set of relationships. As the maid in the Hathaway's advertisement indicates,

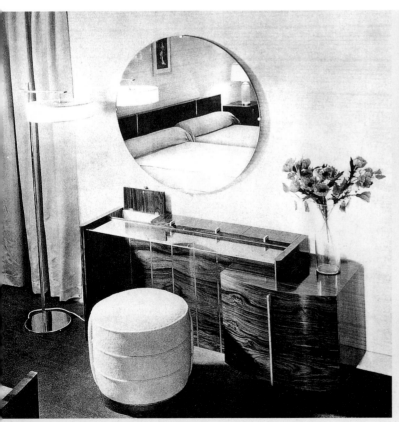

3.28

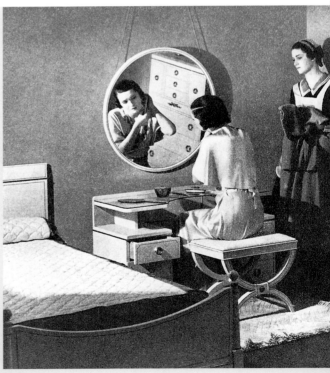

3.29

LIVABLE MODERNISM

a vanity table established a small stage for the application of makeup, hair pins, jewelry, and gowns. To sit on that stage meant to perform a series of acts that would be viewed by others in the room, perhaps a maid or, more likely, a husband. As enacted in a film still from the 1931 MGM movie *Possessed,* Clark Gable gazes at Joan Crawford as they both stand in front of her vanity table, she turned to the mirror (or to us, as the voyeuristic eyes of the camera) fastening a piece of jewelry (fig. 3.30). Not only does he watch her at her vanity, but the specific context of the movie's story provides added meaning to the ritual before the mirror: Gable plays a wealthy single man and Crawford his kept woman; the jewelry she wears in this scene are mementos of their non-married "anniversaries," emblems of his possession of her. Thus her performance at the vanity becomes a performance for him and a performance owned by him.

A 1933 article in *House Beautiful* demonstrates another example of the degree to which dressing and making up one's face could become a performance of femininity for the pleasure of a husband. The article narrates a fictional shopping trip executed by a man in honor of his first wedding anniversary: "Oh, sure, I admit we're young yet and we haven't been at it long," this appealing young husband rambled to a friend,

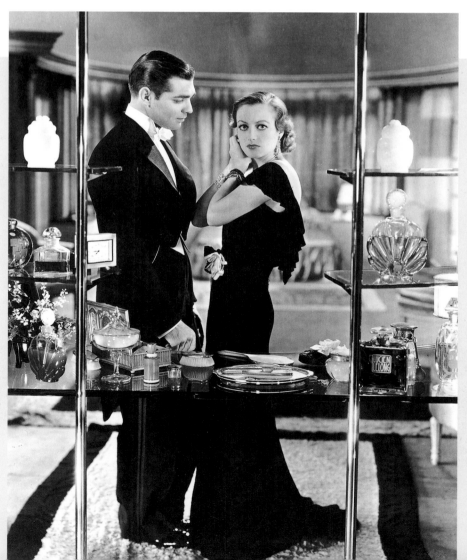

3.28
VANITY TABLE (NO. 3770) IN HERMAN MILLER
FURNITURE COMPANY SHOWROOM
Grand Rapids, Mich., c. 1937
Gilbert Rohde, *designer*

3.29
ADVERTISEMENT FOR HATHAWAY'S
FURNITURE STORE
In *The New Yorker,* 12 May 1934, 53

3.30
FILM STILL, *POSSESSED* (MGM), 1931
Cedric Gibbons, *supervisory set director*

3.30

but we might as well make it last if we can. Besides, our house is still so new Louisa really needs a lot of things we haven't got. She's mentioned a dressing table several times lately—not that she's really asked for it, or even hinted. It's just come up in the conversation when we've been dressing mornings. And I've pretended not to notice, so I know she'll be surprised if I cash in with one.[75]

For his "ultra-modern" wife, he chose a smaller Simmons design with an "apple-green" lacquered body, a chrome-plated tubular metal base, and a chrome-framed mirror (fig. 3.31). His gift, promoted in a decorating magazine with a largely female readership, places the vanity in a complex matrix of social relationships. Not only does the narrative affirm that the husband has a kind of ownership over the performance staged at the table, but it also presumes that the wife reading the article would want to perform for her husband: in short, it tells her that she *should* perform for her husband.[76] Thus, the vanity table transports the concept of spectatorship from the public realm to the private realm by creating a stage for performing. Moreover, the vanity table brings with it a set of social guidelines forged in the public sphere that dictate the intimate interactions between husband and wife. As a central component in any bedroom suite, it reveals how thoroughly social expectations penetrated the supposedly private zone of the bedroom. The vanity table, for all its flamboyance and erotic innuendo, forces us to reconsider the possibility of true individuality and free self-expression in the privacy of the bedroom.

Conclusion: Questions of Privacy

The evidence that can be gleaned about the bedroom from Depression-era decorating manuals, magazines, and the furniture itself appears, in the end, to be profoundly ambivalent. The bedroom was supposed to be, on the one hand, a place where taste and propriety are instilled and, on the other, a place of self-expressiveness and perhaps indulgence. It was meant to be a zone of respite from the pace of the modern day world, yet many livable modernist designs used daring mixtures of color and asymmetries that actively embraced the flair and energy of twentieth-century life. These apparent contradictions can be understood as symptoms of a larger uncertainty about the status of the bedroom: how private is a room that all of society agrees is private?

The privacy of the 1930s bedroom was a publicly shared belief. The editor of *House and Garden* commented in 1930 about "the modern philosophy of living and hospitality," assuming that all of his readers would agree that a bedroom was a private room, and that all house guests and hosts alike desired an impermeable zone of privacy: "Guests are guests—even the nicest of them. We should never make them, nor do they expect to be made, intimate members of the family. The old idea of placing guest rooms on a second floor seems rather bad planning—privacy is not available for either family or guest."[77] The public nature of this concept of privacy was compounded by the fact that many bedrooms in a 1930s house were usually accessi-

3.31
VANITY TABLE
Simmons Company, manufacturer.
In *House Beautiful* (March 1933), 99

LIVABLE MODERNISM

ble by people outside of the family. Guest bedrooms, for example, were a room of privacy constructed for the use of a member of the public (i.e., not a member of the family). Some manuals referred to their decoration as a test of the hostess's ability to foster a zone of privacy for someone outside of that zone, as did Aronson when he reminded readers that the guest room should not be far from the living room, "so that the guest has a place to which he may flee. Have an easy chair and a writing table: colorful bright tones are recommended, but avoid overdefinite shades which may be offensive."[78] Nurseries were another instance of a private room laid open for public scrutiny: medical experts dictated the nature of their furnishings, and the consequences of failing to meet those standards—resulting in an ill-tempered, disorganized, or overly dependent child—could be construed as a public hazard. And finally adult bedrooms themselves were publicly private spaces in the Depression years. Not only were bedrooms often the focus of magazine stories about decorative make-overs, but also as we have seen, such rooms were often furnished to accommodate a select circle of intimates, be it teenage boys to play cards or women friends for confidential chats.[79]

In fact, the idea that the bedroom was a place for the private expression of one's personal, unconstrained identity was in itself a societal injunction, a public command to have a private, inner life. To the extent that the media portrayed modernism as a style of individuality and self-actualization, one must consider the possibility that some of the appeal of livable modernism was the opportunity it offered to consumers *to be seen* to have an expressive side, the chance it gave to participate in and belong to a group of vivacious individuals. The bedroom zone may have retained some perfunctory sense of privacy—not as many guests entered it as the living room—but, in the end, the life it contained was hardly secret. The Simmons advertising campaign evocatively captured the social pressure that a housewife might have felt to transform her bedroom into a jazzier expression of herself by imploring "Does your bedroom seem dull and out of date?"[80] Some ads went even further, dragging public arbiters of fashion right to the bedroom door: "Why should [your bedroom] be the room in the house you have to apologize for? *You know it's out of date!*"[81]

The livable modernist bedroom furniture discussed in this chapter offered, ultimately, only a circumscribed type of self-expression. Livable modernism was offered through the mainstream market, and buying it was, in essence, simply making a particular selection among many options. Furthermore, in its forms and designs, livable modernism largely maintained the patterns and standards of a two-parent, heterosexual home life, supporting the distinct gendered identities that predominated in the mainstream. The privacy forged in a bedroom was of the kind that was curiously always on display, and the individuality encouraged in it was a kind of performative exercise—an act of exhibitionism, publicly displaying one's private self.

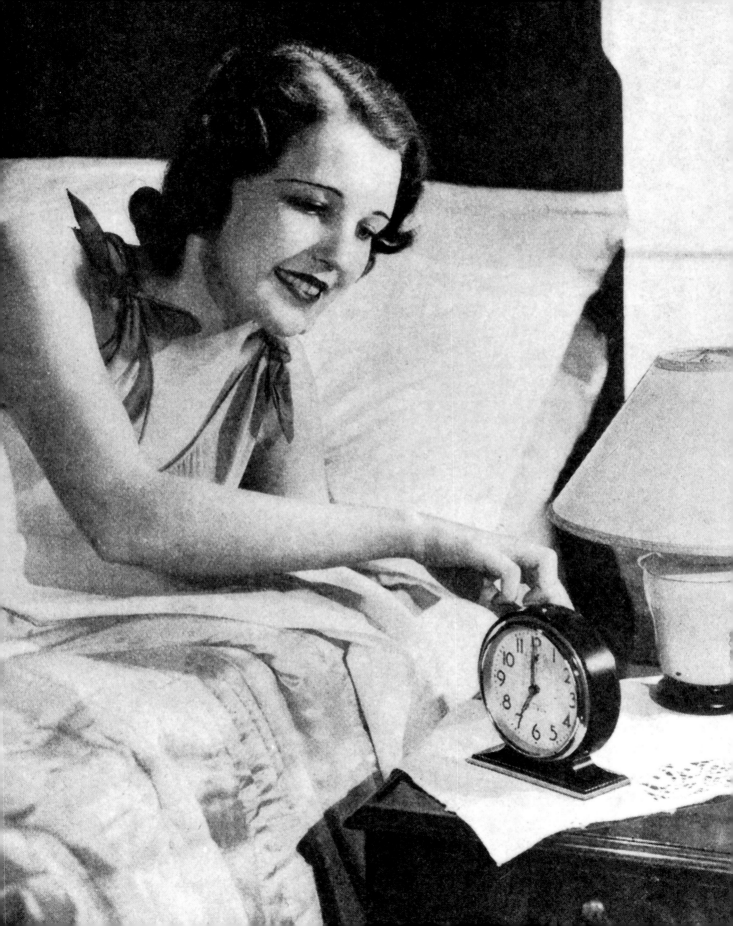

Conclusion: The Legacy of Livable Modernism

The designers and manufacturers studied in this book were the first in the United States to attempt to cultivate a broad, middle-class consumer audience for modernist design. To do so, they actively negotiated between functionalist, socially progressive ideals, which had defined such European modernist schools as the Bauhaus and the Deutscher Werkbund, and the more sentimental conservatism that predominated in mainstream American culture. While this negotiation could be interpreted as an abdication of modernism's alleged high moral ground, persisting above and beyond petty human emotions, I argue that this struggle produced a school of modernist design more committed to reaching a broad public than any that had preceded it. Through the sophisticated use of popular culture ideals and of marketplace strategy, the livable modernists made great strides in the quest to establish modernism as a style of affordable quality available to all.

The humanly sympathetic elements of livable modernism must be understood as a response to the broad cultural fears and fantasies of the Great Depression. At a time when Americans grasped onto the social forms (and furniture forms) of earlier eras, hoping to import the alleged stability of the past into the uncertain present, livable modernism incorporated elements of tradition to appeal to consumers' concerns. The effects of these designs were often embracing and empowering, such as the emphasis on psychological and physical comfort in the living room, the aspiration to magnanimous hospitality in the dining room, or the liberation of the individual in the bedroom. However, other consequences of these designs were more insidious, such as the reluctance to forgo vestiges of patriarchal hierarchy in formal dining and the perpetuation of gender stereotypes in the bedroom. Ultimately, these references to convention, no matter how conservative, are evidence of livable modernism's attempts to attend to the psychological needs of those who will live with its products.

The livable modernist tools were also, however, multivalent. Even as they referred to tradition they left open the possibility that consumers might eventually cease to use them as implements of convention and instead establish new modes of living with them. Thus Russel Wright's American Modern armchair conjures up

associations to homespun interiors filled with irregularities and clutter, but it could also be used to cultivate a living room atmosphere of greater simplicity and openness. Lurelle Guild's canapé plate can be used to enforce a buffet party etiquette of meeting new people, balancing food and drink with one hand while shaking hands with the other, or it can simply be an accessory for freewheeling, casual socializing. Gilbert Rohde's vanity table reinforces the wife's femininity as she sits before it, but it can also be employed as a symbol of her individuality.

Although livable modernism demonstrates sentimental, conservative, indeed "anti-modern" overtones on occasion, such content must be understood not as a detraction from the modernity of the objects, but rather as signifying a different kind of modernity: the modernity of the pop-culture world, not that of the removed, modern artist. Livable modernism's very engagement with the ideals put forth in magazines, department stores, and film—as well as its participation in the vast, consumer-oriented marketplace—indicates another level of evaluation for the scholar: this modernist design used the modern institutions of the media and marketplace to find an audience. Indeed, it allowed itself to be shaped to some extent by the demands of those institutions. The result of this interaction is an overlapping of modernity with modernism—that is, the overlapping of the structures of modern society with the forms created to interpret that society.

In catering to certain consumer desires such as comfort and familiarity, the livable modernists developed a mode of design that possessed, among other things, greater warmth and personality than the cool functionalism of the International Style aesthetic. Their expanded concept of modernist design laid the groundwork for the post-World War II generation of modern designers such as Charles and Ray Eames and George Nelson. The innovative, playful, yet functional forms of this later modernism possess a "personalized, humanized" quality[1] that, like the work of the designers examined in this book, seeks to integrate the emotional world of consumers with the efforts of efficient design. The modernists of the 1930s pioneered the active engagement with the marketplace that characterized much post-1945 design, and they developed creative ways to satisfy public interest in comfort, respectability, familiarity, and individuality. Their work, driven by the limitations of the Great Depression, ultimately emphasized both a practical approach to design and a practical approach to the realm of commerce. In its balance of ideals and pragmatism, of modernist efficiency and consumer appeal, livable modernism broadened both the shape of modernist design and its audience, and established the foundation on which future designers built their practice.

PERIODICAL PUBLICATIONS

AH	*American Home*
A&D	*Arts and Decoration*
BHG	*Better Homes and Gardens*
CD	*Creative Design*
CGJ	*Crockery and Glass Journal*
FR	*Furniture Record*
GH	*Good Housekeeping*
HFA	*Home Furnishing Arts*
H&G	*House and Garden*
HB	*House Beautiful*
LHJ	*Ladies' Home Journal*
RHFE	*Retailing: Home Furnishings Edition*

ARCHIVAL COLLECTIONS

Century of Progress, CHS
Century of Progress, Chicago World's Fair Collection,
Chicago Historical Society

Century of Progress, Yale
Century of Progress, World's Fair Collection,
Manuscripts and Archives, Yale University Library

Deskey Archives
Donald Deskey Collection, Industrial Design Archives,
Cooper-Hewitt National Design Museum Library

Geddes Papers
Norman Bel Geddes Papers, Performing Arts
Collection, Harry Ransom Humanities Research
Center, University of Texas, Austin

Guild Archives
Lurelle Guild Archives, Department of Special
Collections, Syracuse University Library

HMI
Corporate Archives, Herman Miller, Inc., Zeeland, Mich.

Rohde Scrapbooks
Gilbert Rohde Scrapbooks, Industrial Design Archives,
Cooper-Hewitt National Design Museum Library

Wright Archives
Russel Wright Archives, Department of Special
Collections, Syracuse University Library

Notes

INTRODUCTION

1 The best-known non-German International Style designer is, of course, Le Corbusier. In *Design 1935–1965,* Martin Eidelberg uses the term "International Style" to describe the modernism that came out of the Bauhaus and Le Corbusier's studio, and which was promoted by MoMA. Although he goes on to delineate other strands of modernist design, such as the work of Alvar Aalto, Eidelberg's history of modern design uses the International Style as the standard-bearer. See "The Modernist Canon," in Eidelberg, *Design 1935–1965,* 22–28. Among the most influential texts that argued for the superiority of the International Style were: Pevsner, *Pioneers of Modern Design,* 1936; and Gideon, *Space, Time and Architecture,* 1941. The defining exhibitions at MoMA were: *Modern Architecture: International Exhibition* (1932), *Machine Art* (1934), and *Bauhaus, 1919–1928* (1938).

2 Among the most important publications in the "new" modernist design history is the anthology edited by Paul Greenhalgh, *Modernism in Design,* which consists of a series of case studies of modernist design practice in various European countries, Britain, and the United States. Eidelberg's *Designed for Delight* provides a thematic look at the tropes in twentieth-century design that had often been discounted from the modernist canon, such as ornament and craft, which constitute "the secret history of Modernism" (17).

3 Nancy Troy provides a nuanced account of the politics and historical references (despite its claims to newness) behind much French modernist design in *Modernism and the Decorative Arts.* Tag Gronberg discusses the spectacle and commerce that helped to define modernism at the Paris Exposition in *Designs on Modernity.*

4 Most of these designers were World War I-era émigrés, including Paul Frankl, Ilonka Karasz, and Joseph Urban.

5 The official report submitted by Hoover's U.S. Commission is *Report of Commission...,* 1926.

Among the delegates were Richard F. Bach (of the Metropolitan Museum), Hiram C. Bloomingdale (of the department store), Walter W. Kantack (lighting fixture designer), Karl Schmieg (furniture manufacturer), and Richardson Wright (editor of *H&G*).

6 Elizabeth L. Cary, quoted in "Bringing Art Into Trade," *Literary Digest* 93 (28 May 1927): 26. Richard F. Bach, the Metropolitan Museum's evangelist for modern design, was quoted at the 1927 Macy's exhibition proclaiming, "In time you will come to realize that there is just as much art in your rug or your doorknob as in any oil painting in the Met." Murdock Pemberton, "The Art Galleries," *The New Yorker,* 14 May 1927.

7 Ibid.

8 Quoted in "Art in Manufacture and Trade," *Bulletin of the Metropolitan Museum of Art* 22 (June 1927): 180. The following year, in another exhibition of modern design at Macy's, the President of the Arts Council of New York asserted, "We have traded the joy of creation, which is now done by a few 'hands' who tend machines, for the joy of use in which all of us can participate as personalities." John A. Agar, "The New Emphasis in American Industrial Art," *An International Exposition of Art in Industry,* exhibition pamphlet (New York: Macy's, 14–26 May 1928), 64.

9 Douglas Haskell, "The Architects' Modern Rooms at the Metropolitan," *Creative Art* 4 (March 1929): xlvii.

10 "What D'You Mean, Modern?," 97.

11 Walter Rendell Storey, "Modern Trends in Decorative Art," *New York Times Magazine,* 11 November 1934, 14.

12 Ely Jacques Kahn, "Note by the Chairman of the West Gallery Unit," *Bulletin of the Metropolitan Museum of Art* 29 (December 1934): 205. The anonymous writer for *Fortune* also called for affordable modern designs in the Depression era, asserting that a goal of modernist design in the United States must be "to design modern furniture for mass production at low costs and at low prices" ("What D'You Mean, Modern?," 100).

13 Rutt, *Home Furnishing,* 146. I am grateful to Phyllis Ross for directing me to Anna Rutt's book.

14 Mies's chair was featured in houses at the *Weissenhofsiedlung,* with the implication that it would be affordable to the working families meant to live in those houses. In fact, however, its industrial reproduction was not particularly cost-effective, and the design was far more expensive than other furnishings displayed in the model homes. Pommer and Otto, *Weissenhof 1927,* 252 n.47.

15 Ibid., 129. See also Hitchcock and Johnson, *The International Style,* 92.

16 Aronson, *Furniture and Decoration,* 157. Designer Paul T. Frankl also argued for greater warmth in modernist designs of the 1930s. He contrasted metal furniture, which "has the disadvantage of lacking warmth, texture, and appeal to the sense of touch that wood and other materials possess," with cork, another modern material that is "pleasant to the touch; its texture interesting to the eye; its warmth congenial to its use in furniture covering" ("Furniture for the House of Tomorrow," *Architecture* 69 [April 1934]: 194).

17 The strength of Colonial Revival styles in the furniture market is mentioned in many trade articles, including "A Style Synthesis," *RHFE,* 30 January 1933, 5; "North West East South," *FR* (February 1933): 45; and "Style—and Still More Style," *RHFE,* 15 January 1934, 3.

18 Stillinger notes that the Centennial kitchen was not the first reconstruction of a "colonial" kitchen; the first was probably in 1864 at the Brooklyn Sanitary Fair. However, it was the celebration of the nation's centennial, across the country, that spurred the Colonial Revival into a major home decorating movement. *Antiquers,* 8–9, 14–16.

19 Wallace Nutting, *Furniture of the Pilgrim Century (of American Origin): 1620–1720* (1924), quoted in Rhoads, "Colonial Revival," 42. For an in-depth study of Nutting and his commercialization of American history, see Denenberg, *Wallace Nutting.* For an excellent study of the Anglo-American biases behind the creation of the American Wing, see Wendy Kaplan, "R. T. H. Halsey: An Ideology of Collecting American Decorative Arts," *Winterthur Portfolio* 17 (Spring 1982): 43–53.

20 Ad for W. F. Whitney Co., *GH* 96 (June 1933): 162.

21 "The Story of America is the Story of Colonial Furniture" *HFA* 2 (Fall & Winter 1934): 52. *HFA* was a large-format glossy magazine, published between 1933 and 1935, that featured watercolor renderings of model rooms (reprinted throughout this book) in many styles, to be either copied in the retail environment or shown to potential customers for decorating inspiration.

22 Warren I. Susman, "The Culture of the Thirties," in *Culture as History,* 156–58.

23 Mintz and Kellogg, *Domestic Revolutions,* 116–17.

24 Paul Towsley, "In Dull Times Women Listen— Then Buy," *FR* (April 1933): 36; "Mrs. Customer— The Buyer's Best Friend and Severest Critic," *CGJ* 114 (June 1934): 11.

25 The sophistication of the advertising industry in the 1920s and 1930s, both in its use of design and emotional appeal, is discussed in Marchand,

Advertising the American Dream, and in Lears, *Culture of Consumption.*

26 Russel Wright, "Modern Design," *AH* 11 (January 1934): 60-61.

27 [Gilbert Rohde], *20th Century Modern Furniture Designed by Gilbert Rohde,* manufacturer's pamphlet (Zeeland, Mich.: Herman Miller Furniture Company, 1934), 1–2.

28 An editorial from 1932 in *LHJ* exalted the power of women consumers by proclaiming that their spending would save the national economy: "The pocketbook of the American woman is the barometer of American business… Right now, if she opens her purse, she can help end the depression… The household buyers in 29,000,000 homes [have refused] to recognize their responsibility" ("Pocketbook Patriotism," *LHJ* [February 1932]: 3).

29 Le Corbusier, *Towards a New Architecture,* 279.

30 Philippe Garner displayed this prejudice when he set modern design in opposition to the twentieth-century marketplace: modern design, in his words, is "expressive of a new order, embracing democratic, utopian ideals," but in the first decades of the twentieth century, it "had little immediate impact on the marketplace," which he dismissed as defined by a "desire for display, decoration, and opulence… symbols of status" ("Modern Design: The Quest for Ideal Form," in *Sitting on the Edge: Modernist Design from the Collection of Michael and Gabrielle Boyd,* ed. Aaron Betsky [San Francisco: San Francisco Museum of Modern Art, 1998], 18–19). R. Craig Miller also expressed disapproval of this particular vein of 1930s modernism—which he dubbed "the moderne": "… even from today's perspective, one would be reluctant to say that [the moderne mode] produced many masterworks" (*Modern Design,* 179).

31 Lupton and Miller offer a creative account of the aesthetics of hygiene and waste in domestic designs in *The Bathroom, the Kitchen.*

32 Warren I. Susman, "Culture and Commitment," in *Culture as History,* 184-210.

33 Mintz and Kellogg, *Domestic Revolutions,* 134; Wandersee, "Working Women," 51.

34 Wandersee, "Working Women," 49–51.

35 The phrase "making do" is taken from Westin's *Making Do.* Her book is a series of autobiographical statements from women who lived through the Depression, describing economizing strategies such as menu planning, reusing items, and borrowing and sharing with adult siblings. Susman describes the mindset that led citizens to blame themselves for their financial shortcomings in "Culture and Commitment," in *Culture as History,*

192–97. Horowitz explains that in the Depression, access to material goods became a sign of health, whereas in the 1920s the rise of materialism had been branded by some pundits as a moral failing. He proposes that the materialism of the 1920s thus only became fully entrenched and embraced in American society during the Depression. See Horowitz, *Morality of Spending,* 152–60.

36 Mintz and Kellogg, *Domestic Revolutions,* 137; Wandersee, "Working Women," 49; Westin, *Making Do;* Ware, *Holding Their Own,* chapter 1. On the status of women in the work place—more married women worked during the Depression, but with a general loss of prestige and earning power—see Scharf, *To Work and to Wed,* 1980.

37 Wandersee points out that many budgets featured in women's magazines were based on annual incomes far in excess of the national median, and writes, "A budget implies that there is room for flexibility with respect to expenditures, and, although most families established priorities through the simple act of buying, few had a surplus requiring conscious decision or varied choices" ("Working Women," 51).

38 Advertisement for Royal Baking Powder, *BHG* 12 (April 1934): 45. The irony of this advertising campaign was that it encouraged consumers to buy Royal through appeals to frugality, while admitting it was a more expensive baking powder; the company's argument was that Royal's quality made it a better investment for the housewife. Another advertisement featured a housewife saying "Even though we're living on $900 a year—there are some things I won't give up…" *BHG* 12 (March 1934): 9.

39 Haberler, *Consumer Instalment Credit,* 2. Haberler's research indicates that the percentage of sales made on credit at furniture stores increased from approximately 38 percent in 1925 to 43 percent in 1940; he charts a steady increase from 1925 to 1934, and relatively stable percentages from 1934 to 1940 (Chart XI, p. 137). Furniture production reached a nadir in 1932–33 but regained pre-Depression levels by 1936–37; the percentage of sales made with credit remained basically stable throughout these years (Chart XIII, p.156). Interestingly, the percentage of credit sales at department stores from 1925 to 1940 was considerably lower: 8 percent to 12 percent over the period. This is no doubt due to the quantity of smaller goods for sale in department stores that would not have been sold on credit; however, when Macy's introduced Russel Wright's Modern American furniture line, it specified that purchases could be made with cash only. See Advertisement for Macy's, *New York Times,* 26 January 1936, 11.

40 Ware, *Holding Their Own,* 2.

41 "Pocketbook Patriotism," 3 (see note 28).

42 A Donald Deskey dining suite was described as an example of "mass production" design, among other more expensive designs, in "House & Garden Presents a Portfolio of Furniture Showing the Latest Developments in Modern Design," *H&G* 65 (February 1934): 46. The Amodec line, designed by Deskey and Leo Jiranek to be inexpensive and widely available, was highlighted in both magazines as an intelligent, selected purchase one might make: a dining table and dressing table were featured in "Good Buys of the Month," *HB* 77 (January 1935): 35; a bedroom suite appeared in "Inexpensive Groups," *H&G* 67 (January 1935): 55.

43 *AH* featured Deskey and Jiranek's Amodec line as the means for outfitting an entire multifunctional living room in a modern house they sponsored: "We Decorate a Modern Home," *AH* 14 (October 1935): 374–75.

44 The editors of *LHJ* provided designs by Walter Dorwin Teague for readers to copy in 1934, claiming that "Brass, copper, aluminum and wood—a little patience, a little time, a lot of fun—and the work is soon done!" ("Metalcraft," *LHJ* [March 1934]: 75).

45 De Pree, *Business as Unusual,* 41. De Pree is also quoted as saying he believed there "was more integrity in modern than traditional [furniture]" (Guilfoyle, "Herman Miller," 40). Ralph Caplan also discusses De Pree's belief in modernist design in *The Design of Herman Miller.*

46 Hazel H. Adler, "Looking into the Future in Furniture Design," *FR* (January 1933): 39.

47 Advertisement for *The Evening Bulletin, Saturday Evening Post,* 2 April 1932, 83. The *LHJ* editorial, "Pocketbook Patriotism," from 1932 is another example of this rhetoric (see note 28).

48 For a more in-depth discussion of the development of ensemble displays in the museum and retail worlds during the 1920s, see Kristina Wilson, "Exhibiting Modern Times: American Modernism, Popular Culture, and the Art Exhibit 1925–1935" (Ph.D. diss., Yale University, 2001), chapter 2.

49 Edward M. Benesch, "Collars on Necks—Stockings on Legs—Why Not Furniture in Rooms?" *FR* (May 1933): 16–17.

50 "Furniture on Display," *A&D* 42 (March 1935): 48.

51 Ellen Newman, "Small-town Furniture Selling," *FR* (January 1933): 44.

52 Century Homes, Inc., "House of Tomorrow," exhibition pamphlet (Chicago: 1933), 1, Century of Progress, Yale.

53 See, among others, R. Craig Miller, *Modern Design;* Gebhard, *Kem Weber;* Wilson, et al., *Machine Age;* and Eidelberg, *Design 1935–1965.*

54 For a discussion of the role of advice manuals in design history, as well as a formulation of the concept of an "ideal" life for design objects, see the entire volume of the *Journal of Design History* 16, no. 1 (2003). See especially in that volume essays by Grace Lees-Maffei and Penny Sparke.

55 Susman, "Culture and Commitment," in *Culture as History,* 185.

CHAPTER 1

1 I found the cartoon in the archives at Herman Miller, Inc., in Zeeland, Michigan. While the format of the cartoon is clearly from the *Saturday Evening Post,* its exact date is unknown. Based on the design of the chair, almost identical to one featured on page 36 of Warren McArthur's 1936 product catalogue (see note 23 below), the cartoon can arguably be dated to the middle years of the decade.

2 Architects and critics at the turn of the century interpreted such changes not as a mere consequence of technology, but as a progressive movement that would influence and inspire the daily lives of families. Fewer rooms with more open access, many believed, would encourage less formal interactions and less materialistic values than those allegedly fostered by the segregated, elaborately decorated spaces of typical Victorian dwellings. In such progressive, efficient houses, the family was intended to gather together in a series of casual, open spaces that accommodated a wide variety of social and private interactions. Wright, *Moralism and the Modern Home,* chapter 8, esp. 233–34. See also Clark, *American Family Home,* chapter 5.

3 The multi-use trend in living room spaces was endorsed by the *Architectural Record* by the mid-1930s, when editors wrote, "Dining and living rooms often serve diverse purposes and should be of ample size to allow for dining, entertaining, and in some cases as play space for children" ("Planning the House Interior," *Architectural Record* 77 [May 1935]: 312).

4 Guild, *Designed for Living,* 21.

5 "They Asked for Modern," *HB* 75 (May 1934): 55.

6 Norman Bel Geddes, "The House of Tomorrow," *LHJ* 48 (April 1931): 12–13, 162. Frank Lloyd Wright is usually credited with popularizing the first domestic structures that reoriented the family spaces of the house away from the street for greater privacy. See, for example, H. Allen Brooks, *The Prairie School:*

Frank Lloyd Wright and His Midwest Contemporaries (New York: W. W. Norton and Co., 1972), chapters 5, 6, 7.

7 "Design for Living: House Number Four of the Home and Industrial Arts Group at the Century of Progress," *HB* 73 (May 1933): 210, 230.

8 Dorothy Fleitmann, "Beds Brought Up to Date," *HB* 73 (April 1933): 164. Rohde also made this point when he reminded consumers in a product brochure: "Our rooms are smaller, yet we want more comforts. Space must be used to the greatest advantage. In some cases we combine dining and living facilities. Occasionally, we require sleeping facilities in the living quarters... All this can be accomplished in a haphazard way with furniture of past periods but so much more easily, perfectly and beautifully with furniture that was planned to fill these modern needs" (*Smartset: Adapted to the Spirit and the Living Needs of Our Age, designed by Gilbert Rohde,* manufacturer's pamphlet [Chicago: Valentine-Seaver/Kroehler Manufacturing Company, 1934–35], 1. HMI).

9 A typical unsubstantiated claim for the technological efficiency of modernist furnishings was made by a writer for *Fortune* magazine in 1935: "True Modernism proceeds out of a completely practical idea. The modern house and everything in it is built for just one purpose: to work. Only that is modern which works and which *looks as though it worked*" (italics original; "What D'You Mean, Modern?," 97–100).

10 Italics original; "Bulletin No. 3," The Herman Miller Furniture Company, Zeeland, Mich., 31 May 1934, 1. HMI.

11 Attributed to Russel Wright, "American Modern—Furniture Designed by Russel Wright for Conant Ball Company," typed ms., undated, c. 1935, 3. Wright Archives. My thanks to Donald Albrecht for sharing his copy of this document.

12 Albrecht et al., *Russel Wright,* 31, 83–84, 144–45.

13 "American Modern," 3, 4, 5 (see note 11).

14 For an overview of Rohde's career and his work at Herman Miller, see Ostergard and Hanks, "Gilbert Rohde"; Piña, "American Modernist"; Guilfoyle, "Herman Miller"; and Abercrombie, "The Company That Design Built." For a discussion of the likely origins of modernist modular furniture, as well as information about other modular cabinet pieces designed by Rohde, see Ross, "Modular Meets Industry." The forthcoming book on Rohde by Ross will be a definitive study of his career.

15 Elinor Hillyer, "Complete in Three Acts," *Delineator* (May 1936): 62. Rohde Scrapbooks.

16 Ibid.

17 "What D'You Mean, Modern?," 97. This article identifies Wright's line as "middle-priced," which is

corroborated by a home furnishings budget published in 1935 by Anna Hong Rutt, professor of Interior Design at the University of Chicago, based on Department of Commerce publications. I use Rutt's budgets throughout this book as a benchmark to give a general sense of the relative expensiveness of items; however, her budgets must be taken as a guideline only, since no one can account for how individuals choose to spend within or beyond their means. Rutt asserts that consumers in the lower-third or middle-third nationally of income-earners (she estimates that the middle-third of families earn between $1,000 and $2,000 annually), should spend between $180 and $400 on living room furniture, which Wright's line allows one to do, although its individual prices vary from Rutt's itemized budget: she suggests an easy chair cost $40 and a coffee table $20, while Wright's armchair (see p. 36) retailed for $19.98 and his coffee table for $11; Rutt suggests $27.50 for a desk and $7.50 for a desk chair, while Wright's cost $40 and $13.50, respectively. Rutt, *Home Furnishing,* 195. For Wright's prices, see Advertisement for Macy's, *New York Times,* 2 February 1936, 16; and "We Furnish Two Houses," *HB* 78 (October 1935): 106.

18 Advertisement for Macy's, *New York Times,* 2 February 1936, 16. The new finish, "blond," was announced in the Winter 1936 furniture market; see "More Reviews from the Midwest," *RHFE,* 20 January 1936, 30. Wright's wife, Mary, coined the phrase blonde to describe the lighter finish. Lindsay Stamm Shapiro, "A Man and His Manners: Resetting the American Table," in Albrecht et al., *Russel Wright,* 31.

19 In the context of Rutt's furnishing budgets from 1935, Rohde's first sectional sofa and the East India Laurel Group would have fallen in either the middle-third or the upper-third income budget, whereas Wright's could have fallen in either the lower-third or middle-third. See Rutt, *Home Furnishing,* 195. Some of Wright's and Rohde's designs were comparable in price: Wright's bookcase from the modular group retailed for $31, while the two simplest bookcases in the East India group retailed for about $20 (no. 3454) and $23.50 (no. 3432); and a larger utility cabinet (no. 3437) was about $49. However, the individual seats in the sectional sofa were $48 and the corner seat was $73.50; compare with $19.98 for Wright's armchair and $39.95 for his three-seater settee. For Wright's prices, see "We Furnish Two Houses," 106; and Advertisement for Macy's, *New York Times,* 2 February 1936, 16. For Rohde's prices, see the files for the Herman Miller Consortium, The Henry Ford Museum, Dearborn, Mich.; and *HFA Confidential*

Pricing Guide 2 (Fall–Winter 1934): 41; and 3 (Fall–Winter 1935): 18.

20 See *Herman Miller 1940,* 12–13, 20–21, 34–35. Ross discusses the differing prices of Rohde's later modular designs for Herman Miller in "Modular Meets Industry," 36–40.

21 "American Modern," 3 (see note 11).

22 *Modern Chromsteel Furniture by Howell,* manufacturer's catalogue (Geneva, Ill.: The Howell Company, 1933), 1.

23 *Warren McArthur Corporation,* manufacturer's catalogue (New York: Warren McArthur Corporation, 1936), 2.

24 *Modern Chromsteel Furniture by Howell,* 1. The trade journal *RHFE* noted the interest that the Chicago Fair had stimulated in the tubular metal furniture industry, and in Howell's products in particular. See "See World's Fair Influencing Call for Metal Furniture," *RHFE,* 4 September 1933, 6.

25 Advertisement for Howell Chromsteel, *HFA* 2 (Fall–Winter 1934): 105. For more on Hoffmann's career, see Downs, *Shaping the Modern,* 52–53. Hoffmann was married to the designer Pola Hoffmann, although they divorced in the 1930s; he was involved in numerous design organizations, such as AUDAC.

26 *Howell Modern Chromsteel Furniture,* manufacturer's catalogue (St. Charles, Ill.: The Howell Company, 1936), 3.

27 *Modern Chromsteel Furniture by Howell,* 1.

28 Many of the Howell designs attributed to Hoffmann are similar to pieces produced by Troy Sunshade Company, attributed to Rohde, and Lloyd Manufacturing Company, attributed to Kem Weber; in this realm of furniture production, the sharing—or stealing—of basic design concepts and specific design details seems to have been unusually prevalent and is a ripe topic for future research.

29 Rutt's model living room budget for middle-income consumers recommended spending about $110 for a sofa, $40 for an easy chair, and $20 for a coffee table. Hoffmann's sofas retailed for about $100 (design no. 393-2) in 1934 and $140 in 1936, and an easy chair cost between $60 and $85 (design no. 469-1) during this period; however in 1935, the lounge chair (no. 360-1; fig. 1.17) was markedly more expensive, retailing for about $95 upholstered in mohair. A coffee table (no. HA 140) was $13. Rutt, *Home Furnishing,* 195. The price lists found in surviving Howell catalogues are often for wholesale, and retail figures must be corroborated elsewhere. For sample retail prices see *HFA Confidential Pricing Guide* 2 (Fall–Winter 1934): 14–15; and 3 (Fall–Winter 1935): 20; and "Smokers Take on New Aspects," *RHFE,* 20 July 1936, 26.

30 An influential retailing manual featured two domestic vignettes of Howell furniture in 1934—one for a sunroom and one for a living room—further corroborating the significance of sales for the private home market. See "Sunrooms Go Modern," *HFA* 2 (Spring–Summer 1934): 57; "Beauty and Utility," *HFA* 2 (Fall–Winter 1934): 29.

31 For an overview of McArthur's career and a discussion of his manufacturing technology, see Berman, "McArthur Returns."

32 *Warren McArthur Anodic Aluminum Furniture,* manufacturer's pamphlet (Rome, N.Y.: c.1933). Century of Progress, Yale.

33 The annual meeting of the AIA is referred to in the manufacturer's catalogue, *Warren McArthur Corporation,* 2.

34 *Warren McArthur Corporation,* 3.

35 Downs and Berman both cite the relatively limited scope of his retailing campaigns (Downs, *Shaping the Modern,* 50–53; Berman, "McArthur Returns," 74). A price list located in the 1936 McArthur catalogue at Columbia University appears to be discounted retail, since the company did not wholesale to other retailers; comparisons with Howell are thus necessarily generalized, since McArthur's prices were probably higher than the figures I found. A McArthur sofa (no. 987AU) comparable in size and heft to the $100 1934 Hoffmann (no. 393-2) is listed at prices ranging, depending on fabric, from $87 to 116; a McArthur chair (no. 1079AU) comparable to the $85 1934 Hoffmann (no. 469-1) is listed from $50 to 80. McArthur's coffee tables were markedly more expensive than Hoffmann's: compare $13 (Howell HA 140) with $15 to 22 (McArthur 1558-5) for a similar-size item. See *HFA Confidential Pricelist* 2 (Fall–Winter 1934), 15; *Warren McArthur Corporation,* pricelist 1, 2, 4.

36 *Warren McArthur Anodic Aluminum Furniture,* n.p. The 1936 catalogue lists selected private owners, including E. L. Cord, Norma Shearer, Constance Bennett, and Marlene Dietrich.

37 "American Modern," 4 (see note 11).

38 The popular magazine *AH* featured a model modern house in its October 1935 issue furnished with objects from the short-lived Amodec line, designed by Donald Deskey and Leo Jiranek. Like the other chairs discussed here, the Amodec living room chairs were intended to be mobile: "These chairs are 'pullups' too, and can be moved easily to either the library or conversation group [in the living room]. This arrangement makes the room adaptable and adjustable for most of the different occasions to which a living room must be equal" ("We Decorate a Modern Home," *AH* 14 [October 1935]: 375). It is worth noting that these Amodec chairs, in moving from the typically masculine preserve of the "library group" to the typically feminine realm of conversation, appear to transcend gender specificity.

39 Rutt, *Home Furnishing,* 198.

40 Guild, *Designed for Living,* 21.

41 Post, *Personality of a House,* 338.

42 For feminist critiques of modernist orthodoxy, see, for example, Beatriz Colomina, "War on Architecture," *Assemblage* 20 (1993): 1–29; Caroline Constant, "E.1027: The Nonheroic Modernism of Eileen Gray," *JSAH* 53 (1994): 265–79; Mary McLeod, "Charlotte Perriand: Her First Decade as a Designer," *AA Files* 15 (Summer 1987): 3–13; and Sparke, *As Long as It's Pink.*

43 Mintz and Kellogg, *Domestic Revolutions,* 113. Chapter 6 in Mintz and Kellogg provides an extensive discussion of the impact of the companionate model on interpersonal relationships and family dynamics. For a discussion of the influence of the companionate model on Hollywood's representation of the romantic couple, see Wexman, *Creating the Couple.* Another good survey of the place of the companionate model in a national framework is May, "Myths and Realities."

44 Tess Slesinger, *The Unpossessed* (1934; reprint, New York: The Feminist Press, 1984), 15.

45 *Modern Priscilla,* 134. Rutt offered a similar gender-balanced account of the living room in 1935: "There should be a place for every member of the family to follow his or her occupation, and a well-lighted comfortable chair for each. A small chair should be provided for each small child" (*Home Furnishing,* 198).

46 "Bizarre" and "eccentric" were two favorite words of condemnation among critics and the public. Wright's American Modern line, for example, was advertised as "not bizarre" (Advertisement for Macy's, *HB* 78 [August 1935]: 61). For other instances of these epithets, see, for example, Richard F. Bach, "Styles A-Borning: Musings on Contemporary Industrial Art and Education," *Creative Art* 2 (June 1928): xxxviii; and Todd, "Some Reflections on Modernism," 417.

47 Lewis Mumford, "At the Galleries," *The New Yorker,* 14 April 1934, 64.

48 "The House that Works: I," 64.

49 Donald Deskey, "Modern vs. Modernistic," typed ms., c. 1935. Deskey Archives. Deskey was not the first in the period to use these terms for precisely this distinction. See also "Modern Making a Bigger Showing," *RHFE,* 2 January 1933, 3; and, probably the most widely disseminated source, a MoMA-sponsored lecture on modern design (Lecture # 12, "The Modern Room") from an NBC series on

modern American art and design, broadcast on December 22, 1934. MoMA Archives.

50 Ibid.

51 "The House that Works: I," 64.

52 Aileen Spafford, "Modern Living Room That Yet is Comfortable and Homey," *Detroit Free Press,* 31 October 1934. Rohde Scrapbooks. Rutt also encouraged her readers to think of their living rooms in these terms: "A living room so fine that the men of the house do not feel free to lounge in it does not serve its purpose" (*Home Furnishing,* 15).

53 D. W. Jones, "Design Marches On," *FR* (June 1933): 49.

54 [Gilbert Rohde], *20th Century Modern Furniture Designed by Gilbert Rohde* (Zeeland, Mich.: Herman Miller Furniture Company, 1934), 4. HMI.

55 Crowley, "The Sensibility of Comfort"; and Grier, *Culture and Comfort,* chapters 4 and 7. Karen Halttunen documents the increasing interest in a comfortable living room around the turn of the century in "From Parlor to Living Room: Domestic Space, Interior Decoration, and the Culture of Personality," in Bronner, *Consuming Visions,* 157–90.

56 Slesinger, *The Unpossessed,* 355. Margaret's reference is made more poignant by her situation as she offers these comments, returning home deeply remorseful from having had an illegal abortion.

57 "This Charming Room Holds Firm to Its Genuine American Origin," *HFA* 2 (Spring–Summer 1934): 40. Another example from *HFA* demonstrates the safe authority of historical styles as well. In describing a model living room in a modernist style, the editors wrote: "[T]his attractive living room can hold up its head with the most seasoned of period rooms and still not feel like an awkward child in the presence of its elders" ("Combining Traditional Dignity with Twentieth Century Dash," *HFA* 2 [Fall–Winter 1934]: 28).

58 "Conant Ball Introduces American Modern Designed by Russel Wright," manufacturer's pamphlet (Gardner, Massachusetts, c.1935). Wright Archives. My thanks to Donald Albrecht for sharing his copy of this document.

59 Rohde, *20th Century Modern Furniture,* 1.

60 Gilbert Rohde, *An History of Modern Furniture from Prehistoric Times to the Post War Era by the Herman Miller Furniture Company* (Zeeland, Mich.: The Herman Miller Furniture Company, 1940), 1. HMI.

61 Ibid.

62 Advertisement for Herman Miller Furniture Company, *HFA* 1 (Fall 1933): 8; and Rohde, *20th Century Modern Furniture,* 2.

63 *Howell Modern Chromsteel Furniture,* 3.

64 *Warren McArthur Corporation,* 1.

65 Ibid., 67.

66 Advertisement for Lloyd Manufacturing Company, in Sironen, *American Furniture,* n.p. For an extensive history of Lloyd, see Beebe, "Lloyd Manufacturing Company."

67 Post, *Personality of a House,* 336–38. The editors at *HFA* praised a model interior outfitted with Rohde's recent designs for Herman Miller in similar terms: the living room had "an inviting atmosphere of warmth and livability" ("A New Viewpoint on a Fine Old Custom," *HFA* 3 [Fall–Winter 1935]: 31).

68 Rutt, *Home Furnishing,* 198.

69 Aronson, *Furniture and Decoration,* 300; Guild, *Designed for Living,* 21.

70 Lynd and Lynd, *Middletown in Transition,* 269.

71 Ibid., 270.

72 Ibid., 270–71.

73 Ewen, *Captains of Consciousness,* 160–61. See also Lorraine Greaves, *Smoke Screen: Women's Smoking and Social Control* (Halifax, Canada: Fernwood Publishing, 1996), 16–23.

74 See, for example, advertisements from the 1933–35 period, in magazines such as *H&G* and *LHJ,* featuring endorsements by beautiful, youthful society women.

75 Paul T. Fankl, "Why We Accept Modernist Furniture," *A&D* 2 (June 1928): 59, as quoted in Downs, *Shaping the Modern,* 53.

76 "A New Viewpoint on a Fine Old Custom," 31 (see note 67).

77 Aronson, *Furniture and Decoration,* 300.

78 Post, *Personality of a House,* 342.

79 Advertisement for Macy's, *New York Times,* 2 February 1936, 16.

80 For a history of the rocking chair form, see Ellen and Bert Denker, *The Rocking Chair Book* (New York: Mayflower Books, 1979). Howell also staked a large part of its company in the 1930s on a technological improvement to the rocking chair, the "glider" sofa, which was an outdoor sofa suspended with springs above metal runners that made a gliding back-and-forth motion.

81 *Howell Modern Chromsteel,* 3. Warren McArthur also emphasized the importance of bodily comfort in his designs in his 1933 brochure. Two product descriptions read: "Deep cushions make this Davenport luxuriously comfortable"; and "[Here is] a grand chair to be lazy in. It's a real invitation to sit down and rest awhile" (*Warren McArthur Anodic Aluminum Furniture,* n.p.).

82 "Here is the Tempo of Today—and the Decoration of the Future," *HFA* 3 (Fall–Winter 1935): 33.

83 Rutt, *Home Furnishing,* 198. Post also recommended that a living room be "a room in which a big fire burns on cold days and evenings" (Post, *Personality of a House,* 341). A 1934 article demonstrated the importance of the fireplace by concluding

that it provided "the stage" for "happy times ahead" for those who effectively arrange their living room furniture around it (Grace Cornell, "Fun Around Your Fireplace," *LHJ* [February 1934]: 26–27).

84 "Design for Living," 222.

85 Reynolds, *Decorating Your Home,* 47.

86 "Decoration for the Customer," *A&D* 41 (November 1934): 51.

CHAPTER 2

1 "The Old Homestead Goes Modern," *Official World's Fair Weekly,* Chicago, Illinois: Week ending 22 July 1933, 5. Century of Progress, CHS. Anna Rutt echoed this opinion of the dining room: "The dining room is not taken so seriously as it used to be; in fact it is often omitted. In a small house or apartment it is not sensible to reserve one fourth, one fifth, or one sixth of the home for dining, if the family uses it no more than seven times a week" (Rutt, *Home Furnishing,* 204). Although the economic plight of the Depression lent the campaign against separate dining rooms urgency, the architects of the 1930s were actually joining a debate that was several decades old. Its origins, like those of the multi-purpose living room, lay in the smaller, simplified floor plans of turn-of-the-century homes discussed in Chapter 1. See Wright, *Moralism and the Model Home,* chapter 8; and Clark, *American Family Home,* 163.

2 Alfred Auerbach, "Do You Know How the New Houses Will Influence Your Sales?" *RHFE,* 3 August 1936, sec. 2, p.4.

3 Devereaux Fay, "A Bride's Dining Room," *LHJ* (June 1932): 107. This article advises brides to register for gifts for the dining room so as to receive "a maximum of permanent reminders of real love and thoughtfulness." A decorating manual author from 1930 captured the lingering desire for a formal dining room, balanced with a recognition of contemporary limitations, when she described two potential functions for a dining room: the dining room should be "formal enough to pass muster for the boss's visit...yet [not be] too formal for Bobby's birthday party" (Reynolds, *Decorating Your Home,* 49).

4 The survey specified that dining rooms were still preferred, "particularly outside areas of urban influence and in western states" ("Building Types: Dining Rooms," *Architectural Record* 85 [May 1939]: 101). The article cites the Retail Furniture Association for the furniture figures.

5 "The Season's Trends in New York," *RHFE,* 18 December 1933, 25.

6 In *HFA,* one of the rare modernist dining suites was described as "Scaled for restricted quarters, the furniture is especially adaptable for use in a

small dining room" ("The Modern Urge Keeps its Head in This Refreshing Dining Room," *HFA* 2 [Spring–Summer 1934]: 38).

7 "Their First Dinette Suite," *RHFE,* 27 January 1936, 14. Although the dinette was included in a Lloyd catalogue for restaurant furniture, its publicity photograph—fig. 2.5, reproduced in *RHFE* and in the company catalogue—showed it in a distinctly domestic setting, replete with curtains, a floor lamp, and paintings on the wall, which indicates it was intended to be marketed to domestic buyers as well. *RHFE* cites Bach as the designer, but the Lloyd catalogue does not. *Lloyd Furniture: Chromium Furniture, Outdoor Furniture, Settee Booths and Rock-A-Feller Chairs for the Hotel, the Tavern, the Restaurant, the Cocktail Room, the Night Club, the Road House, and Other Interiors,* manufacturer's catalogue (Menominee, Mich.: 1936), 17. The name "Rock-a-Feller" in the catalogue title, which refers to a group of reclining and gliding lounge chairs, is a noteworthy example of the attempt to establish metal furniture as a luxury item; I am grateful to James Beebe for sharing this document with me.

8 For a discussion of the influence of ideas of hygiene on kitchen design, see Lupton and Miller, *The Bathroom, the Kitchen,* 41–63. For a broader study of hygiene in the kitchen and social standards of cleanliness, see Cogdell, *Eugenic Design,* chapter 5.

9 *Modern Priscilla,* 152; Aronson, *Furniture and Decoration,* 316.

10 Kinchin, "Interiors," 15–19.

11 Ames, *Death in the Dining Room,* chapter 2.

12 Allen explained this preferential seating in the 1915 edition of *Table Service,* 86.

13 Advertisement for Kroehler Manufacturing Company, in Sironen, *American Furniture,* n.p.

14 The *RHFE* editors noted that case pieces for dining rooms had sold best as open-stock items in the fall of 1933. "The Season's Trends in New York," 25. The editors at *CD,* another trade journal, commented in the Spring 1935 furniture market that "Suites are out and units are in," referring to the modular and open-stock items. Indeed, the effect of open-stock buying was similar to modular systems: the consumer could buy just what she needed. "Talking Points on the New Furniture," *CD* 1 (Fall 1934): 4. Both Kroehler's dining suite and Lloyd's dinette were offered open stock, as itemized prices for each object in both suites were available; Deskey's suite seems to have been retailed as a coordinated group. The Kroehler and Lloyd objects retailed in the middle- to upper-thirds of the market, as described by Rutt. Kroehler's simple side chairs were about $9, and the full padded and upholstered

armchairs about $19; a smaller version of the dinner table was about $23. Lloyd listed its smaller chair wholesale at $21, the larger at $22; the least expensive version of the table was $44.50, but the most expensive table top was $111. Deskey's suite, although described as "mass-produced," retailed for $350, which placed it firmly in the upper-level market. For a sample dining furniture budget, Rutt recommends spending $130 for middle-third income earners; $225 for upper-third; and $390 for luxury level. See Rutt, *Home Furnishing,* 196; and Eleanor Le Maire, "We Furnish the Prize $5000 House for $1200," *LHJ* 53 (August 1936): 61. For Rohde prices, see "What D'You Mean, Modern?," 102; for Bach prices, correspondence from James Beebe to author, 21 February 2003 and 21 November 2003; for Deskey, see "Modern Furniture Takes the Limelight," *RHFE,* 17 July 1933, 14.

15 "Lloyd Mfg. Co.," *RHFE,* 20 January 1936, 21.

16 *Lloyd Furniture: Chromium Furniture,* 17.

17 An example of mid-level architecture that included a living-dining room was published in *LHJ* in 1936. See Le Maire, "We Furnish the Prize $5000 House for $1200," 18ff.

18 *Modern Priscilla,* 151.

19 Auerbach noted that in urban apartments, living-dining rooms were more prevalent, and he called on manufacturers to provide more dinette options appropriate for these spaces. Auerbach, "Do You Know How the New Houses…" sec. 2, p. 5. *RHFE* reported that dinettes were among the strongest components of dining room furniture sales in the spring of 1934. "An Analysis of the N.Y. Sales in May," *RHFE,* 4 June 1934, 7.

20 In light of the continued popularity of entire suites of furniture throughout the decade, it is unlikely that Rohde's multifunctional dining objects ever sold as well as more traditional dining furniture.

21 William Muschenheim, "Furnishing the Interior," *Architectural Record* 77 (May 1935): 308–9. Toasters were advertised throughout the decade as an indispensable accessory for meals and hors d'oeuvres. The Toastmaster Automatic Electric Toaster (McGraw Electric Company, Minneapolis, Minn.) was featured in many advertisements. In 1932, the company proclaimed, "How much more appetizing toast makes a meal! Especially when it's Toastmaster Toast" (*Saturday Evening Post,* 5 March 1932, 108). A few years later they reminded consumers that "no crowd can stay stiff and formal when all the guests are making beautiful toast in the Toastmaster…and spreading snacks in inspired combinations" (*Collier's,* 5 October 1935, 39).

22 Christine Holbrook, "Now Modern Furniture of Good Design for the Average Purse," *BHG* 13 (May 1935): 25.

23 Rohde, *20th Century Modern Furniture,* 8.

24 Throughout the early years of the decade, modernist designs appeared least frequently in dining furniture. In a 1933 survey of furnishing markets nationwide, *RHFE* reported that modernist dining suites were almost nonexistent. "Modern Home Furnishings Found to be Consistently Improving in Sales," *RHFE,* 4 September 1933, 3–4ff; and 11 September 1933, 3. In its three years of publication from 1933 to 1935, *HFA* consistently featured far fewer modernist dining rooms than bedrooms or living rooms. In 1936, *RHFE* noted that more modernist options had become available in dining furniture. Alfred Auerbach, "The Fashion Story in Furniture," *RHFE,* 10 February 1936, sec. 2, p. 4.

25 Blaszczyk, *Imagining Consumers,* 146; Venable, *American China and Glass,* 57–64. Depression-era accounts also corroborate the trend toward fewer formal dinner parties, although sometimes these are offered in articles promoting buffet parties, the most popular alternative to formal dining, and thus must be viewed with some skepticism. See, for example, "The Buffet Table…Its Present Importance…Its Style Trends," *RHFE,* 24 August 1936, 19.

26 Photographs of formal table settings were extremely popular in Depression-era magazines. Both *H&G* and *HB* featured a model table almost every month throughout the early and mid-1930s, set to complement the season. In the same years, *AH* and *GH* had regular articles on table settings, particularly in the late spring, in anticipation of summer entertaining, and before the yearend holidays of Thanksgiving and Christmas. Among the many examples of table settings described as "modern," see (in addition to those reproduced here): *AH* 12 (November 1934): 352; *HB* 72 (April 1932): 92; *H&G* 67 (April 1935): 34; and 68 (July 1935): 35; and *CD* 1 (Fall 1934): 8–9.

27 Mary L. Van Dyck, "Serve it with Distinction," *AH* 12 (November 1934): 355.

28 R. Chamberlain and R. McCracken, "Modern Approach to Table Settings," *RHFE,* 21 September 1936, sec. 2, p.15. Some magazine editors emphasized the "originality" of modernist tablewares through their descriptive vocabulary. *H&G* referred to modernist tables as "dramatic," "unexpected," and "striking." *H&G* 67 (June 1935): 44; 68 (July 1935): 35. *AH* described one stylist who set a modernist table as "One of us has 'gone modern,'" implying an extreme departure from convention (*AH* 14 [November 1935]: 478).

29 *H&G* 68 (July 1935): 35. Piña dates the Plume candlestick (no. 2594) to 1930–34. Piña, *Fostoria,* 68. The pressed-glass technique, with which the Plume candlestick was made, had transformed the glass industry in the nineteenth century from one that created luxury items into one that catered to middle-class consumers. The pressed-glass candlestick no. 2484 from Fostoria, comparable in size to the Plume, retailed in 1933 for about $5, which gives a general indication of the market in which the Plume competed. According to the industry publication *CGJ,* a consumer of "moderate means who might be called an average china and glass customer" in 1934 would be prepared to spend about $5 on a normal trip to the store. For candlestick price, see Advertisement for Fostoria, *CGJ* 112 (February 1933): 3. For average consumers, see "Mrs. Customer," *CGJ* 114 (June 1934): 28.

30 For more extended discussion of Fostoria's company history and Sakier's work for Fostoria, see Venable, *American China and Glass,* 174–78; Piña, *Fostoria,* chapter 2; and Johnson, *American Modern,* 181.

31 Aronson, *Furniture and Decoration,* 322.

32 "Contemporary Dining," *A&D* 40 (November 1933): 13.

33 From a Cambridge Glass catalogue from about 1937, the individual candlesticks were priced between $2.50 and $3.75 per unit, and the flower bowls were also priced between $2.50 and $3.75. A configuration of five pieces could thus have cost between $12 and $20. In late 1937, Fostoria advertised a centerpiece group, consisting of two candlesticks and a bowl, for $7; Heisey Glass Company offered a pair of very ornate, traditional candelabras for $30. Thus the Table Architecture was priced for a consumer of more than "moderate means," but not at the luxury level. For Cambridge prices, see Cambridge Glass Company catalogue, courtesy of the National Cambridge Collectors, Inc. For Fostoria, see Advertisement, *AH* 19 (December 1937): 67. For Heisey, see "Glass," *H&G* 72 (December 1937): 63. For consumers of "moderate means," see "Mrs. Customer," 28.

34 Advertisement for Cambridge Glass Company, *H&G* 72 (December 1937): 102.

35 Allen, *Table Service,* 66–69.

36 Ibid., 65.

37 Kasson, *Rudeness and Civility,* 205–11.

38 Ibid., 207.

39 Allen, *Table Service,* 78, 82.

40 Herb Smythe, "Dinnerware and Company," *CGJ* 108 (December 1930): 54–55ff.

41 John Meredith, "Education by Demonstration," *CGJ* 108 (March 1930): 82–83ff; Greta O'Connell, "Jordan Marsh Customers Hear Table Talks," *CGJ* 110 (September 1932): 15; Mrs. Clara V. Eastman, "New Quirks Give Table-Setting Contest More Selling Power," *CGJ* 114 (January 1934): 33–34.

42 "Repeal! How Dining Tables Will Glow!" *CGJ* 113 (September 1933): 16; Advertisement for Fostoria Glass Company, *CGJ* 114 (May 1934): 5.

43 Weatherman, *Fostoria,* chapters 4 and 5; Piña, *Fostoria,* 16; Venable, *American China and Glass,* 437.

44 For other examples of motifs relating to outer space, see the logo for the 1933–34 Chicago World's Fair—a planet with Saturn-like rings—and Walter Von Nessen's "Saturn" bowl for Heisey from 1937.

45 Alden Welles, "Ebony Glass," *CGJ* 108 (May 1930): 19.

46 Sakier's designs for Fostoria were also a critical success. The 4020 pattern was included in the Metropolitan Museum of Art's 1931 *Twelfth Exhibition of Contemporary American Art* (October 12–November 22, 1931), where the *New York Times* said it "admirably illustrate[s] good design applied to quantity production" (Walter Rendell Storey, "Now the Factory Makes Beauty for Us," *New York Times,* 18 October 1931, 85). Also, the Cheneys endorsed him in their 1936 book, *Art and the Machine:* "[T]here is, in Sakier's list of achievements, the design of glass for moderate-priced tableware. This is one part of the widespread industrial design activity which is introducing a modern art standard to commodities hitherto without appearance standards. Pressed glass, one of the cheapest and earliest products of American industry, takes on distinction, even when marketed in ten-cent stores" (80).

47 An advertisement for Macy's department store from December 1930 listed Fostoria stemware at approximately $7/dozen; compare with the "average china and glass shopper" who is prepared to spend $5, in 1934. For Fostoria prices, see "The Nobel Prize in China and Glass Advertising Would Go To These Stores," *CGJ* 108 (December 1930): 72; "Mrs. Customer," 28.

48 "Notes on Glass Design," *Advertising Arts* (January 1933): 21. Source courtesy W. Scott Braznell.

49 Ibid.

50 Although it is difficult to generalize across the varied production of American glass companies, other lines that follow this basic trend are: Libbey's Greenbrier (1938), Embassy (1939), and Monticello (1940); Fostoria's 6011 stem design (introduced in 1934 with engraved patterns such as Celestial, Rocket, and Whirlpool) and the Westchester design

(1934). For illustrations of these designs, see Venable, *American China and Glass,* 167–76; Taragin, *Alliance of Art and Industry,* 159–65; and Advertisement for Fostoria, *CGJ* 114 (May 1934): 5. Contributing to the air of restraint was a trend toward colorless stemware, as indicated in the casual comment made by an author in *AH* in 1933: "this year more of us are choosing table glass in sparkling crystal-clear color" (Elizabeth MacRae Boykin, "Cordially Yours," *AH* 10 [June 1933]: 48).

51 Bredehoft, *Heisey Glass,* 239.

52 The design patent for the New Era line, issued to Rodney C. Irwin, is reproduced in Piña, *Depression Era,* 32.

53 "Tasteful Simplicity," *CGJ* 115 (July 1934): 24. Other examples of very similar language are "smart... simple...tasteful," from "In the Modern Manner...," *CGJ* 114 (April 1934); and "tastefully decorated setting of almost extreme simplicity" in "Mrs. Customer," 11. For repeal, see Edmondon Warrin, "And Now—A Toast! May Repeal Bring Fine Glassware Once More Into Its Own," *CGJ* 113 (October 1933): 13. Prices for Heisey wares, in the middle of the market, can be gleaned from a Macy's advertisement in the *New York Times,* 14 October 1934, 12, where 60 percent of glasses retailed for $7/dozen or less.

54 "Libbey Re-enters Field of Fine Crystal," *CGJ* 113 (August 1933): 26. The staple line had a low-end price of $10/dozen when it was introduced in mid-1933. A year later, the low-end price had been lowered to $3.50/dozen, no doubt because the original pricing had been too high to compete in the mid-level market. See, for example, advertisements in the *New York Times:* 27 August 1934, 16; and 5 August 1935, 16. For more on the commercial viability of the Libbey wares, see Venable, *American China and Glass,* 160–62, 436–37; and Taragin, *Alliance of Art and Industry,* 156, 160.

55 "Modern!" *CGJ* 114 (January 1934): 16.

56 The Malmaison pattern was featured in many Libbey advertisements, including one in *CGJ* 113 (September 1933): 10; and in *Vogue,* 15 January 1934. In *AH,* a Malmaison goblet was photographed with a Wedgwood plate possessing "dignity," and the editors reported that the glass accompanied it "pleasingly" (*AH* 10 [November 1933]: 286).

57 Advertisement for Libbey Crystal, *HB* 44 (March 1934): 3; and Advertisement for Libbey Crystal, *H&G* 64 (October 1933): 67.

58 "Repeal! How Dining Will Glow!," 16.

59 A. Douglas Nash, "Can Your Saleswomen Sell Thoroughbred Glass?" *CGJ* (October 1933): 16.

60 Weatherman's *Fostoria* lists the approximate dates of production for each variation of the accordion stem; see pp. 109ff and 223ff.

61 Allen, *Table Service,* 79.

62 Guild also designed for the Wear-Ever line in the 1930s. For a comprehensive account of the design history of aluminum products, see Nichols, *Aluminum by Design,* especially the essays by Dennis P. Doordan ("From Precious to Pervasive: Aluminum and Architecture") and Penny Sparke ("Cookware to Cocktail Shakers: The Domestication of Aluminum in the United States, 1900–1930").

63 Advertisement for Kensington, Incorporated, *AH* (May 1937). Guild Archives.

64 "Giftware Series Uses New Alloy," *RHFE,* 13 August 1934, 20; "The Story of Kensington," typed ms., c. 1935. Guild Archives. Guild believed that Kensington aluminum would compete with sterling silver in the marketplace because it, like silver, could be engraved: "A very important [item] in this group is the cigarette case. I have checked the field with great care and find there is a need for this piece in Kensington. This would compete with the sterling cases for it can be beautifully engraved and sell for half the price of sterling. Best of all, it is light and a good looking metal" (Lurelle Guild to W. H. Smith, 11 February 1937. Guild Archives).

65 "Suggested Uses for Kensington Pieces," typed ms., dated 1935. Guild Archives.

66 "The Story of Kensington." Guild's Zodiac platter, a serving dish to complement the dinner plates, balanced its austere, unornamented expanse with figural ornaments referring to classical mythology. The commercial success of this particular object can be anecdotally gauged by a story related by Guild: a visitor to his studio claimed that he had "recently attended two fashionable debutante weddings—one of the girls had received fourteen of these [Zodiac] platters as wedding presents and the other one, eight" (Lurelle Guild to W. C. White, 4 November 1935. Guild Archives).

67 An advertisement for Kensington coat brushes reminded readers that they would make a "prized" gift for the man in your life, "Especially if you have them engraved with his initials" (Advertisement for Kensington Incorporated, *Esquire* [December 1937]. Guild Archives).

68 *Kensington: Eleven New Pieces for Fall 1939,* manufacturer's pamphlet (New Kensington, Penn.: Kensington, Inc., 1939), 1. Guild Archives.

69 Prices for Kensington items were aimed at the upper-middle market, comparable to Cambridge's Table Architecture and pricier than the mid-market Fostoria designs. In December 1937, the Stratford compote was advertised at $12.50; in November 1937

the Northumberland canapé platter retailed for $7.50 and the large Zodiac platter for $12.50 (although in May of that year the Zodiac was advertised for only $10). For prices, see advertisements in Guild Archives.

70 "Buffet Service, a Distinctly New Contribution," *RHFE,* 27 November 1933, 10. A similar account was offered in 1936: "[The buffet party] is the outcome of the servant problem in America and living in small quarters. When the formal dinner passed from popularity for all but the top strata of society, the buffet table came into being, this group feels. And American women, sensing the opportunity for lighter, gayer parties that could be handled in small spaces, without servants if necessary, have adopted the buffet table as its own smart way of entertaining more guests than can be handled comfortably in the average dining room" ("The Buffet Table... Its Present Importance... Its Style Trends," 19 [see note 25]).

71 "Today and Yesterday," *BHG* 13 (May 1935): 63.

72 "Shopping Around," *H&G* 67 (March 1935): 15.

73 Emily Post warned buffet hostesses of the following scenario: "[P]erhaps, as at a dance, the men fill plates and bring them to their partners. This is what they are supposed to do. If they don't then you have to direct them as you would direct children at a party" (*How to Give Buffet Suppers* [Waterbury, Conn.: Chase Brass and Copper Co., 1933]: 11). An author for *AH* also advised women hosting buffet parties: "Men like to feel there's enough of everything; they don't like small, dainty servings... Follow the technique of the chop house, not the tea room, if you want to please the masculine sex" (Helen Anderson Storey, "Aids to Informal Entertaining," *AH* 10 [July 1933]: 56).

74 Advertisement for Chase Brass & Copper Co., *HB* 75 (May 1934): 123.

75 "Contemporary Dining," 13.

76 Russel Wright Associates [Mary Wright], "Stove to Table Ware and Informal Serving Accessories," catalogue, 1934. Wright Archives. For more on the collaborations between Russel and Mary, see Shapiro, "A Man and His Manners," in Albrecht et al., *Russel Wright,* 27–28.

77 In comparison, a General Electric refrigerator could be bought for $77.50 in 1935. Advertisement for General Electric, *AH* 14 (September 1935): 293.

78 Advertisement for Chase Brass & Copper Co., *RHFE,* 6 November 1933, 11.

79 *Chase Chromium Brass and Copper Specialties,* manufacturer's catalogue (1935; reprint, Atglen, Penn.: Schiffer, 1998), 20.

80 Ibid., 15. Chase also promoted the dignified character of its wine cooler by describing Rockwell Kent

as the "youngest American [artist] ever to have a painting purchased and hung by the Metropolitan Museum" (Advertisement for Chase Brass and Copper Company, *The New Yorker,* 19 May 1934, 83).

81 Mrs. Russel [Mary] Wright, "Super Supper," *Fashions of the Hours* [Marshall Field & Co., Chicago] (Spring 1935): 23.

82 Typed caption for publicity photograph of "Maple handled server and tray," c. 1933. Wright Archives.

83 Wright, "Super Supper," 23.

84 "Memorandum From Mary Ryan on the Russel Wright Line," 1933. Wright Archives.

85 Ibid.

86 Post, *How to Give Buffet Suppers,* 8, 6, 14.

87 Shapiro, "A Man and His Manners," 27–28.

88 "Memorandum From Mary Ryan."

89 Wright, "Super Supper," 23. Mary Wright's public appearances promoting Russel's wares are discussed in Shapiro, "A Man and His Manners," 27–28; and Schonfeld, "Marketing Easier Living," in Albrecht et al., *Russel Wright,* 141–42.

90 Post, *How to Give Buffet Suppers,* 11. Allen's formal Russian Service, in contrast, instructs the "host [to lead] the way to the dining room with the guest of honor... The hostess and her escort come last" (Allen, *Table Service,* 80).

91 Wright, "Super Supper," 23.

92 Advertisement for Chase Brass & Copper Co., *HB* 75 (May 1934): 123.

CHAPTER 3

1 Cromley, "Sleeping Around"; Elizabeth Collins Cromley, "A History of American Beds and Bedrooms, 1890–1930," in Foy and Schlereth, *American Home Life,* 120–41.

2 Susan James has discussed the significance of the master bedroom in postwar architectural designs and advice literature. She documents how architects and authors emphasized the importance of privacy in master bedrooms as a salve for strained marital relations. There is less evidence of this in the pre-WWII period; master bedrooms seem to be noted, but not highlighted with any particular symbolism. See James, "Master Bedroom," 107–8.

3 Richardson Wright, "House & Garden Designs Its Own Modernist House," *H&G* 57 (January 1930): 132.

4 In the post-World War II classic film on building a home, *Mr. Blandings Builds His Dream House,* the architect specifically cites Mrs. Blandings's desire for multiple en-suite bathrooms as the reason their planned house is far beyond the original budget.

5 "One Living Space Convertible Into Many Rooms," *HB* 75 (January 1934): 32–33.

6 "'Here's Mine,' Says Leon," *BHG* 12 (June 1934): 23.

7 "'Here's My Idea of a Room' Says Martha," *BHG* 12 (June 1934): 22.

8 Cromley, "Sleeping Around," 8.

9 Guild, *Designed for Living*, 46–48.

10 Aronson, *Furniture and Decoration*, 310.

11 "'Here's My Idea of a Room' Says Martha," 23. A 1936 advertisement for linoleum flooring also demonstrates the assumption that the bedroom should be a place of retreat by arguing that the evidence of the linoleum's success lies in its ability to create a restful environment for a fictional guest room: a customer writes to the company that her friend's "guest room made me feel at home the moment I stepped into it...so comfortably cozy...so alive with loveliness." The manufacturer emphasized the point by reminding the reader that the flooring "is restful and quiet underfoot—and just as kind to the hostess as to the guest" (Advertisement for Armstrong's Linoleum Floors, *LHJ* [June 1936]: 90).

12 "Modern is Functional—this Room's Function Being to Invite Repose," *HFA* 3 (Fall–Winter 1935): 57.

13 I am grateful to Bill Straus for sharing his insights on the dating and styles of Wright's American Modern bedroom furniture.

14 "'American Modern' Designed by Russel Wright for the Conant Ball Co./ Picture No. 7," typed ms., c. 1935. Wright Archives.

15 Advertisement for Macy's, *New York Times*, 2 February 1936, 16. In this ad, the suite is described as a "new addition" to the line. Wright's bedroom suite with the rolled-edge top retailed for $89.95 at Macy's, including the chest, dresser, and single bed; the bedside table was an additional $11.50. This corresponds with Rutt's middle-income budget for bedrooms, which recommended spending $92.50 on the same items. The Widdicomb suite was more expensive, retailing firmly in the upper-third income bracket. For Widdicomb prices, see *HFA Confidential Pricing Guide* 3 (Fall–Winter 1935): 42. Rutt, *Home Furnishing*, 196. Deskey and Jiranek's Amodec bedroom furniture was priced to compete at the same middle level as Wright's American Modern; the Amodec line is not as aesthetically interesting as those discussed here. See "Modern for A Hundred Dollars," *A&D* 42 (February 1935): 21.

16 Helen Sprackling, "*Parents' Magazine* Presents a Health-First Nursery," *Parents' Magazine* (October 1934): 33. Rohde Scrapbooks.

17 Helen McLean Griggs, "For His Little Sons," *BHG* 13 (November 1934): 18. Russel Wright also included a nursery set in his American Modern line, which like Rohde's was predicated on easy-to-clean, appropriately scaled objects. See "Gift Furniture,"

CD 1 (Winter 1936–37): 33. *H&G* reminded parents of the importance of properly scaled furniture for small children in 1931: "Psychologists agree that children are less apt to develop inferiority complexes when they are provided with furniture scaled to their own size" ("Market Place," *H&G* 60 [December 1931]: 13).

18 Griggs, "For His Little Sons," 18.

19 For a discussion of Karasz's career, including her nursery designs from 1928 and 1929, see Ashley Brown, "Ilonka Karasz."

20 Ilonka Karasz, "Children Go Modern," *H&G* 68 (October 1935): 103.

21 Ibid.

22 Griggs, "For His Little Sons," 18.

23 Ibid., 18–19. Although psychology experts and proponents of livable modernism both claimed that their analysis of the nursery space was new, it actually followed a tradition of reformist nurseries that had first appeared at the end of the nineteenth century, in the Arts and Crafts movement. For an excellent discussion of the philosophy behind nursery furniture in the nineteenth and early twentieth centuries, see Karin Calvert, "Children in the House, 1890–1930," in Foy and Schlereth, *American Home Life*, 75–93.

24 Karasz, "Children Go Modern," 64.

25 The Simmons ads appeared in *H&G, HB*, and *Saturday Evening Post*, among others. Simmons's marketing strategies for the line received plenty of coverage in the trade press. See, for example, "Simmons Featuring Colored Enamel Bedroom Group," *RHFE*, 8 May 1933, 6; "Simmons Co. Plan Big Drive Behind Metal Bedroom Furniture," *RHFE*, 25 December 1933, 10; "Simmons Co. to Hold 40 Style Shows," *RHFE*, 22 January 1934, 8; and "The Winner—So Far," *RHFE*, 30 April 1934, 2.

26 Geddes's enamel and chrome bedroom designs from 1929 are more clunky and less unified than those illustrated in figs. 3.10–3.12. He also sketched a bed, probably never manufactured, that has the curved footboard of the suite in fig. 3.13; here, Geddes's design is more horizontal and streamlined than the 1934 version. For Geddes's designs, see Geddes, *Horizons*, 236–37. There is no record of Geddes doing any work for Simmons besides his 1929 design in the Geddes Archive at the University of Texas at Austin. Moreover, his name never appears in any of the extensive publicity devoted to this line. In 1933 and 1934, Geddes did design a few modest metal beds for the Rome Bed Company, and they are advertised throughout this period with his name. The fact that his name appears in Rome marketing material, but not in Simmons material from the same years, coupled with Geddes's reputation as a publicity hound, makes it highly unlikely that he could have

claimed credit for this popular carnival of color. Stuart's name appears on some of the patents issued to the Simmons Company in the early 1930s, including a design patent for a shaped metal tubing. See Design Patent 91, 692, *U.S. Patent Office Official Gazette* 440, 6 March 1934, 280. No records discovered thus far at the Simmons Company provide any information about the designer of the line (author correspondence with Brandy Nagel, Simmons Company, 17 June 2003).

27 De Wolfe, *House in Good Taste*, 215–16.

28 Advertisement for Simmons, *H&G* 63 (May 1933): opp. 65.

29 Advertisements for Simmons: *H&G* 63 (May 1933); *H&G* 64 (November 1933): inside back cover; *HB* 73 (May 1933): inside back cover.

30 Advertisement for Simmons, *HFA* 1 (Fall 1933): 18.

31 "A Suitable Room for a Girl or Two Young Girls Together," *HFA* 1 (Fall 1933): 67; "Taking Its Cue From the Art of a Famous Stage Designer," *HFA* 1 (Fall 1933): 61.

32 Advertisements for Simmons: *H&G* 63 (May 1933); *Saturday Evening Post*, 12 May 1934, 70; and *HB* 73 (May 1933).

33 Advertisement for Simmons, *HB* 73 (May 1933).

34 The success of Simmons's metal furniture was noted at the January 1934 market, where one executive was quoted as saying, "We feel we have something 'hot' in this line and we're going to follow through" ("Simmons Co. to Hold 40 Style Shows" [see note 25]). The Simmons designs were more expensive than Wright's American Modern and retailed at a level that put them in Rutt's budgets for either a middle-third or upper-third income earner. The twin bed no. 16085 (in fig. 3.10) retailed for about $24.75; twin bed no. 171 (fig. 3.13) retailed for $23. The vanity and mirror no. 16085 (fig. 3.26) retailed for $77 combined; vanity no. 171 (fig. 3.27) for $84. Night table no. 23002 (fig. 3.12) was $15.75; no. 171 (fig. 3.13) was $19. The bed prices fell within Rutt's middle range, but the vanity and night table prices were in the upper-third range. Rutt, *Home Furnishing*, 196. For Simmons prices, see Advertisements, *HB* 73 (May 1933) and *H&G* 64 (November 1933); also *HFA Confidential Pricing Key* 1 (Spring 1933): 15; 2 (Fall-Winter 1934): 25–26.

35 Advertisement for Simmons Company, *H&G* 64 (November 1933).

36 Cromley, "Sleeping Around," 8–9.

37 Rolfe, *Interior Decoration*, 92.

38 Post wrote that the living room "must also express the combined needs and tastes of the family that lives in it" (*Personality of a House*, 341). Rutt agreed: the living room "should express the spirit of

home to the family" (*Home Furnishing,* 198). Guild noted that the living room was the "heart of the house," and that a house should, in general "show… the personality of the family expressed in terms of flawless good taste" (*Designed for Living,* 15).

39 *Modern Priscilla,* 169. Rutt confirmed this interpretation when she advised her readers that "Bedrooms may be more personal than any other rooms as to type of furnishing and as to color" (*Home Furnishing,* 208).

40 Post, *Personality of a House,* 364.

41 Colomina continues, "In other words, fashion is a mask which protects the intimacy of the metropolitan being" ("Loos," 12).

42 Aronson, *Furniture and Decoration,* 297.

43 John Hanrahan, "Let Us Study the Tide Tables," *CD* 1 (Spring 1935): 3. Editors for *AH* endorsed a similar view when they featured modernism as a decorating style in their March 1934 issue; as they explained to their readers, its "chief characteristics to date are: utility, unity, simplicity…and originality" ("Modernism—A Refreshing Note," *AH* 11 [March 1934]: 195).

44 Many reports in the trade newspaper *RHFE* indicate the greater popularity of modernist designs in the bedrooms rather than the living and dining rooms of the Depression. In the fall of 1933, a survey of sales of modernist design in stores across the country revealed that bedroom furnishings were, almost unanimously, the most popular market for modernism, far exceeding sales (or even interest) in modernism in other rooms of the house. See *RHFE,* 4 September 1933, 3–4, 6; and 11 September 1933, 3. In 1934, the newspaper reported that manufacturers at the spring market were offering more examples of modernist bedroom furniture than living or dining room furniture. "Chicago 'Inbetween' Market Brought Forth Many Smart Newcomers," *RHFE,* 21 May 1934, 13. Evidence for the popularity of modernist design in the bedroom can also be found in the trade magazine *HFA,* published between 1933 and 1935. While modernist or hybrid-modern styles accounted for about 20 percent of their living and dining room sketches, modernism appeared in about half of their fictional bedrooms.

45 Jacobs, *Wages of Sin,* chapter 3. See also Albrecht, *Designing Dreams,* 94–96; and Mandelbaum and Myers, *Screen Deco,* 38, 82. Another example of a movie in which modernism is a style of expressive rebellion is *Topper* (1937), where an insouciant, irresponsible couple, the Kirbys, undertake to liberate their stodgy banker, Topper, from his prim ways. In their modernist living room he passes out from drinking champagne next to a chromed coffee table, and Mrs. Kirby (Constance Bennett) com-

ments, "Look—his whole soul is crying out for self-expression!"

46 Jacobs, *Wages of Sin,* chapter 1.

47 Meikle, *Twentieth Century Limited,* 12–13, 15–16; Pulos, *American Design Ethic,* 324. *RHFE* compared the Simmons ad campaign in 1934 with the annual restyling of the auto industries. See "Simmons Co. to Hold 40 Style Shows" (see note 25).

48 Arthur H. Little, "Getting On in the World," *Saturday Evening Post,* 1 June 1929, 68.

49 Glassgold, "The Modern Note in Decorative Arts: Part One," 155.

50 Advertisement for Simmons, *Saturday Evening Post,* 12 May 1934.

51 Advertisements for Simmons: *H&G* 63 (May 1933); *Saturday Evening Post,* 12 May 1934; and *HFA* 2 (Spring-Summer 1934): 12.

52 Deskey designed several examples of colored bedroom furniture for Widdicomb and Estey (see fig. 3.15). See Hanks and Toher, *Deskey,* 94, 183; and "Let It Be," *H&G* (September 1998): 250.

53 "Furniture on Display," *A&D* 42 (March 1935): 48; *HFA Confidential Pricing Key* 2 (Fall–Winter 1934): 25–26.

54 "Modern is as Modern Does—and This Room Accomplishes Things," *HFA* 2 (Fall–Winter 1934): 50.

55 "House and Garden's Furniture Survey," *H&G* 67 (February 1935): 68.

56 "Furniture on Display," 48. Deskey's suite for Widdicomb was described as "inexpensive" by *A&D,* but its retail prices appear to have been notably more expensive than the Simmons suites, matching prospective prices in Rutt's upper-third or luxury-level budgets. The beds were listed at $76 each; the vanity at $134; and the bedside table at $36. Rutt, *Home Furnishing,* 196. *HFA Confidential Pricing Key* 2 (Fall–Winter 1934): 25–26.

57 "Custom-Tailored Modern—Plus a Clever Touch of the Dramatic," *HFA* 2 (Spring–Summer 1934): 54. A wholesale price list for this line tentatively indicates that it cost more than the Simmons, but less than Deskey's Widdicomb suite, probably falling in Rutt's upper-third budget. The bed (twin) was $23; vanity $52; and bedside table $9. Rutt, *Home Furnishing,* 196. *The Herman Miller Furniture Company Price List,* Zeeland, Mich., 2 October 1933. HMI.

58 "Quoted from an article by Marta K. Sironen in 'Furniture Age,'" *Bedroom, Dining Room, Living Room Ensembles, Traditional and Modern,* manufacturer's catalogue (Zeeland, Mich.: Herman Miller Furniture Company, 1933), n.p. HMI.

59 Two of the more prominent "before and after" studies of the era were Frederick Lewis Allen's *Only Yesterday* of 1931, which opened with a snapshot of life in 1919 to contrast with life in 1931; and the

Lynds' *Middletown in Transition* of 1937, which was an attempt to classify the changes in American life since 1925, when they had first visited Muncie, Indiana, and written *Middletown: A Study in Modern American Culture.*

60 In a case history of the modernization of electric clock designs, *Advertising Arts* reported that modernist clocks "had blasted the theory that metropolitan areas were alone in appreciating and buying the novel in design. It seems that the country sections not only approve such tactics but have done more to support them than the cities" (T. J. Maloney, "Case Histories," *Advertising Arts* [September 1934]: 30).

61 Lawson Time, Inc., patented its digital movement; the patent was granted on 12 February 1935. Eidelberg, ed., *Design 1935–1965,* 346.

62 The company was founded in 1926 as the Herman Miller Clock Company by D. J. De Pree, head of the Herman Miller Furniture Company. It hired Rohde to design its first line of modern clocks in 1933, which were featured at the *Century of Progress.* For this early line of products, see *Modern Clocks Designed by Gilbert Rohde,* manufacturer's pamphlet (Zeeland, Mich.: Herman Miller Clock Company, 1934). Century of Progress, Yale. Herman Miller's son, Howard Miller, took over the clock company in 1937 and the name changed to Howard Miller Clock Company. Carron, *Grand Rapids Furniture,* 188–89.

63 Other Rohde clocks are illustrated in Wilson et al., *Machine Age,* 320; and Johnson, *American Modern,* 114, 142, 143.

64 Meikle, *Twentieth Century Limited,* 88–89; Flinchum, *Dreyfuss,* 72–73.

65 Advertisement for Big Ben Chime Alarm, *Saturday Evening Post,* 12 April 1932, 1. A reporter later described the process by which Dreyfuss settled on the shape of the numbers on the clock face; his anecdote again presumes that the bedroom is a place of respite against outside demands: "Then he set about designing a simple, easy-to-read face, not too somber, not too gay, since he reasoned that the clock was the first face you saw every morning, and the wrong one was liable to get you off to a bad start emotionally" (Bill Davidson, "You Buy Their Dreams," *Collier's,* 2 August 1947, 23).

66 Lynd and Lynd, *Middletown in Transition,* 177.

67 "House & Garden's Furniture Survey," 59.

68 The penultimate efficiency of the stereotypical man was apparently inculcated from childhood—he had absorbed the lessons of the nursery. Similarly, teenaged Leon's model room from *BHG* featured numerous organizational devices including a bookshelf, magazine rack, and wastebasket ("It encourages neatness.") See "'Here's Mine,' Says Leon," 64. Many custom-made modernist bedroom designs for

men also included built-in cubby holes and book-shelves, indicative of the owner's rationality. See Dorothy Fleitmann, "Beds Brought Up To Date," *HB* 73 (April 1933): 164; "Modernistic into Modern," *A&D* 42 (November 1934): 12; and "Built-in Beds," *HB* 82 (January 1940): 38.

69 *Modern Priscilla,* 178. Chaise longues appeared in many high-profile women's bedrooms in the 1920s and 1930s, including John Wellborn Root's "Room for a Lady" at the 1929 exhibition *The Architect and the Industrial Arts,* Greta Garbo's bedroom in *The Kiss* (1929), and Kay Francis's bedroom in *Trouble in Paradise* (1932).

70 The chaise was only one object of several that urged women to recline while encouraging men to stand. As Cromley observes, the model "Lady's Bathroom" in the Crystal House was equipped with a bath, while the "Man's Bathroom" had a shower only. Cromley, "American Beds and Bedrooms," 125.

71 *The Bedrooms in the "Design for Living" House at a "Century of Progress" Exposition, Designed by Gilbert Rohde, Made by Herman Miller Furniture Company,* manufacturer's pamphlet (Zeeland, Mich.: Herman Miller Furniture Company, 1933). HMI. Rohde also put forward this explanation of bedroom design in an article entitled "The Modern Designer Considers Floor Plans," *A&D* 42 (April 1935): 10–13.

72 Aronson, *Furniture and Decoration,* 309.

73 More examples of glass-topped vanity tables from the 1930s can be found in the Herman Miller 1939 catalogue (reprint Schiffer, 1998); and Sironen, *American Furniture,* especially the advertising section at the back.

74 Advertisement for Angelus Rouge Incarnat, *The New Yorker,* 21 April 1934, 91. Frederick Lewis Allen described the booming popularity of cosmetics: "Women who in 1920 would have thought the use of paint immoral were soon applying it regularly and making no effort to disguise the fact" (Allen, *Only Yesterday,* 88). For a history of the use of makeup and other beauty products in middle-class American culture, see Kathy Peiss, *Hope in a Jar: The Making of America's Beauty Culture* (New York: Metropolitan Books, 1998).

75 Margaret Fishback, "…And so to Town," *HB* 73 (March 1933): 97.

76 A 1935 ad for a vanity table clock echoed these themes of ownership and performance: "The gentleman can wait while she powders her nose, but gentlemen this season like their waiting done with great consideration. When the hour is set for nine o'clock, he may be more patient if he knows that she, too, knows when nine o'clock has come. So we suggest the Du Barry [model] for her dressing table. A vanity clock that can do its reminding with the greatest

diplomacy and tact. It is a worthy table-top companion for dainty perfumes and colorful powder boxes" (Advertisement for Seth Thomas Clocks, *HB* 77 [December 1935]: 74).

77 Wright, "House & Garden Designs its Own Modernist House," 64 (see note 3).

78 Aronson, *Furniture and Decoration,* 322.

79 The front page of *RHFE* on 6 April 1936 featured a large photograph of a bedroom and the headline, "A Look at Mae West's Bedroom." The room was furnished with an extravagant Louis XV suite.

80 Advertisement for Simmons, *H&G* 64 (November 1933).

81 Italics original. Advertisement for Simmons, *Saturday Evening Post,* 12 May 1934.

CONCLUSION

1 Kirkham, *Eames,* 371.

Bibliography

Abercrombie, Stanley. "The Company that Design Built." *AIA Journal* 70 (February 1981): 54–57.

Adamson, Glenn. *Industrial Strength Design: How Brooks Stevens Shaped Your World.* Exhibition catalogue. Milwaukee, Wisc.: Milwaukee Art Museum and MIT Press, 2003.

Albrecht, Donald. *Designing Dreams: Modern Architecture in the Movies.* 1986. Reprint, Santa Monica: Hennessey and Ingalls, 2000.

———, Robert Schonfeld, and Lindsay Stamm Shapiro. *Russel Wright: Creating American Lifestyle.* Exhibition catalogue. New York: Cooper-Hewitt National Design Museum, Smithsonian Institution, and Harry N. Abrams, 2001.

Allen, Frederick Lewis. *Only Yesterday: An Informal History of the Nineteen-Twenties.* 1931. Reprint, New York: Harper and Row, 1964.

———. *Since Yesterday: The Nineteen-Thirties in America.* 1939. Reprint, New York: Bantam Books, 1965.

Allen, Lucy G. *Table Service.* Boston: Little, Brown, 1933.

American Union of Decorative Artists and Craftsmen. *Annual of American Design, 1931.* New York: Ives Washburn, 1931.

Ames, Kenneth L. *Death in the Dining Room and Other Tales of Victorian Culture.* Philadelphia: Temple University Press, 1992.

Appadurai, Arjun, ed. *The Social Life of Things: Commodities in Cultural Perspective.* Cambridge: Cambridge University Press, 1986.

Aronson, Joseph. *The Book of Furniture and Decoration: Period and Modern.* New York: Crown, 1936.

Attfield, Judith. "What Does History Have to Do With It? Feminism and Design History." *Journal of Design History* 16, no. 1 (2003): 77–87.

Bachelard, Gaston. *The Poetics of Space.* Translated by Maria Jolas. Boston: Beacon Press, 1994.

Banham, Mary, ed. *A Critic Writes: Essays by Reyner Banham.* Berkeley: University of California Press, 1996.

Banham, Reyner. *Theory and Design in the First Machine Age.* 2d ed. Cambridge, Mass.: MIT Press, 1960.

Bayer, Patricia. *Art Deco Interiors: Decoration and Design Classics of the 1920s and 1930s.* New York: Thames and Hudson, 1997.

Beebe, James D. "Tubular-Steel and Metal-Framed Furniture of the Lloyd Manufacturing Company of Menominee, Michigan, 1929–1947." Master's thesis, Bard Graduate Center for Studies in the Decorative Arts, 2000.

Benton, Charlotte, Tim Benton, and Ghislaine Wood, eds. *Art Deco, 1910–1939.* Boston: Bulfinch Press, 2003.

Berman, Avis. "McArthur Returns." *Art and Antiques* 20 (November 1997): 72–77.

Blaszczyk, Regina. *Imagining Consumers: Design and Innovation from Wedgwood to Corning.* Baltimore: Johns Hopkins University Press, 2000.

Blumin, Stuart M. "The Hypothesis of Middle-Class Formation in Nineteenth-Century America: A Critique and Some Proposals." *The American Historical Review* 90 (April 1985): 299–338.

Bourdieu, Pierre. *Distinction: A Social Critique of the Judgment of Taste.* Translated by Richard Nice. Cambridge, Mass.: Harvard University Press, 1984.

Bredehoft, Neila and Tom. *Heisey Glass, 1896–1957.* New York: Collector Books, 2001.

Bronner, Simon J., ed. *Consuming Visions: Accumulation and Display of Goods in America, 1880–1920.* New York and London: W. W. Norton and Company for the Henry Francis Du Pont Winterthur Museum, 1989.

Brown, Ashley. "Ilonka Karasz: Rediscovering a Modernist Pioneer." *Studies in the Decorative Arts* 8 (Fall–Winter 2000–2001): 69–91.

Brunhammer, Yvonne, and Suzanne Tise. *French Decorative Art: The Société des Artistes Décorateurs, 1900–1942.* Paris: Flammarion, 1990.

Buckley, Cheryl. "Made in Patriarchy: Toward a Feminist Analysis of Women and Design." *Design Issues* 3, no. 2 (1986): 3–14.

Caplan, Ralph. *The Design of Herman Miller.* New York: The Whitney Library of Design, 1976.

Carron, Christian G. *Grand Rapids Furniture: The Story of America's Furniture City.* Grand Rapids, Mich.: The Public Museum of Grand Rapids, 1998.

Chase, Stuart. *Men and Machines.* New York: Macmillan, 1929.

Cheney, Sheldon and Martha Candler. *Art and the Machine: An Account of Industrial Design in Twentieth-Century America.* 1936. Reprint, New York: Acanthus Press, 1992.

Clark, Clifford E. *The American Family Home, 1800–1960.* Chapel Hill: University of North Carolina Press, 1986.

Clute, Eugene. *The Treatment of Interiors.* New York: Pencil Points Press, 1926.

Coben, Stanley. *Rebellion Against Victorianism: The Impetus for Cultural Change in 1920s America.* New York: Oxford University Press, 1991.

Cogdell, Christina. *Eugenic Design: Streamlining America in the 1930s.* Philadelphia: University of Pennsylvania Press, 2004.

Cohen, Lizabeth. "The Class Experience of Mass Consumption: Workers as Consumers in Interwar America." In *The Power of Culture: Critical Essays in American History,* edited by Richard Wightman Fox and T. J. Jackson Lears, 135–61. Chicago: University of Chicago Press, 1993.

Colomina, Beatriz. "Intimacy and Spectacle: The Interiors of Adolph Loos." *AA Files,* no. 20 (Autumn 1990): 5–15.

Cowan, Ruth Schwartz. *More Work for Mother: The Ironies of Household Technology from the Open Hearth to the Microwave.* New York: Basic Books, 1983.

Cromley, Elizabeth. *Alone Together: A History of New York's Early Apartments.* Ithaca, N.Y.: Cornell University Press, 1990.

———. "Sleeping Around: A History of American Beds and Bedrooms." *Journal of Design History* 3, no. 1 (1990): 1–17.

Crow, Thomas E. "Modernism and Mass Culture in the Visual Arts." In *Modern Art in the Common Culture.* New Haven: Yale University Press, 1996.

Crowley, John E. *The Invention of Comfort: Sensibilities and Design in Early Modern Britain and Early America.* Baltimore: Johns Hopkins University Press, 2001.

———. "The Sensibility of Comfort." *American Historical Review* 104 (June 1999): 749–82.

Csikszentmihalyi, Mihaly, and Eugene Rochberg-Halton. *The Meaning of Things: Domestic Symbols and the Self.* Cambridge: Cambridge University Press, 1981.

Davies, Karen. *At Home in Manhattan: Modern Decorative Arts, 1925 to the Depression.* Exhibition catalogue. New Haven: Yale University Art Gallery, 1983.

———. "Tastemaking in America: The Birth of Mass Design." *Industrial Design* 30 (November-December 1983): 30–35.

Debord, Guy. *The Society of the Spectacle.* Translated by Donald Nicholson-Smith. New York: Zone Books, 1995.

de Certeau, Michel. *The Practice of Everyday Life.* Translated by Steven Rendall. Berkeley: University of California Press, 1984.

Dell, Simon. "The Consumer and the Making of the *Exposition Internationale des Arts Décoratifs et Industriels Modernes, 1907–1925.*" *Journal of Design History* 12, no. 4 (1999): 311–25.

Denenberg, Thomas Andrew. *Wallace Nutting and the Invention of Old America.* New Haven: Yale University Press and the Wadsworth Atheneum of Art, 2003.

De Pree, Hugh D. *Business as Unusual: The People and Principles at Herman Miller.* Zeeland, Mich.: Herman Miller, 1986.

de Wolfe, Elsie. *The House in Good Taste.* New York: The Century Co., 1913.

Douglas, Mary, and Baron C. Isherwood. *The World of Goods.* New York: Basic Books, 1979.

Downs, Jennifer M. *Shaping the Modern: American Decorative Arts at The Art Institute of Chicago, 1917–1965.* The Art Institute of Chicago: Museum Studies 27, no. 2. Chicago, 2001.

Duncan, Alastair. *American Art Deco.* New York: Thames and Hudson, 1986.

Eidelberg, Martin, ed. *Design 1935–1965: What Modern Was.* Exhibition catalogue. New York: Le Musée des Arts Décoratifs de Montréal, 1991.

——. *Designed for Delight: Alternative Aspects of Twentieth-Century Decorative Arts.* Exhibition catalogue. New York: Le Musée des Arts Décoratifs de Montréal and Flammarion, 1997.

Eliel, Carol S. *L'Esprit Nouveau: Purism in Paris, 1918–1925.* Exhibition catalogue. With essays by Françoise Duros and Tag Gronberg. Los Angeles: Los Angeles County Museum of Art, 2001.

Ewen, Stuart. *Captains of Consciousness: Advertising and the Social Roots of Consumer Culture.* New York: McGraw-Hill, 1976.

Fass, Paula S. *The Damned and the Beautiful: American Youth in the 1920s.* New York: Oxford University Press, 1977.

Fiell, Charlotte and Peter. *Decorative Art: 1920s.* Cologne: Taschen, 2000.

——. *Decorative Art: 1930s and 1940s.* Cologne: Taschen, 2000.

Flinchum, Russell. *Henry Dreyfuss, Industrial Designer: The Man in the Brown Suit.* Exhibition catalogue. New York: Cooper-Hewitt National Design Museum, Smithsonian Institution, and Rizzoli, 1997.

Forty, Adrian. *Objects of Desire: Design and Society Since 1750.* New York: Thames and Hudson, Inc., 1995.

Foy, Jessica H., and Thomas J. Schlereth, eds. *American Home Life, 1880–1930: A Social History of Spaces and Services.* Knoxville: University of Tennessee Press, 1992.

Frank, Isabelle, ed. *The Theory of Decorative Art: An Anthology of European & American Writings, 1750–1940.* New Haven: Yale University Press and The Bard Graduate Center for Studies in the Decorative Arts, 2000.

Frankl, Paul T. *Form and Re-form: A Practical Handbook of Modern Interiors.* New York: Harper and Brothers, 1930.

——. *Machine-Made Leisure.* New York and London: Harper and Brothers Publishers, 1932.

Gans, Herbert J. *Popular Culture and High Culture: An Analysis and Evaluation of Taste.* New York: Basic Books, 1974.

Gebhard, David. *Kem Weber: The Moderne in Southern California, 1920 through 1941.* Exhibition catalogue. Santa Barbara: University of California, Santa Barbara, Art Gallery, 1969.

Geddes, Norman Bel. *Horizons.* Boston: Little, Brown, 1932.

Gideon, Sigfried. *Space, Time and Architecture: The Growth of a New Tradition.* 3rd ed. Cambridge, Mass.: Harvard University Press, 1956.

Glassgold, C. Adolph. "The Modern Note in Decorative Arts." Parts 1 and 2. *The Arts* 13 (March 1928): 153–67; (April 1928): 221–35.

Golan, Romy. *Modernity and Nostalgia: Art and Politics in France Between the World Wars.* New Haven: Yale University Press, 1995.

Gorman, Carma R. "'An Educated Demand': The Implications of Art in Every Day Life for American Industrial Design, 1925–1950." *Design Issues* 16 (Autumn 2000): 45–66.

Greenhalgh, Paul, ed. *Modernism in Design.* London: Reaktion Books, Ltd., 1990.

Greif, Martin. *Depression Modern: The Thirties Style in America.* New York: Universe Books, 1975.

Grier, Katherine C. *Culture and Comfort: Parlor Making and Middle-Class Identity, 1850–1930.* Washington, D.C.: Smithsonian Institution Press, 1997.

Gronberg, Tag. *Designs on Modernity: Exhibiting the City in 1920s Paris.* Manchester: Manchester University Press, 1998.

Guild, Lurelle. *Designed for Living: The Blue Book of Interior Decoration.* Scranton, Penn.: Scranton Lace Company, 1936.

Guilfoyle, J. Roger. "Herman Miller." *Industrial Design* 21 (June 1974): 36–47.

Gura, Judith B. "Modernism and the 1925 Paris Exposition." *Antiques* 157 (August 2000): 194–203.

Haberler, Gottfried. *Consumer Instalment Credit and Economic Fluctuations.* Washington, D.C.: National Bureau of Economic Research, 1942.

Hanks, David A. *Innovative Furniture in America from 1800 to the Present.* New York: Horizon Press, 1981.

——, and Jennifer Toher. *Donald Deskey: Decorative Designs and Interiors.* New York: E. P. Dutton and Company, 1987.

Hansen, Miriam. *Babel and Babylon: Spectatorship in American Silent Film.* Cambridge, Mass.: Harvard University Press, 1991.

Harris, Neil. "The Drama of Consumer Desire." In *Cultural Excursions: Marketing Appetites and Cultural Tastes in Modern America.* Chicago: University of Chicago Press, 1990.

Hayden, Dolores. *Redesigning the American Dream: The Future of Housing, Work, and Family Life.* Rev. ed. New York: W. W. Norton, 2002.

Herman Miller Furniture Company. *1939 Catalog and Sales Guide.* Reprinted with a preface by Leslie Piña. Atglen, Penn.: Schiffer, 1998.

——. *Catalog 1940.* Reprinted with a preface by Leslie Piña. Atglen, Penn.: Schiffer, 1998.

Hillier, Bevis. *Art Deco of the '20s and '30s.* New York: E. P. Dutton, 1968.

Hitchcock, Henry-Russell, and Philip Johnson. *The International Style: Architecture Since 1922.* 1932. Reprint, New York: W. W. Norton and Company, 1966.

Hobbs, Douglass B. "Aluminum—A Decorative Metal." *Good Furniture and Decoration* (August 1930): 89–94.

Horowitz, Daniel. *The Morality of Spending: Attitudes toward the Consumer Society in America, 1875–1940.* Baltimore: Johns Hopkins University Press, 1985.

"The House That Works: I." *Fortune* 12 (October 1935): 59–65ff.

Jacobs, Lea. *The Wages of Sin: Censorship and the Fallen Woman Film, 1928–1942.* Berkeley: University of California Press, 1995.

Jahn, Anthony. "Arthur Fraser's Age of Art Deco at Marshall Field's." *Chicago Art Deco Society Magazine* (Fall 2002–Winter 2003): 6–9.

James, Susan. "The Master Bedroom Comes of Age: Competition, Gender, Sexuality, and the CMHC Series," *Bulletin SSAC* 2, no. 4 (1995): 104–11.

Johnson, J. Stewart. *American Modern, 1925–1940: Design for a New Age.* Exhibition catalogue. New York: American Federation of Arts and Harry N. Abrams, 2000.

——. *Eileen Gray: Designer.* Exhibition catalogue. New York: Museum of Modern Art, 1979.

Kahn, Ely Jacques. "The Province of Decoration in Modern Design." *Creative Art* 5 (December 1929): 885–89.

Kaplan, Wendy, ed. *Designing Modernity: The Arts of Reform and Persuasion, 1885–1945.* Exhibition catalogue. New York: The Wolfsonian and Thames and Hudson, 1995.

Kardon, Janet, ed. *Craft in the Machine Age.* Exhibition catalogue. New York: The American Craft Museum and Harry N. Abrams, 1995.

——. *Revivals! Diverse Traditions, 1920–1945.* Exhibition catalogue. New York: The American Craft Museum and Harry N. Abrams, 1994.

Kasson, John F. *Rudeness and Civility:* Manners in Nineteenth-Century Urban America. New York: Hill and Wang, 1990.

Kennedy, David M. *Freedom from Fear: The American People in Depression and War, 1929–1945.* New York: Oxford University Press, 1999.

Kentgens-Craig, Margret. *The Bauhaus and America: First Contacts, 1919–1936.* Translated by Lynette Widder. Cambridge, Mass.: MIT Press, 2001.

Kerr, Ann. *Collector's Encyclopedia of Russel Wright.* 3rd ed. Paducah, Kentucky: Collector Books, 2002.

Kinchin, Juliet. "Interiors: Nineteenth-Century Essays on the 'Masculine' and the 'Feminine' room." In *The Gendered Object,* edited by Pat Kirkham, 12–29. Manchester: Manchester University Press, 1996.

Kirkham, Pat. *Charles and Ray Eames: Designers of the Twentieth Century.* Cambridge, Mass.: MIT Press, 1995.

——, and Penny Sparke. "'A Woman's Place...'? Women Interior Designers, Part One: 1900–1950." In *Women Designers in the USA, 1900–2000,* edited by Pat Kirkham, 304–16. New Haven: Bard Graduate Center for Studies in the Decorative Arts and Yale University Press, 2000.

Kirsch, Karin. *The Weissenhofsiedlung: Experimental Housing Built for the Deutscher Werkbund, Stuttgart, 1927.* New York: Rizzoli, 1989.

Leach, William. *Land of Desire: Merchants, Power, and the Rise of a New American Culture.* New York: Vintage Books, 1993.

Lears, T. J. Jackson. "From Salvation to Self-Realization: Advertising and the Therapeutic Roots of Consumer Culture, 1880–1930." In *The Culture of Consumption: Critical Essays in American History, 1880–1980,* edited by Richard Wightman Fox and T. J. Jackson Lears, 1–38. New York: Pantheon Books, 1983.

——. *No Place of Grace: Antimodernism and the Transformation of American Culture, 1880–1920.* Chicago: University of Chicago Press, 1994.

Le Corbusier. *The Decorative Art of Today.* Translated by James I. Dunnett. 1925. Reprint, Cambridge, Mass.: MIT Press, 1987.

——. *Towards a New Architecture.* Translated by Frederick Etchells. 1931. Reprint, New York: Dover Publications, 1986.

Lees-Maffei, Grace. "Introduction: Studying Advice: Historiography, Methodology, Commentary, Bibliography." *Journal of Design History* 16, no. 1 (2003): 1–14.

Long, Christopher. "The New American Interior: Paul T. Frankl in New York, 1914–1917." *Studies in the Decorative Arts* 9 (Spring–Summer 2002): 2–32.

——. "Wiener Wohnkultur: Interior Design in Vienna, 1910–1938." *Studies in the Decorative Arts* 5 (Fall–Winter 1997–98): 29–51.

Lupton, Ellen, and J. Abbott Miller. *The Bathroom, the Kitchen, and the Aesthetics of Waste (A Process of Elimination).* Exhibition catalogue. New York: Kiosk Books, 1992.

Lynd, Robert S., and Helen Merrell Lynd. *Middletown: A Study in Contemporary American Culture.* 1929. Reprint, New York: Harcourt, Brace and Company, 1957.

——. *Middletown in Transition: A Study in Cultural Conflicts.* 1937. Reprint, New York: Harcourt, Brace and Company, 1965.

Mandelbaum, Howard, and Eric Myers. *Screen Deco.* New York: St. Martin's Press, 1985.

Marchand, Roland. *Advertising the American Dream: Making Way for Modernity, 1920–1940.* Berkeley: University of California Press, 1985.

Margolin, Victor, ed. *Design Discourse: History, Theory, Criticism.* Chicago: University of Chicago Press, 1989.

May, Elaine Tyler. "Myths and Realities of the American Family." In *A History of Private Life: Volume V: Riddles of Identity in Modern Times,* edited by Antoine Prost and Gérard Vincent, translated by Arthur Goldhammer, 539–93. Cambridge, Mass.: Belknap Press, 1991.

McCracken, Grant. *Culture and Consumption: New Approaches to the Symbolic Character of Consumer Goods and Activities.* Bloomington: Indiana University Press, 1988.

McNeil, Peter. "Designing Women: Gender, Sexuality and the Interior Decorator, c. 1890–1940." *Art History* 17 (December 1994): 631–57.

McQuaid, Matilda. *Lilly Reich, Designer and Architect.* Exhibition catalogue. New York: Museum of Modern Art, 1996.

Meikle, Jeffrey L. "Material Virtues: On the Ideal and the Real in Design History." *Journal of Design History* 11, no. 3 (1998): 191–99.

——. *Twentieth Century Limited: Industrial Design in America, 1925–1939.* Philadelphia: Temple University Press, 1979.

Miller, Daniel, ed. *Acknowledging Consumption: A Review of New Studies.* London: Routledge, 1995.

Miller, R. Craig. *Modern Design in the Metropolitan Museum of Art, 1890–1990.* New York: Metropolitan Museum of Art and Harry N. Abrams, 1990.

Mintz, Steven, and Susan Kellogg. *Domestic Revolutions: A Social History of American Family Life.* New York: Free Press, 1988.

Modern Priscilla Home Furnishing Book: A Practical Book for the Woman Who Loves her Home. Special subscription ed. Boston: Priscilla Publishing Company, 1925.

Motz, Marilyn Ferris, and Pat Browne, eds. *Making the American Home: Middle-Class Women and Domestic Material Culture, 1840–1940.* Bowling Green, Ohio: Bowling Green State University Popular Press, 1988.

Nichols, Sarah. *Aluminum by Design: Jewelry to Jets.* Exhibition catalogue. Pittsburgh: Carnegie Museum of Art and Harry N. Abrams, 2000.

Nye, David E. *Electrifying America: Social Meanings of a New Technology.* Cambridge, Mass.: MIT Press, 1990.

Ockner, Paula, and Leslie Piña. *Art Deco Aluminum: Kensington.* Atglen, Penn.: Schiffer, 1997.

Orvell, Miles. *The Real Thing: Imitation and Authenticity in American Culture, 1880–1940.* Chapel Hill: University of North Carolina Press, 1989.

Ostergard, Derek, and David A. Hanks. "Gilbert Rohde and the Evolution of Modern Design, 1927–1941." *Arts Magazine* 56 (October 1981): 98–107.

Park, Edwin Avery. *New Backgrounds For a New Age.* New York: Harcourt, Brace and Company, 1927.

Pells, Richard H. *Radical Visions and American Dreams: Culture and Social Thought in the Depression Years.* New York: Harper and Row, 1973.

Pevsner, Nikolaus. *Pioneers of Modern Design: From William Morris to Walter Gropius.* 1936. Reprint, New York: Penguin Books, 1991.

Phillips, Lisa. *High Styles: Twentieth-Century American Design.* Exhibition catalogue. New York: Whitney Museum of American Art and Summit Books, 1985.

Piña, Leslie. "American Modernist: Gilbert Rohde." *Modernism Magazine* 2 (Fall 1999): 24–27.

———. *Depression Era Art Deco Glass.* Atglen, Penn.: Schiffer, 1999.

———. *Fostoria: Designer George Sakier.* Atglen, Penn.: Schiffer, 1996.

Pommer, Richard, and Christian F. Otto. *Weissenhof 1927 and the Modern Movement in Architecture.* Chicago: University of Chicago Press, 1991.

Porter, Glenn. *Raymond Loewy: Designs for a Consumer Culture.* Exhibition catalogue. Wilmington, Del.: Hagley Museum and Library, 2002.

Post, Emily. *The Personality of a House.* New York: Funk and Wagnalls Company, 1930.

Pulos, Arthur J. *The American Design Adventure, 1940–1975.* Cambridge, Mass.: MIT Press, 1988.

———. *The American Design Ethic: A History of Industrial Design to 1940.* Cambridge, Mass.: MIT Press, 1983.

Rapaport, Brooke Kamin, and Kevin L. Stayton. *Vital Forms: American Art and Design in the Atomic Age, 1940–1960.* Exhibition catalogue. New York: Brooklyn Museum of Art and Harry N. Abrams, 2002.

Read, Helen Appleton. "The Exposition in Paris." Parts 1 and 2. *International Studio* 82 (November 1925): 93–97; (December 1925): 160–65.

Read, Herbert. *Art and Industry: The Principles of Industrial Design.* New York: Harcourt, Brace and Company, 1935.

Reed, Christopher, ed. *Not at Home: The Suppression of Domesticity in Modern Art and Architecture.* London: Thames and Hudson, 1996.

Reynolds, Grace. *Decorating your Home: Where to Start, What to Do, How to Do It.* New York: Bigelow-Sanford Carpet Co., Inc., 1930.

Rhoads, William B. "Colonial Revival in American Craft: Nationalism and the Opposition to Multicultural and Regional Traditions." In *Revivals! Diverse Traditions, 1920-1945,* edited by Janet Kardon, 41–54. Exhibition catalogue. New York: The American Craft Museum and Harry N. Abrams, 1994.

Richards, Charles R. *Art in Industry.* New York: Macmillan Company, 1929.

Rolfe, Amy L. *Interior Decoration for the Small House.* New York: Macmillan Company, 1926.

Ross, Phyllis. "Modular Meets Industry: Gilbert Rohde's Designs for Unit Furniture." Master's thesis, Cooper-Hewitt/Parsons Master's Program in the History of Decorative Arts, 1993.

Russel Wright: Good Design is for Everyone—In His Own Words. New York: Manitoga/The Russel Wright Design Center and Universe Publishing, 2001.

Rutt, Anna Hong. *Home Furnishing.* New York: John Wiley and Sons, 1935.

Scharf, Lois. *To Work and to Wed: Female Employment, Feminism, and the Great Depression.* Westport, Conn.: Greenwood Press, 1980.

Schwartz, Frederic J. *The Werkbund: Design Theory and Mass Culture before the First World War.* New Haven: Yale University Press, 1996.

Seldes, Gilbert. "Profiles: Industrial Classicist: Walter Dorwin Teague." *The New Yorker*, 15 December 1934, 28–32.

———. "Profiles: The Long Road to Roxy: Donald Deskey." *The New Yorker,* 25 February 1933, 22–26.

"Showroom: Aluminum Company of America: Lurelle Guild, Designer." *Architectural Forum* 65 (October 1936): 305.

Sironen, Marta K. *A History of American Furniture.* New York: Towse Publishing, 1936.

Sklar, Robert. *Movie-Made America: A Social History of American Movies.* New York: Random House, 1975.

Smith, Elizabeth A.T., and Michael Darling, eds. *The Architecture of R. M. Schindler.* Exhibition catalogue. Los Angeles: Museum of Contemporary Art and Harry N. Abrams, Inc., 2001.

Smith, Terry. *Making the Modern: Industry, Art, and Design in America.* Chicago: University of Chicago Press, 1993.

Solon, Leon V. "The Viennese Method for Artistic Display." *Architectural Record* 53 (March 1923): 266–71.

Sparke, Penny. *As Long As It's Pink: The Sexual Politics of Taste.* New York: Harper-Collins, 1995.

———. "The 'Ideal' and the 'Real' Interior in Elsie de Wolfe's *The House in Good Taste* of 1913." *Journal of Design History* 16, no. 1 (2003): 63–76.

Stern, Robert A. M. "Relevance of the Decade." *Journal of the Society of Architectural Historians* 24 (March 1965): 6–10.

———, Gregory Gilmartin, and Thomas Mellins. *New York 1930: Architecture and Urbanism Between the Two World Wars.* New York: Rizzoli, 1987.

Stillinger, Elizabeth. *The Antiquers: The Lives and Careers, the Deals, the Finds, the Collections of the Men and Women Who Were Responsible for the Changing Taste in American Antiques, 1850–1930.* New York: Knopf, 1980.

Susman, Warren I. *Culture and Commitment: 1929–1945.* New York: George Braziller, 1973.

———. *Culture as History: The Transformation of American Society in the Twentieth Century.* New York: Pantheon Books, 1984.

Tamely, Allen. "Profiles: Man Against the Sky: Raymond Hood." *The New Yorker,* 11 April 1931, 24–27.

Taragin, Davira S. *The Alliance of Art and Industry: Toledo Designs for a Modern America.* Exhibition catalogue. Toledo, Ohio: Toledo Museum of Art and Hudson Hills Press, 2002.

Todd, Dorothy. "Some Reflections on Modernism: What it is, Here and Abroad, and What it is Not." *House Beautiful* 66 (October 1929): 416ff.

———, and Raymond Mortimer. *The New Interior Decoration: An Introduction to its Principles, and International Survey of its Methods.* New York: Charles Scribner's Sons, 1929.

Troy, Nancy J. *Modernism and the Decorative Arts in France: Art Nouveau to Le Corbusier.* New Haven: Yale University Press, 1991.

Urbach, Henry. "Closets, Clothes, disClosure." *Assemblage* 30 (August 1996): 62–73.

U.S. Commission on International Exposition of Modern Decorative and Industrial Art, Paris, 1925. *Report of Commission Appointed by the Secretary of Commerce to Visit and Report upon the International Exposition of Modern Decorative and Industrial Art in Paris, 1925.* Washington, D.C.: Department of Commerce, 1926.

Veblen, Thorstein. *The Theory of the Leisure Class.* 1899. Reprint, Amherst, N.Y.: Prometheus Books, 1998.

Venable, Charles L. *American China and Glass, 1880–1980: From Table Top to TV Tray.* Exhibition catalogue. Dallas: Dallas Museum of Art, 2001.

Wandersee, Winifred D. "The Economics of Middle-Income Family Life: Working Women During the Great Depression." In *Decades of Discontent: The Women's Movement, 1920–1940,* edited by Lois Scharf and Joan M. Jensen, 45–58. Westport, Conn.: Greenwood Press, 1983.

Ware, Susan. *Holding Their Own: American Women in the 1930s.* Boston: Twayne, 1982.

Weatherman, Hazel Marie. *Fostoria: Its First Fifty Years.* Springfield, Mo.: The Weathermans, 1972.

Westin, Jeane. *Making Do: How Women Survived the '30s.* Chicago: Follett Publishing, 1976.

Wexman, Virginia Wright. *Creating the Couple: Love, Marriage and Hollywood Performance.* Princeton: Princeton University Press, 1993.

Wharton, Edith, and Ogden Codman, Jr. *The Decoration of Houses.* 1902. Reprint, New York: W. W. Norton, 1978.

"What D'You Mean, Modern?" *Fortune* 12 (November 1935): 97–103ff.

Whitford, Frank. *Bauhaus.* New York: Thames and Hudson, 1984.

Wilk, Christopher. *Marcel Breuer: Furniture and Interiors.* Exhibition catalogue. New York: Museum of Modern Art, 1981.

Williamson, Judith. *Decoding Advertisements: Ideology and Meaning in Advertising.* London: Boyars, 1978.

Wilson, Richard Guy, Dianne H. Pilgrim, and Dickran Tashjian. *The Machine Age in America, 1918–1941.* Exhibition catalogue. New York: The Brooklyn Museum of Art and Harry N. Abrams, 1986.

Wright, Gwendolyn. *Moralism and the Model Home: Domestic Architecture and Cultural Conflict in Chicago, 1873–1913.* Chicago: University of Chicago Press, 1980.

Wright, Richardson. "The Modernist Taste: At the Exhibition des Arts Décoratifs in Paris, Modernism Concentrated Its Latest Experiments." *House and Garden* 48 (October 1925): 77–79ff.

Photocredits

Index